CHINA
BY RAIL

The Vendome Press

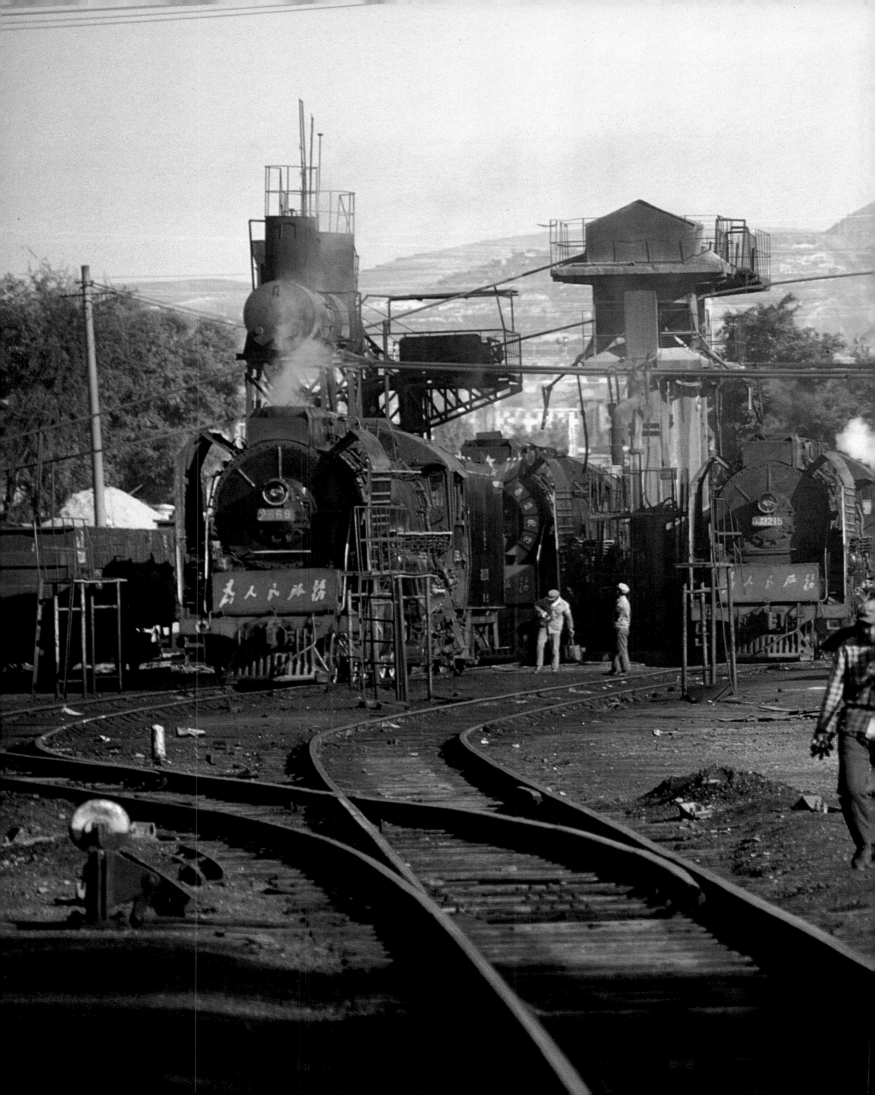

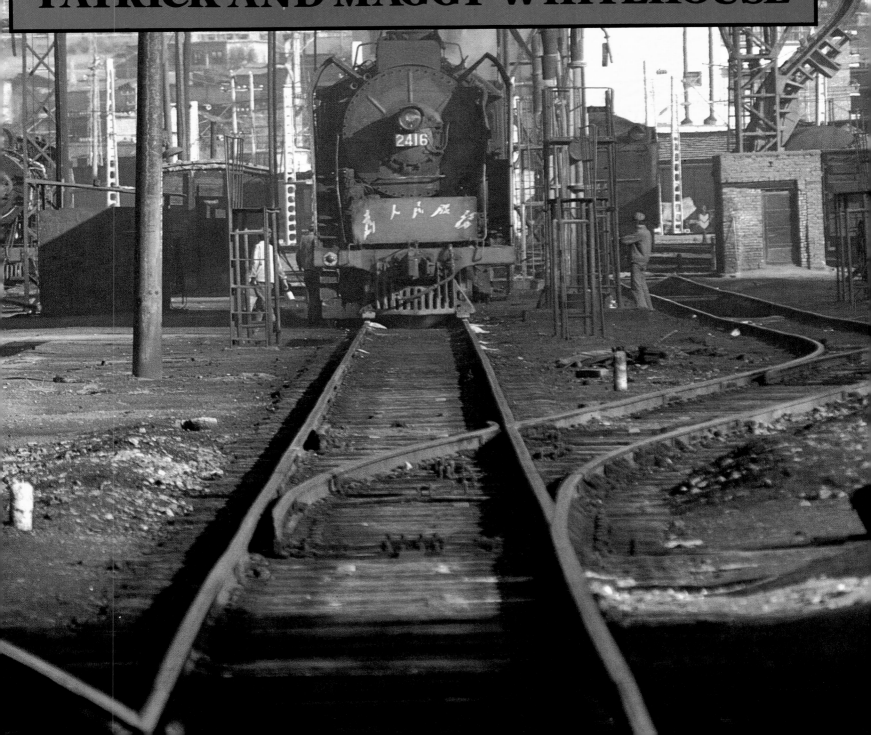

CHINA
BY RAIL
PATRICK AND MAGGY WHITEHOUSE

Published in the USA in 1988 by
The Vendome Press, 515 Madison Avenue, New York City, NY 1022

Distributed in the USA by
Rizzoli International Publications, 597 Fifth Avenue, New York, NY 10017

A John Calmann and King book.

Library of Congress Cataloging in Publication Data
Whitehouse, P.B. (Patrick Bruce)
China by rail/text and photographs by Patrick and Maggy Whitehouse.
p. cm
ISBN 0–86565–090–X: $45.00
1. Railroads – China. I. Whitehouse, Maggy. II. Title.
TF101. W46 1988
385'.0951–dc19 88–14403 CIP

This book was designed and produced by
JOHN CALMANN AND KING LTD, LONDON

Designed by Robert Updegraff
Typeset by Composing Operations, Kent
Printed in Italy by Lito Terrazzi

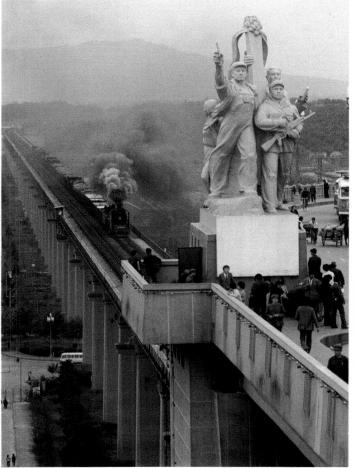

Previous pages: *Steam in the evening. QJ and JF locomotives prepare for a night's work on Lanzhou shed.*

By afternoon, Nanjing's smog has become a perpetual haze aggravated by the smoke and diesel fumes from the many trains crossing the river. The long bridge's huge steel girders rest on nine giant piers sunk deep into the river bed. Its political and economic significance is marked by the immense statues which overlook the river and symbolically keep guard over all its traffic.

CONTENTS

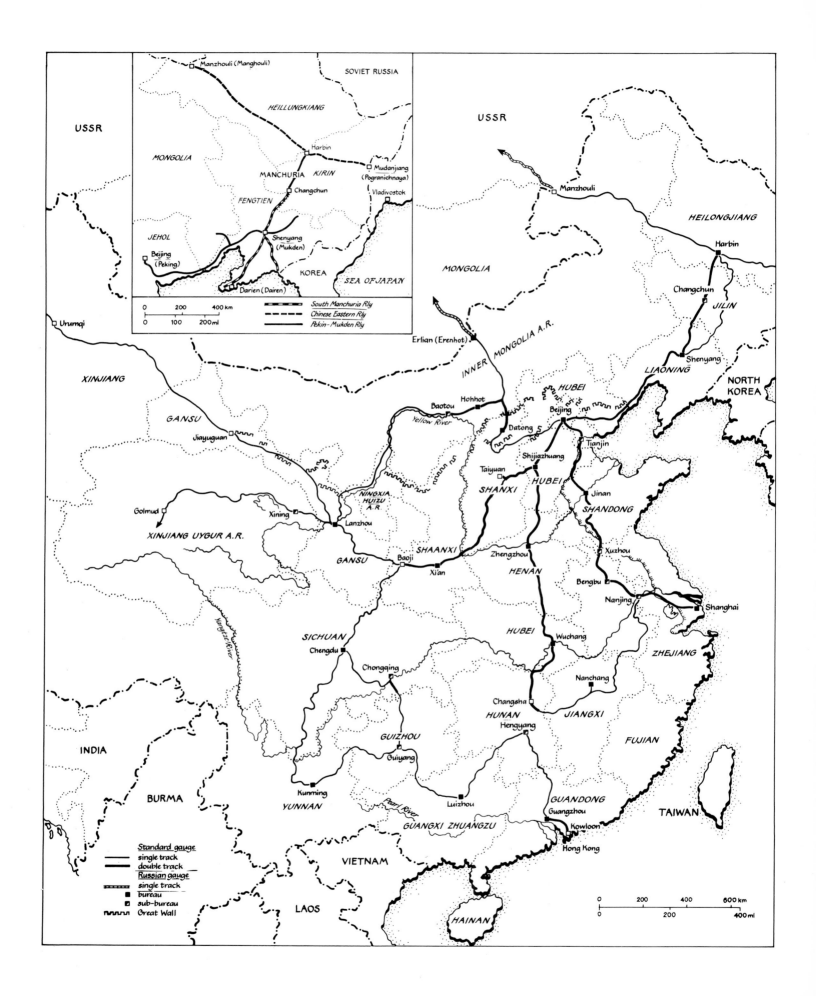

Manzhouli (Manghouli)

SOVIET RUSSIA

HEILLUNGKIANG

MONGOLIA

MANCHURIA KIRIN
 Mudanjiang
 (Pogranichnaya)
 FENGTIEN Changchun
 Vladivostok
JEHOL
 Shenyang
Beijing (Mukden)
(Peking)
 KOREA
 Darien (Dairen) SEA OF JAPAN

0 200 400 km
0 100 200 ml

South Manchuria Rly
Chinese Eastern Rly
Pekin-Mukden Rly

USSR

USSR

Manzhouli

HEILONGJIANG

MONGOLIA

Harbin

Changchun JILIN

Shenyang LIAONING

NORTH
KOREA

Erlian (Erenhot)

INNER MONGOLIA A.R.

HUBEI

Urumqi

XINJIANG

GANSU

Jiayuguan

Baotou Hohhot

Yellow River

Datong Beijing

Tianjin

Shijiazhuang

Taiyuan HUBEI

SHANXI

Jinan

SHANDONG

Golmud

Xining

Lanzhou

NINGXIA
HUIZU
A.R.

XINJIANG UYGUR A.R.

Baoji

SHAANXI

Zhengzhou

Xuzhou

Xi'an

GANSU

HENAN

Bengbu

Nanjing Shanghai

SICHUAN

Chengdu

Chongqing

HUBEI

Wuchang

Nanchang

ZHEJIANG

Yangtze River

Changsha

JIANGXI

FUJIAN

HUNAN

Hengyang

INDIA

GUIZHOU

Guiyang

BURMA

Kunming

Luizhou

YUNNAN

Pearl River

GUANGXI ZHUANGZU

GUANDONG

Guangzhou

Kowloon

Hong Kong

TAIWAN

VIETNAM

LAOS

HAINAN

0 200 400 600 km
0 200 400 ml

Standard gauge
 single track
 double track
Russian gauge
 single track
■ bureau
▣ sub-bureau
ﬥﬥ Great Wall

Acknowledgements

No book of this kind could possibly be written without the help of many people in China, a number of whom have become old friends over the years. The Chinese definition of an 'old friend' is one to be highly prized, for the term is the sign of a solid and lasting relationship, and one not earned easily. The China Railway Publishing House and the China Railway Foreign Service Corporation have made countless arrangements for our travel over the years, doing their very best to fit in with our often difficult requests for visits to parts of the country not normally open to foreigners and to see and photograph technical installations. In each case this has meant constant liaison with local Railway Foreign Affairs organizations who have put themselves out to be helpful. It has been a truly co-operative effort. In particular we would like to thank both ex-President Tu Rongju and President Li Yusheng of the China Railway Publishing House, Yang Tianmin and Chen Hong Bao from the Foreign Affairs Department in the City of Changchun and Duan Ning Fang who whilst working for the Railway Publishing House looked after our needs so well and who is now in the United Kingdom working with us for a time. Considerable assistance has come from the management of the Kowloon–Canton Railway in Hong Kong including full facilities for travel over the new system and a thorough inspection of the modern operating practices.

Particular thanks goes to the Continental Railway Circle, a group of learned enthusiasts for overseas railways, for the tables at the end of the book which have been reproduced from the Continental Railway Journal through the kindness of its editor, Lance King. The list was prepared by Brian Garvin, Ivor Harding and Jonathan Smith. Our thanks are also due to *Railway Magazine* and to its editor, John Slater, for permission to reproduce the extracts which appear in the first part of the book. The publishers, too, have been a source of encouragement from the very beginning, keeping us on a straight and narrow path with their eyes on the production of a really good book which will appeal worldwide. Paula Iley in her capacity as editorial director and Sophie Collins as editor have taken a very special interest and we are most grateful. Finally we would like to thank Linda Griffin who has overseen all the manuscript typing – not an easy task with so many technicalities and far-flung names.

Patrick B. Whitehouse
Maggy A. Whitehouse

Birmingham 1988

Foreword

The China Railway Publishing House has had a long and friendly relationship with Patrick Whitehouse. Both Patrick and his daughter Maggy have been to China many times travelling the length and breadth of Chinese railways where they have visited numerous locomotive depots, stations, bridges, workshops and other railway facilities meeting our staff: drivers, chief-conductors, conductors, engineers, superintendents and many others. Much information has been gained and thousands of impressive photographs have been taken. China is a huge country making it impossible for one foreign writer to cover every line in one or even two books, but we hope that readers of China by Rail will find an image of the railway system here; its successful development of new lines, facilities, modernisation and its improvement in services. The book also shows a China which tourists can rarely see. The China Railway Publishing House and China Railway Foreign Service Corporation have been able to provide help both by accompanying Patrick and Maggy on their many journeys and by the provision of photographs; we hope that our joint co-operation and the mutual friendship linking our two peoples will be enhanced by the book.

Li Yusheng
(President)

Map of China, showing principal railway lines. Inset: Historical lines in north-east China (Railway Magazine, 1928).

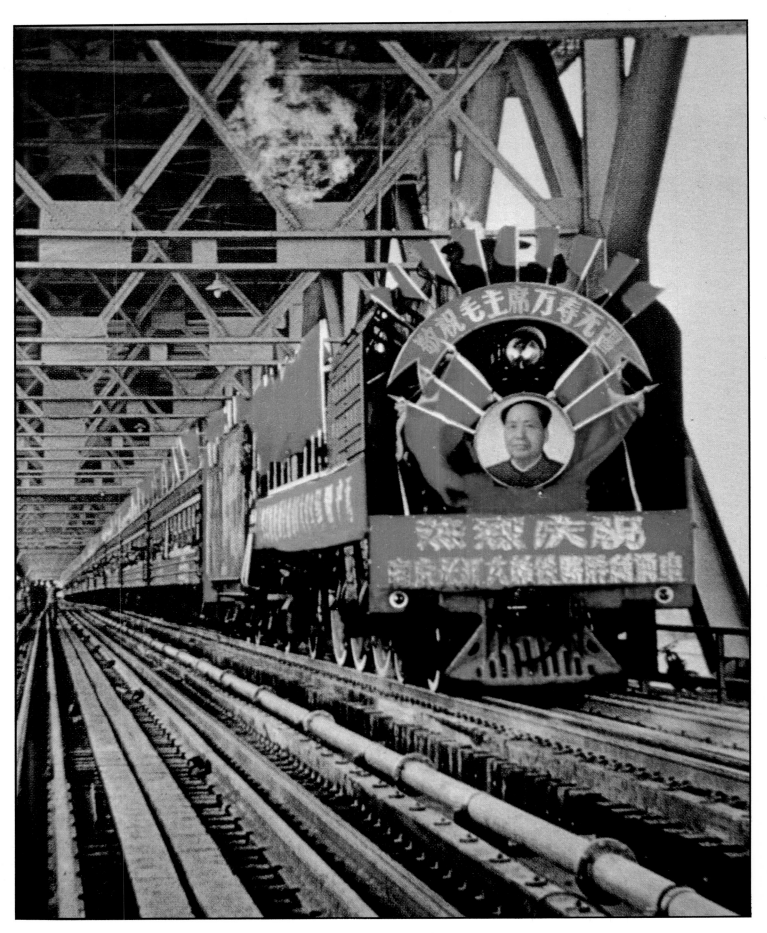

The Railway System

Looking at a map of China's railways today the traveller must be struck not only by the vast distances involved but also by the large number of cities which have been linked in recent years by two parallel threads of steel. With a population of over 1,000 million spread unevenly across a huge land, and with natural resources from crops and timber to coal and oil abounding in an area covering one eighth of the fertile globe, the railway system of China has an economic and political importance unsurpassed anywhere in the world. Until the founding of the People's Republic of China, colloquially and nationally known as Liberation, in 1949, the country had a long history of poverty, backwardness and economic exploitation by the Western powers and Japan. Even today she remains a developing country in economic and technological terms, but times are changing fast, largely due to the efficient expansion of communications resulting from a greatly enlarged railway system. Before Liberation the country's railways had a chequered history; prior to 1935 and the Japanese invasion of Manchuria, there were some 12,400 miles (20,000 km) of track, but by 1949 less than half was in working order, the rest having been destroyed by years of internal struggle and disorder. The new Government made the restoration and construction of its railways a top priority and now the network well exceeds 50,000 miles (80,000 km) and is still growing at a rate of over 600 miles (1,000 km) a year. Prior to 1949 seven of China's great provinces had no railways at all; today only Tibet has no tracks or trains. Even in the 1960s signalling was sparse and crude but today China's railways have some of the most modern and sophisticated signalling in the world. Over the last thirty years more than a dozen major trunk lines have been planned and constructed, mostly in the thinly populated and difficult mountain or desert territory of the western provinces. Before Liberation the railway imported practically all its locomotives, rolling stock and equipment; now China manufactures her own without foreign aid, and the system today is a great tribute to the energy of the railwaymen and women who run it.

When China offered to build a railway in East Africa in the troubled 1970s the question of whether the Chinese were technically capable of the task was raised, but those familiar with Chinese accomplishment and determination always laughed and said they could do it easily. That they did is hardly surprising when one looks at the 600 miles (1,000 km) of the Chengdu–Kunming line, which is driven through the foothills of the Tibetan mountains, with deep gorges and swift-flowing rivers adding to already frightening terrain. One only has to absorb the fact that this route incorporates 440 tunnels (many of them built in spiral form) and 653 bridges, totalling 278 miles (447 km) or 40 per cent of its total length and the point is doubly made.

But progress has not always been so swift and the introduction of railways to China was not greeted with enthusiasm. They represented Western ideas and developments which did not fit in to the Qing court's thinking and threatened their sovereignty. These were the days of outside pressures for trade concessions and treaty ports. A British trading company, Jardine Matheson (still a huge conglomerate today), introduced railways to China when, acting with a group of

Red letter day. The first train to cross the newly opened bridge over the Yangtze River in 1968. This was a completely Chinese enterprise, in design, steel and civil engineering work. The locomotive is an RM class Pacific. The Chinese wording on the front of the smoke box reads: 'Warmly celebrate the completion of the Railway at the Nanjing Yangtze River Bridge.'

9

The arrival of the first steam engine in China. Built by Ransome and Rapier of Ipswich in 1874 for the Woosung Road Company, Shanghai, this 2 ft 6 in gauge locomotive was aptly named Pioneer. *It weighed 26 cwt, and could be carried by sixteen men.* Pioneer *made its first trip on 14 February 1876.*

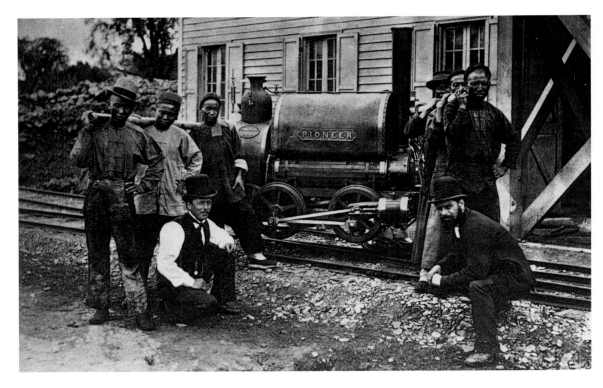

Opening day. The Woosung Road Company's 2 ft 6 in gauge railway was opened from Shanghai to Kangwan on 3 July 1876, using three tank locomotives and wooden-bodied, oil-lit coaches. This photograph shows Pioneer, *which worked on the construction of the railway, and the 0–6–0 tank* Celestial Empire *posed for official records.*

Chinese merchants, it 'improved' on a permission granted to construct a road from Shanghai to Woosung and built a 2 ft 6 in gauge railway alongside for a distance of some 5 miles (8 km). The line opened in 1876 (using Ransome and Rapier's 0-4-0 *Pioneer*) without government sanction and soon became a centre of interest for local people, with crowds coming to watch the strange apparition puffing to and fro. The people may have seemed enthusiastic but the district Taotai (magistrate), Kwang-Hsu, was far from happy, informing the British Consul that although the road was sanctioned the railway was not, and demanding that further work be suspended for a month while he contacted the authorities. At the end of this period, to no one's real surprise, there was no reply from Peking and work re-started. By now the line had passed the town of Kanguan and it re-opened with a service of six trains each way. All went well until a fatal accident occurred on 3 August. This was said to be a case of suicide, but the Taotai's response was that he knew there were five hundred men anxious to commit suicide on the railway. The driver was put on trial before the Consular Court and, not unnaturally, acquitted – although not in the eyes of the Chinese. As a result the line was closed for a second time, re-opening in December, this time all the way to Woosung Creek. The Taotai did not come to the opening. After some negotiation the Chinese purchased the railway from its owners, closed it down, and shipped everything to Taiwan where it lay rusting away for many years prior to re-use on the island. For the present, the Chinese seemed to have won their fight against innovation and foreign influence.

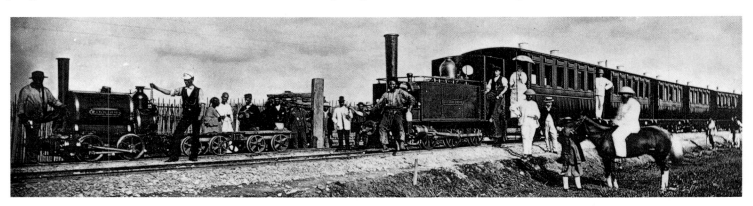

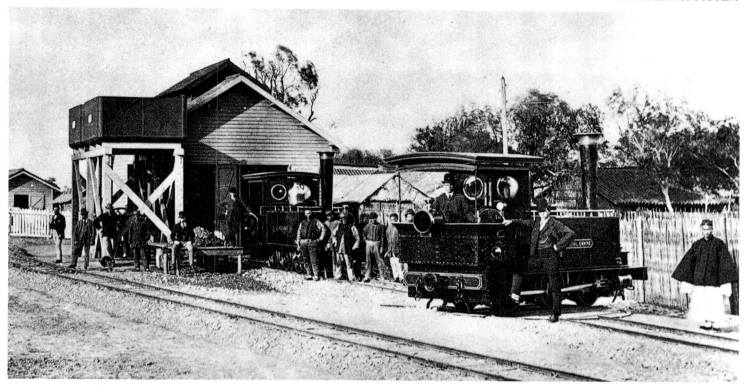

Steam on the shed. The first photograph of a Chinese locomotive depot. Shanghai shed on the Shanghai–Woosung Railway probably taken in late 1876 showing Celestial Empire on the turntable and Flowery Land alongside the primitive coal stage. The carriage sheds are in the background on the left.

The eventual fate of the engines and rolling stock used on the first Chinese railway is discussed in this report of 1938:

From Southwold to China may seem a far cry, but a link is provided by a bungalow in Station Road, which is – or was – known as Shanghai Cottage, and boasted some Chinese characters on the front. This bungalow was at one time occupied by a man named W.G. Jackson, who was the engineer-in-charge of the construction of the Southwold Railway in 1878–1879, but had preceded that experience by acting in a similar capacity for the first railway in China, built in 1875–1876 to connect Shanghai with Woosung across a loop of the Whangpoo River. The gauge of this diminutive concern was only 2 ft 6 in, and the contractors for the line and its equipment were Ransomes and Rapier, of Ipswich. With the first three locomotives, appropriately named *Celestial Empire, Flowery Land*, and *Pioneer*, Ransomes and Rapier sent out one of their skilled men, Jackson, who actually drove the first train to run in China. But the opposition of the Celestials to this innovation of the 'foreign devils' was considerable, and culminated in October, 1877, when a Chinese mob tore up the track, and the Shanghai–Woosung Railway came to a full stop. Jackson thereupon returned to England where his firm were in course of building and equipping the 3 ft gauge Southwold Railway; and to the latter he went with the three engines built by Ransomes and Rapier – *Blyth, Halesworth*, and *Wenhaston* – *Southwold* being purchased later. Herein was the origin of the legend which at one time had wide currency, that the Southwold Railway was built for the Chinese, but not being good enough for them, it was brought back and laid between Halesworth and Southwold.

The Railway Magazine, February 1938

China's first railway timetable.

WOOSUNG ROAD CO., LIMITED.

ON AND AFTER

MONDAY, JULY 3rd, 1876,

UNTIL FURTHER NOTICE, TRAINS WILL RUN ON THIS LINE

BETWEEN

SHANGHAI & KANGWAN

AS UNDER:—

Trains will leave Shanghai at

| A.M. | A.M. | A.M. | P.M. | P.M. | P.M. |
| 7 | 9 | *11 | *1 | 3 | 5 |

Trains will leave Kangwan at

| A.M. | A.M. | A.M. | P.M. | P.M. | P.M. |
| 7.30 | 9.30 | *11.30 | *1.30 | 3.30 | 6 |

FARES:

China's first standard gauge railway was the Kaiping Tramway in Hobei province. This was built by a Chinese mining company to link its new coal mine at Tangshan with a canal some 7 miles (10 km) distant; the motive power was provided by mules. Construction was under the supervision of C.W. Kinder, an Englishman of considerable railway experience, who foresaw that this could be the beginning of a much greater system for which he planned accordingly. Shortly after the tramway was opened in 1881, Kinder took the boiler from a portable winding engine, made some wheels out of scrap iron and constructed a frame from channel iron; the whole became a rather primitive but workable 0-6-0 tank. As 9 June 1881 was the hundredth anniversary of George Stephenson's birth, the locomotive was appropriately named *Rocket*. Kinder was right in his surmise: eventually the line grew into one of China's premier trunk railways, reaching Tientsin in 1887. After being absorbed into the British-financed Imperial Railways of North China, it was extended west to Beijing by 1894, linking with the Russian-built system (coming down from the new Trans-Siberian line) in Manchuria at the beginning of this century, even though the two railways were of different gauges.

It was not just the British and the Russians who stepped in. The Japanese had already cast envious eyes on China's minerals. The Sino-Japanese War of 1894–5 made China's military weakness obvious and left her badly in need of money to pay the large indemnities demanded by the Japanese. The only way to obtain funds was to concede numerous trading operations to the established powers – Britain, Belgium, France, Germany, Russia and the USA. It was claimed that this was done peacefully but treaty ports and concession areas were acquired giving the foreign powers almost unlimited rights, including the policing and the bearing of arms. As might be expected, there was a great scramble for railway concessions and between 1895 and 1903 foreigners obtained control of some 6,000 miles (9,650 km) of proposed railway lines although only 2,708 miles (4,358 km) were actually built. China was, for all practical purposes, divided up: France had the south-west, Belgium, Britain and Germany the rich, fertile east (between Shenyang in north-east Manchuria and Hangchow in the south-east) and America took the section between Hangchow and Canton. In 1910 the British opened the Kowloon–Canton

Hong Kong train. A Kitso. 4–6–0 – KCR No. 3 – leaves Hong Kong with a Canton-bound train in the late 1930s.

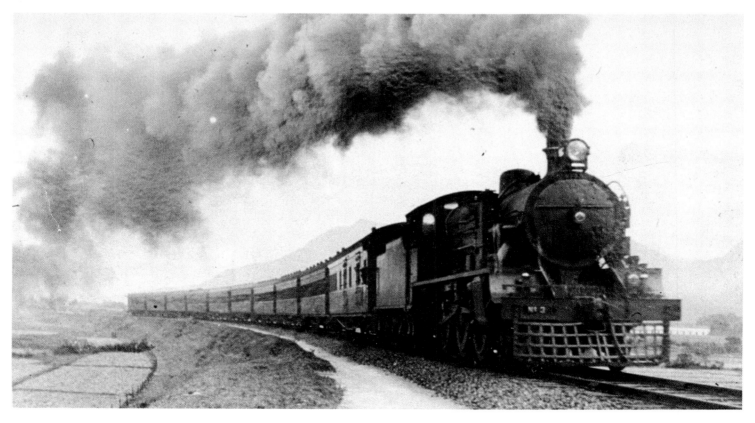

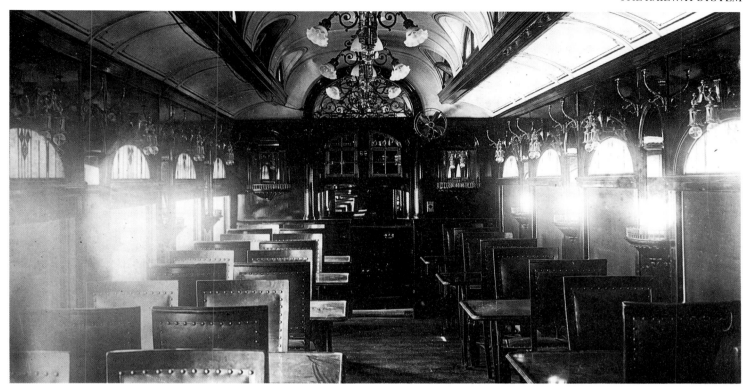

Railway linking China with their jewel in the east – Hong Kong; this was run – then as now – in two sections, 93 miles (150 km) in China and 23 miles (37 km) within Hong Kong. Russia did particularly well out of the series of takeovers having earlier negotiated the construction of the Chinese Eastern Railway (to her own 5 ft 0 in gauge) which provided a direct link between the Sino-Russian border at Manzhouli and Vladivostok as well as extending the railway south from Harbin to Shenyang and the warm-water harbours of Darien and Fushun (then Port Arthur). A total of 1,600 miles (2,575 km) had been laid by 1903.

Japan entered the concession business in another way; she soundly defeated the Russians in the Russo-Japanese War of 1904–5. This enabled the Japanese to invade Manchuria where they were to stay until their defeat at the end of the Second World War in 1945. As a result of their victory the Japanese acquired the lease of two important warm-water ports, Darien and Fushun, as well as the Russian-dominated Chinese Eastern Railway, south of Changchun. This line, together with others built to move troops during the war, became the South Manchurian Railway (SMR), taking in the extensive coal mines in the Fushun area which had also been removed from the Russians in the same way. The Japanese forged the SMR into the foremost railway system in China and changed its original (mostly 3 ft 6 in) gauge to the standard 4 ft 8½ in. This enabled express trains to run through from the junction with the Russian 5 ft 0 in gauge line at Changchun to Fusan in Korea, where fast steamers could take passengers across to Shimonosiki in Japan. It was a most comprehensive scheme which provided the excellent military and commercial links which were vital to ensure a tight Japanese hold on Manchuria. It resembled the old British East India Company, or perhaps the Canadian Pacific Railway, in that everything that was worthwhile in Manchuria was sooner or later taken under the company's protective wing. Everything was of the best quality and largely followed American practice in locomotives, Pullman cars and the general pattern of operating. By using the route from London to Shanghai via Siberia, the journey, which formerly took forty-one days by sea via Suez or thirty days by steamer and across America, could be accomplished in sixteen. Even so, through traffic between the South Manchuria and other Chinese railways was practically impossible because of a difference in coupling heights.

American-style comfort. The interior of a dining car belonging to the South Manchuria Railway and built by the Pullman Car and Manufacturing Company. Ornate interiors were typical of American practice in the early part of the twentieth century.

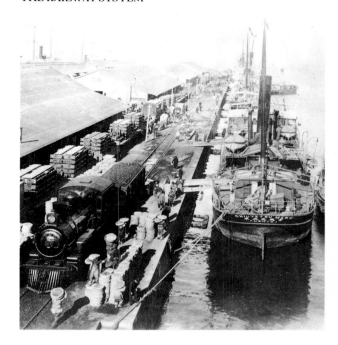

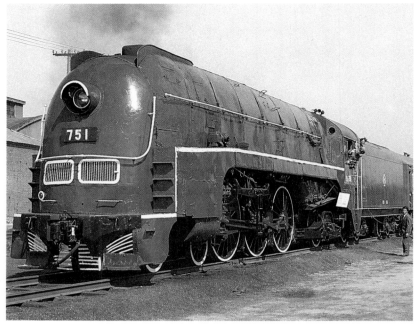

Manchurian port. Equipped by American locomotives and stock and run to American practices, the South Manchuria Railway was one of China's finest examples of rail development. This photograph shows the port facilities at Dalian (then known as Darien or Dalny) with a US-built 2–6–2 No. 208 (Richmond 1907) shunting coal alongside a Japanese freighter.

A great Chinese railway engineer. Statue of Zhan Tianyou, the engineer for the Peking–Kaglan Railway which was completed in 1908.

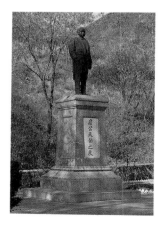

Meanwhile the Chinese Government had not been idle, building railways financed either by private capital or local and national purses. By 1912, when the Qing dynasty finally fell, the Chinese had constructed almost 3,000 miles (4,825 km) of track. Certainly the best-known, and rightly so, was the 125 mile (200 km) long Beijing–Zhangjiakou line beside the old caravan route to Mongolia. This railway was built entirely by Chinese engineers, led by Zhan Tianyou who had been trained both in the United States and Great Britain before taking up a post with C.W. Kinder on the Imperial Railways of North China. Work began in 1905; it included a relatively gentle section from Beijing across the plains to Nankou, but from there on construction was difficult, for the railway had to run through the 13 mile (21 km) Nankou pass to tackle the high mountains to the north-west. This tremendous effort resulted in four long tunnels, a maximum gradient of 1 in 30 topped by a switchback, and a 3,850 ft (1,175 m) tunnel under the Great Wall of China between Qinglongqiao and Badaling, present station for the Great Wall. Opened in 1909, this is China's historical showpiece, and set back from the platform on Qinglongqiao (old) station a bronze statue of Zhan surveys passing trains as he stands watching the evolving scene.

The death of the Dowager Empress in 1908 (a few days after the imprisoned Emperor had died) ended an epoch in China, for the new Emperor was still a small child and was forced by revolutionary pressure to yield and sign away his powers to the Republic in 1911. The change could have been anticipated, for the great reformer Dr Sun Yat Sen had been steadily increasing his power in China over the previous twenty years. When the turmoil eventually quietened down the railways came under direction from central Government, whose Ministry of Communications did their best to try to set standards and sort out the problems of British-built railways with British dimensions, Belgian with Belgian, German with German and American with American. The only main line standards which had been agreed by the individual railway companies were rail weight, bridge loading, the use of buckeye couplers, air brakes and steam heating equipment; but, as has been seen, even these varied, with the China lines having coupler heights of 1,067 mm and the South Manchuria, a very important railway indeed, American heights of 850 mm. Similar problems arose with differences in air brake pressure, steam heating and other details.

The First World War once again changed everything. Russia collapsed into civil war and Japan seized power where the opportunity arose. The railways continued to function, but there were severe problems with through trains where civil unrest was rife with various war lords

The Japanese railway monopoly in Manchuria did not always go unopposed – sometimes the Chinese took matters into their own hands:

A curious controversy is at present raging between China and Japan over the question of railway construction in Manchuria by Chang Tso-Lin, the Northern war lord, who, it is alleged, in direct contravention of a treaty between the two countries, is building railways which parallel and compete with the South Manchurian Railway. Work has been speeded up on the Tahushan–Tungliao Railway, despite protests from the Japanese, surveys for other lines further north competing with the system are proceeding, and the opening of the railway to Hailung Chang last September, in continuation of the Peking–Mukden line, has brought matters to a head. In spite of the refusal of the South Manchurian Railway to convey material for the further extension of this latter line, the earthworks are already in Kirin city. A line is also in process of construction from Kirin *via* Tunhwa to the Korean frontier, with a branch to Ninguta, and the Chinese Government is completing the link to join the isolated railway at Kwainei with their main system. Japan is, therefore, taking steps to secure greater co-operation between the Chinese Eastern, South Manchurian and the Ussuri section of the Soviet Railways to expedite traffic to South Manchuria, and thus bring about the abandonment of the Chinese programme.

The Railway Magazine, September 1928

Opposite: Relic at Shenyang. An original member (No. 751) of the 1934 Japanese-built SL₇ Pacific class, used on the streamlined Asia Express of the South Manchuria Railway from 1935, is now preserved: it was in steam at the opening of the Shengyang Railway Museum on 22 September 1984.

Luxury train in north-east China. As far back as 1906 the Compagnie Internationale des Wagons-Lits inaugurated the de-luxe Trans Manchurien Express between Irkutsk in Siberia and Changchun in Manchuria, the southern terminus of the Chinese Eastern Railway, built to the Russian gauge of 5 ft 0 in. The train is seen here at Harbin in 1923.

fighting each other. In spite of this, the Chinese built several major lines in the 1920s, but these were scarcely completed when Japan provoked the Manchuria Incident of 1932, occupied Manchuria, re-christened it Manchuquo, took the North Manchurian Railway (formerly the Chinese Eastern) from the Russians in 1935 and totally re-gauged it. This was a remarkable feat – the Changchun–Harbin line (149 miles/240 km) was changed over without delaying a single train. By 1936 nearly 2,000 miles (3,200 km) of new track had been completed, with the South Manchurian Railway operating a system over 9,000 miles (14,500 km) long, most of it American-

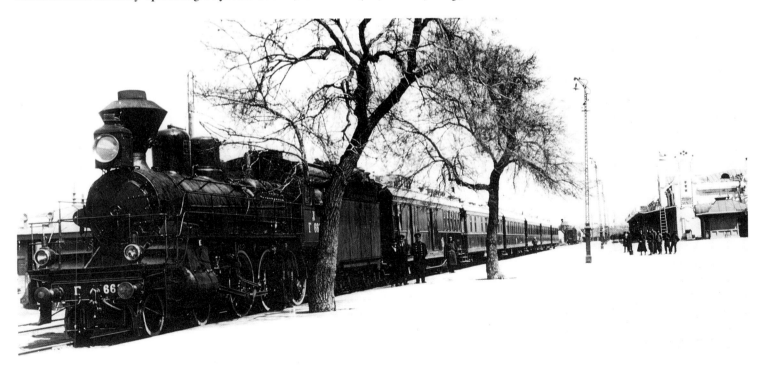

The 'Mukden bomb outrage' came to be known as the Manchuria Incident:

Bomb Explosion on the Railway in China

'Considerable interest was aroused recently over the assassination of Marshal Chang Tso-Lin, the late dictator of Northern China, as he was fleeing from Peking before the approach of the Nationalist armies. When his train was passing under the bridge at the outskirts of Mukden, which carries the South Manchurian over the Peking–Mukden Railway, there occurred what is now popularly termed "the Mukden bomb outrage". Just as the coach in which the Marshal was travelling was passing under the bridge, there was a most violent explosion, far surpassing any which could have been produced by the proverbial anarchist's trick of "throwing a bomb". In actual fact, a considerable charge of explosive had been inserted into or secured on to, one of the piers of the overbridge, the remains of which can be seen in the photograph. As the intended coach passed under the bridge, the mine was fired electrically, with the results illustrated. The girders of the overbridge were brought down upon the vehicle, which was set on fire, had its sides and structure blown asunder, and its frame distorted and driven down into the permanent way. The loss of life was high, but how anyone escaped from such a disaster is amazing. The Marshal succumbed to his injuries on 21 June.'

The Railway Magazine, October 1928

equipped and working to American practices. The Japanese made a polished job of this work, doubling tracks, straightening curves, building new stations and workshops and – so they said, – becoming the 'Great Civilizing Agent'. Among the products was the streamlined 'Asia' express which made the 435 mile (700 km) run from Darien to Shenyang at an average speed of 51 mph (82 kph), and was one of the premier trains in the world at that time both for speed and comfort.

To balance these events in the north-east, the rest of China made rapid progress with the rehabilitation of its railways, aided by an arrangement with the British who returned large sums claimed as indemnities after the Boxer Risings. The agreement was reached in 1931 and 50 per cent of the money was allocated to the Ministry of Railways. This enabled a great many loans to be made to various railways for the purchase of equipment. Consideration was even given to the possibility of a bridge across the Yangtze at Nanjing but after some discussion it was decided to construct a train ferry, largely on the advice of Colonel Kenneth Cantlie, a one-time friend of Dr Sun Yat Sen, and a British engineer of some eminence. A remarkable programme of new construction was put in hand which aimed at creating 1,000 miles (1,600 km) of track each year for five years and, before the Japanese invasion stopped it, this was the crowning achievement of the Ministry. The thousands of miles of new construction works involved were surveyed and built entirely by Chinese engineers and labour. Several of these new lines, notably the Canton–Hankow line, were through extremely difficult country and the speed with which they were all completed was astounding. The first main line locomotives to be designed in China should also be mentioned here. The basis of the design came from Colonel Cantlie who produced a 4-8-4 which was ordered from the British Vulcan Foundry and which lasted in service until the 1970s. The Canton–Hankow line was to be of considerable strategic importance in linking the Government with the outer world during the early days of the Japanese invasion only a few years later. By 1937 the Japanese had taken all of China north of the Yellow River and in July of that year the struggle for total occupation began. This was somewhat thwarted through the waging of guerilla warfare by the Chinese, limiting effective occupation of the country to the railway lines, the towns and their immediate neighbourhood.

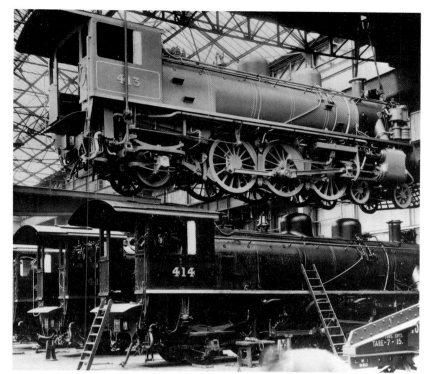

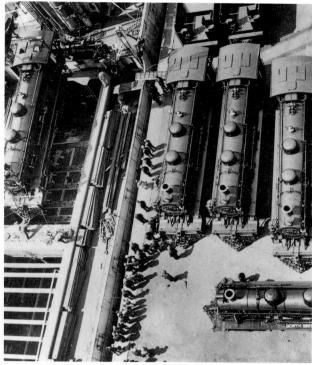

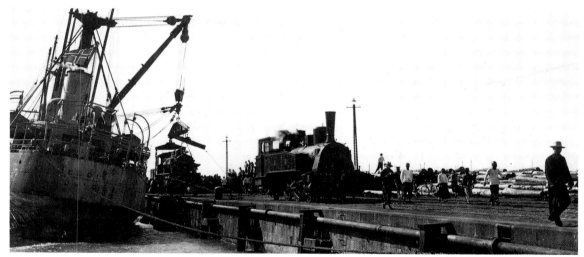

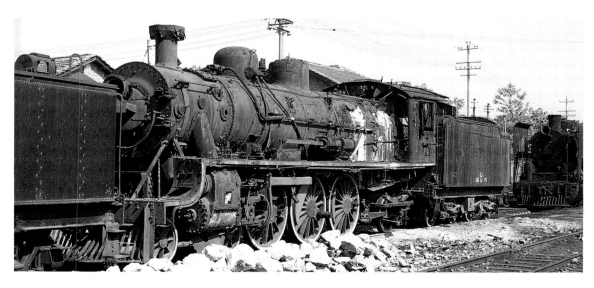

Forty years of useful service. Eight 4–6–2 locomotives were built by the North British Locomotive Company in Glasgow for the Tientsin–Pukow Railway (order number L883, works numbers 24106–13, running numbers 413–20, date of order 20 December 1932, date of delivery 5 July 1933). These photographs show the engines in the erecting shop at the company's Hyde Park works, their loading aboard the SS Beldis at Stobcross Quay, Glasgow, and their final unloading at an unknown destination in China (No. 413 is under the sling). The picture of the semi-derelict locomotive was taken at Xiangtangxi works near Nanchang on 14 August 1986. It is class SL14 No. 924 (works number 24108, the third of the 1933 batch) and had been out of use for about ten years.

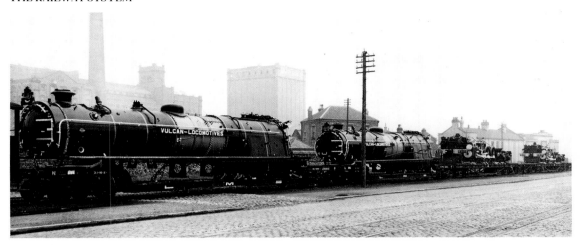

VULCAN
Locomotives
Steam
Electric
Diesel

The
VULCAN
FOUNDRY LTD
NEWTON · LE · WILLOWS
LANCASHIRE

1935 giants. The first main-line locomotives to be designed in China were the KF₁ 4–8–4s, built by the Vulcan Foundry at Newton-le-Willows in Lancashire for the Canton–Hankow line. At the time of their introduction these were the most powerful locomotives in the country. The photograph shows the engines – boilers plus frames and motion – awaiting shipment at Birkenhead docks on 6 November 1935.

Such was the success of Colonel Cantlie's KF₁ 4–8–4 that the manufacturers used an illustration of one of the class for their large advertisement in the 26 September 1936 issue of Modern Transport – read by railway executives all over the world.

A graphic picture of the confusion of rail travel in China in the early thirties is given in this account of 1935:

After twenty years of disturbance following upon the revolution, the railways in the central provinces of China are slowly recovering. During the years of civil war, locomotives and rolling-stock were seized again and again by rival war-lords and the track became incredibly neglected, so much so that no one knew when a train would arrive or depart, or whether a traveller would reach his journey's end safely. Records are not lacking of persons taking two days to cover a distance of forty-five miles, of the track subsiding *en route,* or of the train stopping part way owing to shortage of fuel, and the engine-crew coming along the train to solicit passengers for money with which to buy wood at the nearest village. Two or three years of comparative peace, broken only by sporadic raids by Reds and bandits, have allowed of the tracks being repaired and rolling stock reconditioned, so that nowadays one rarely needs to travel uncertainly on the top of a goods wagon. There is reason to believe that the Central Government at Nanking is slowly gaining authority, and one of its immediate tasks is the rehabilitation of existing lines and the opening up of new ones . . .

The question now facing engineers is how the Yangtze River is to be bridged at Hankow – the one obstacle at present to continuity of track between Calais and Canton, *via* Siberia. The construction of a bridge would certainly present formidable obstacles, but in the long run would seem to offer greater advantages than a train-ferry which has been proposed in some quarters. Again the all-important question is money. For the present the Hankow–Canton Railway begins at Wuchang, on the south bank of the Yangtze, and takes one as far as Changsha, the capital of Hunan province, 260 miles distant, in 14 hours. A China journal of some repute recently described the state of this track as 'sufficient to cause a Western engineer's hair to stand on end'. From a journey on foot down a section of it the writer can endorse this statement; there are broken and incredibly rotten sleepers, splayed rails and missing bolts. One marvels that accidents are so few. A few weeks ago the writer also had occasion to travel over it twice, and cannot soon forget the bumps and the vibration, and this when travelling on the special express. Nevertheless, credit must be given to the Chinese engineers who operate the line under such difficulties, and who are now making praiseworthy efforts to replace the decayed permanent way.

The Railway Magazine, November 1935

The huge advances in rail travel by about 1940 are reflected in this report:

Of two recent return journeys over the Chinese section of the Peking–Mukden (Peiping–Liaoning) Railway from Chingwangtao near Shanhaikwan (on the Manchukuo border) through Tientsin to Peking, Captain M.C. Russell writes that he noted a high standard of permanent way maintenance, and extensive improvement works in hand at various places, including the doubling of the remaining single line sections and the construction of a big new bridge – consisting of a dozen girder spans – at Lanchow. The express trains, carrying first, second and third class passengers, averaged about 40 mph, and included a first class observation car and dining and sleeping accommodation, though the Japanese military appeared to have first call on the latter. The ordinary trains, stopping at all stations, had no first class accommodation. All trains were very long and seemed to be filled to capacity, but the first class cars were comfortable, and were well heated and lighted. Only Japanese and Chinese food was served in the diners, and prices, in keeping with the fares, were low. The locomotives on passenger workings were mainly of the Pacific and 4-6-0 types, and not too clean. British practice in all departments was much in evidence.

The Railway Magazine, September 1940

The story of the struggle is a long one. It is sufficient to say here that the Chinese Nationalists sought to construct new, strategically placed railways, including one in the south-west to link Yunnan with Burma. They even proposed to revise one of Dr Sun Yat Sen's plans to build a 2,000 mile (3,200 km) long railway north-west from Lanzhou, although the latter plan was not viewed kindly by the Russians. All came to nought with the Japanese occupation of Indo-China and by the end of the Second World War less than 1,000 miles (1,600 km) of railway remained under Nationalist control. Meanwhile the Japanese continued to rehabilitate the system which they had taken over and to build new lines in the north-east. Their defeat and withdrawal from China in 1945–6 left the Railway Ministry with 7,150 miles (11,500 km) of railways – fortunately found to be in better condition than expected – allowing a rapid recovery to be made, similar to that of ten years earlier. Sadly this was interrupted once again when civil war began in earnest. It ended in victory for Mao Tse-tung and the Red Army, and China was at least politically stable for the first time in living memory.

The new government ensured that the restoration of the railway system was one of their top priorities and once again the programme of railway reconstruction and renewal came into play. Massive aid was received from the United Nations Relief and Rehabilitation Administration (UNRRA) whilst the Chinese also enlisted Russian help, ensuring that the latter 'returned' Russian-made equivalents of items they had acquired at the end of the war – Soviet troops were reported to have removed hundreds of miles of railway. This collaboration, although only temporary, produced, among other things, the line across the Gobi Desert through Mongolia, thus shortening the journey from Beijing to Moscow by over a day.

Looking at a map of the Chinese railway system where the opening dates of the various routes are marked it becomes clear that these generally can be divided into three parts, that of the one-time Japanese empire of Manchuquo, the Chinese and other foreign-built lines prior to Liberation and those constructed (and still being built) since 1949. When one considers some of the problems posed by the Cultural Revolution, some tremendous steps forward were taken by the early 1970s. In the south-west the long-planned line through the panda-inhabited mountains from Chongqing to Chengdu and the direct line linking the Sichuan provincial capital with

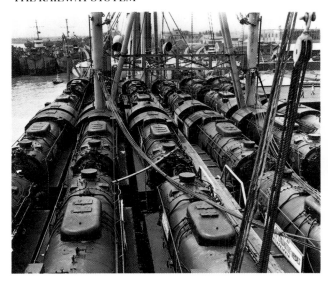

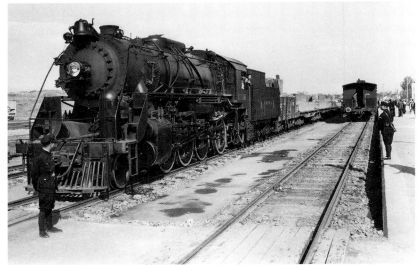

United Nations aid to rehabilitation. A cargo of 48 USA Baldwin and Lima-built UNNRA 2–8–0s on board the Norwegian freighter Beljeanne *at Woosung docks, Shanghai, in July 1947. Designated class KD₇, a number of these engines are still at work, some in the Shanghai area.*

Carrying a diamond-shaped Lima works plate, an UNNRA 2–8–0 waits to leave Jinhua in Zhejiang Province with a train-load of materials for the reconstruction of the Zhejiang–Jiangxi line, shortly after her arrival in China in 1947. The engine carries two numbers, 1148 on the headlamp and IC–CS 1261 on the cabside.

Kunming are typical of the incursions through hostile mountains made by Chinese engineers, often dealing with floods, drifting sands, quicksands and even earthquakes. On one occasion they had to tunnel through rock which registered a temperature of over 105 degrees fahrenheit (40 degrees centigrade). Other major routes receiving attention included the important north–south line from Beijing to Guangzhou, when, in 1957, the Chinese opened the long railway and road bridge over the wide Yangtze River at Wuhan. The bridge was built to Chinese designs and contains Chinese steel, although there was some Russian help involved in the use of the percussion method of sinking piers into the river bed. Possibly the Russians also inspected the plans as would be normal when dealing with such foundation work. But that was all. Their claim, made at the opening ceremony, that the bridge was a present from Russia scarcely added to harmonious relations.

The longest bridge of all, that over the Yangtze at Nanjing, was opened in 1968. This is one of the great bridges of the world by any standard, and is entirely Chinese in design, materials and equipment. It posed far greater construction problems than did that at Wuhan and represents a correspondingly great achievement.

Other new routes include a trunk line from Chongqing northwards to Xiangfan in Hubei Province, a particularly daunting task needing 716 bridges and more than 400 tunnels, taking in more than half of the line's 569 mile (916 km) length – eight years of unremitting toil. Driving a railway from Lanzhou to Xining and on to Golmud 10,000 ft (3,050 m) up in the mountains en route to Lhasa, the Tibetan capital, a total distance of 1,400 miles (2,250 km), has also proved an almost impossible challenge. Trains here carry a doctor with oxygen apparatus to assist those whose respiratory systems fail to cope with the rarified atmosphere. So far the line has stopped at Golmud, but if it should go forward the problems to be overcome will loom very large indeed.

Work begun in the 1980s has included much double tracking and electrification as well as the construction of new routes, many of them to assist in the movement of coal and oil from the hinterland to the harbours on China's east coast. Nearly four decades of determination and progress have given China a truly comprehensive railway network – more than double that in existence at Liberation and still developing fast. By the end of the present century it is predicted that traffic will double that in the 1980s.

The early development already described has taken in the major trunk routes and standard gauge tracks but there is much more, some old and some new, most built to the narrow gauge. Of these lines, the principal system is the 290 mile (465 km) long route running south to the Vietnam border, a metre gauge railway pioneered as long ago as 1901 by the French, who controlled Indo-China, the idea being to link Hanoi with Kunming, then known as Yunnan Fu

or Yunnan Sen. The tracks rose from a height of 288 ft (88 m) at Laokay to 6,207 ft (1,892 m) at the Chinese terminus, with two higher summits in between. It was called the Chemin de Fer de l'Indochine et du Yunnan (CIY). The first section, to the Chinese border, was comparitively easy going but the remaining 300-odd miles (480 km) set the engineers a considerably harder task. These are tropical lands, and rainy seasons mixed with formidable geological difficulties took their toll, with malaria adding to the human problems. The line was not completed until 1910. It was, and is, a very spectacular piece of railway, though today one which is only open to few foreigners and then rarely south of Yiliang. Its main workshops are at Kaiyuan 154 miles (248 km) south of Kunming. Even here one can see instances of the difficulties which the French met, for only a few miles north of Yiliang the railway begins a long, hard twisting climb on the edge of a deep gorge on high stone arches built into the rockface. Until 1940 the CIY operated as a prolongation of the railways of French Indo-China. Linking into this railway there is another which appeals to Western enthusiasts: the last remnants of the 600 mm gauge Yunnan Kopei Railway, opened in 1917 to exploit the local tin mines. It runs from a junction at Gejiu to Jijie and is worked to this day, although only intermittently, by Baldwin 0-10-0 tender locomotives dating from 1926.

In pre-Liberation days there were a number of other metre gauge railways – now converted to standard – the principal two being that linking Taiyuan with Shijiazhuang (the Shi-Tai) built between 1904 and 1907, 143 miles (231 km) long, and the longest metre gauge line in China (the Tong-Pu) running from Datong southwards through Taiyuan, and connecting with the east–west Long-Hai line at Mengyuan, a distance of 549 miles (883 km). The latter was built as a strategic railway in the 1930s when the Communists were in Shaanxi Province, west of the Yellow River; by connecting Datong, Taiyuan and Mengyuan on the east side, the Nationalists were able to transfer troops from north, central or south China to face the Red insurgents. There was also a 3 ft 6 in gauge system built by the Japanese in the west and south of Hainan Island during the Second World War. This is now standard gauge and, with the proposed developments of tourism in the area, may well grow in importance.

Metre gauge in the southwest. A French-built JF₅₁ class 2–8–2 tank emerges from the Old Tiger Pass tunnel on the Kunming–Hekou line built to join French Indo-China with pre-Second World War China. Services no longer run through to Vietnam, and although two or three JF₅₁s were in service in 1987, complete dieselization is imminent.

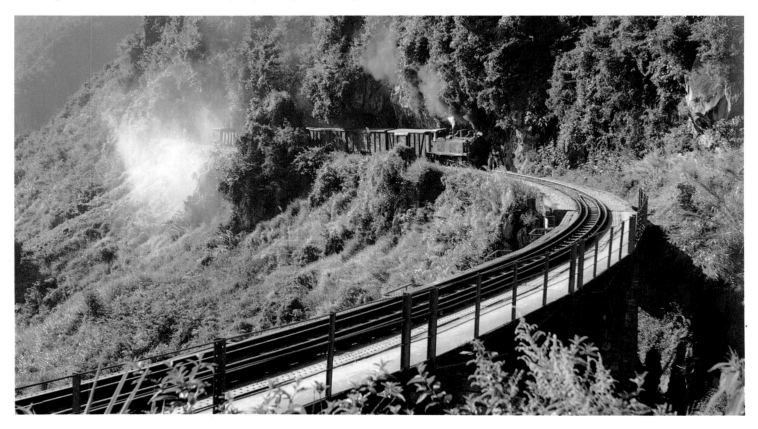

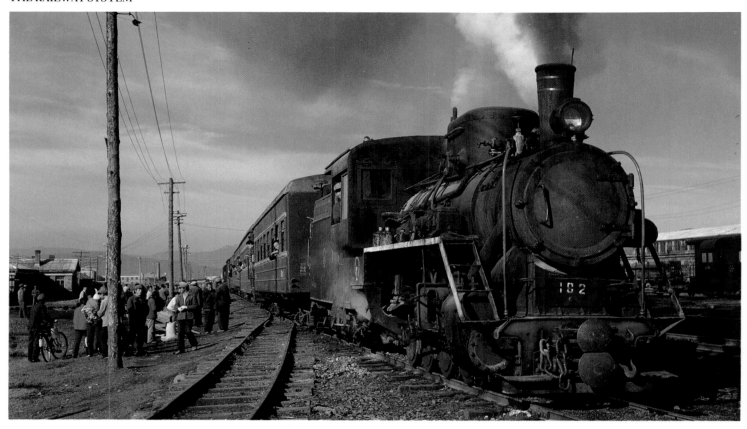

Forestry railway. A passenger train on the Yirxie, Baicheng–Anshan line. The locomotive is one of the standard 760 mm 0–8–0s, based on Russian forestry railway design and built in Eastern Europe as well as in China.

Other narrow gauge lines include a number of provincial local railways built mostly in country areas where the roads are not good. These are 760 mm gauge railways which are similar to the roadside tramways which existed in Europe until destroyed or made redundant by the Second World War. A further network of 760 mm lines can be found in the north-east, all linking in with the state railway system. There are seventy-six in all, and they belong to the Forestry Bureau, some dating from the Japanese occupation, but most built more recently. The forestry railways are impressive operations, often running to more than 200 miles (300 km) of main track with 60 miles (100 km) or so of sidings. Some, for example that at Langxiang, have recently introduced tourist passenger services.

Nowhere has the transformation of China's railways become more evident than in its signalling and communications. Writing in the *Railway Gazette International* in 1981, the Director of these services, Xie Gengchou, began by saying that the new republic's inheritance was 'limited in quantity, poor in quality and technically backward'. This was probably the case when looked at with hindsight, but today's computer-aided traffic control was scarcely available in 1949. Today China has over 25,000 route miles (40,000 km) equipped with a semi-automatic relay block system and nearly two thousand stations have electrical interlocking, but semaphore signalling is still in use and only a few sections of the truly main lines are fully track circuited. Nevertheless centralized train control (CTC), as practised by the sophisticated railways of the West, is more and more evident as each year passes.

Motive power and rolling stock have also taken a leap forward. Prior to 1949 most was purchased from foreign suppliers, today nearly all is made in China; British Rail's engineers have recently been advising on new coach formats in Changchun's major carriage building plant. As can be seen from the tables at the end of this book, as late as 1975 an extraordinary variety of steam locomotives from workshops in Britain, mainland Europe, the United States, Japan and the Soviet Union, were still in service both on standard and narrow gauge lines. Today all that has changed, due largely to the influx of foreign- and Chinese-built diesels and electrics. Since

1950, China has made a determined effort to be self-sufficient in motive power and this has already been attained with steam, with diesel and electric traction catching up fast. Steam locomotives have been built in the old Imperial Railways of China shops at Tangshan, which are still constructing the small SY 'Aiming High' 2-8-2, as well as the South Manchurian works at Darien and Qingdao, whilst the new complex at Datong in Inner Mongolia is completing JS 'Construction' 2-8-2s, and the ubiquitous QJ 'Forward' 2-10-2s, at the rate of some 250 per year. The only other steam locomotive classes extant on the main line are the two Pacifics, SL, 'Victory' and RM 'Peoples', the still huge numbers of JF 'Liberation' 2-8-2s and, in the east, the remnants of UNNRA American-built 2-8-0s, mostly on yard or trip workings. Designs derive from a mixture of American and Russian principles, American and Japanese imports and post-war Russian aid. Until recently there were a number of Russian 2-10-2s supplied as makeshifts and regauged after being found surplus to Soviet requirements on dieselization and electrification in the late 1950s. The letters FD originally stood for Felix Dzerhinski, the founder of the notorious Russian secret police and, although the Chinese kept this designation for the class, the name was altered to 'Friendship'. The FDs were never popular locomotives and with the building of new QJs and the introduction of non-steam power they have gone to their last rest. The single steam locomotive carrying a name as well as a number is the QJ 2-10-2, named *Marshall Zhu-de*, after one of Chairman Mao's chief aides. The engine is stationed at Harbin and lovingly cared for. In earlier days a JF was named *Mao Tsedong* but this distinction has now been transferred to a diesel locomotive to accompany the other member of the 'big three', *Zhou Enlai*.

Main line diesels were introduced to China in the late 1960s, imported from France and West Germany and, in 1975, as a stop gap from Romania; a further supply in the form of General Electric units arrived from the United States in 1985. As the Chinese have improved their skills and technology the workshops have transferred to, or begun the manufacture of, diesel power, many units emerging from Darien, Qingdao and the February 7th shops at Beijing.

Modern American power. Class ND₅ (General Electric 1984–6), diesel electric locomotives used for both passenger and freight workings. Delivery of 420 units was completed in 1986. Most are at work south of Beijing; their introduction has virtually eliminated steam over the great bridges at Wuhan and Nanjing.

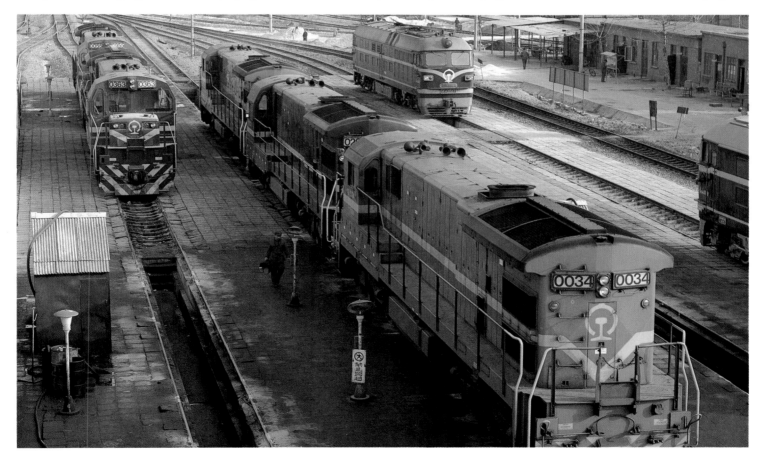

Electrification is also making swift progress, although this form of traction has operated in the industrial areas of Anshan and Fushun in the north-east since 1914, working on 1,400 volts DC. Today's electric power, however, comes on the more standard modern 25,000 kv, 50 cycle AC system which is invaluable in the more mountainous areas of the west. After the purchase of the first few from France, the Chinese have concentrated on locally manufactured Shaoshan (SS or 'South Wind') locomotives and several versions of these are now in service. Even so, with the rapidly expanding electrification it has been decided to import a number of European-built units for coal haulage in Shaanxi Province.

Similar modernization is taking place on the metre gauge, and the line south of Kunming has already been almost totally converted using the DFH2 'East is Red' diesel hydraulics constructed at Qingdao. These are similar machines to those supplied to the African Tan-Zam Railway, which was built by the Chinese to link Tanzania and Zambia in the days of an independent Rhodesia. Once they were on the drawing board the die was cast for metre gauge steam. The 760 mm gauge has also been converted to diesel, principally on the local railways using locomotives built at Shijiazhuang. Some of these have appeared on the forestry lines, but most are worked by a standard Russian design of steam 0-8-0, built in places as far away as Finland and Hungary as part of the reparations made after the Second World War, as well as those produced more recently by the Chinese themselves.

With the abundance of hydroelectric potential it is virtually certain that electrification will continue to increase in China, but coal, although of poor quality, is also available in vast quantities. As a result, the QJ and JS classes continue to be useful and economic machines, in addition to the small SYs which are mainly used in industry. Steam has not been written off altogether, for David Wardale, the eminent South African engineer, is currently employed as a consultant at Datong, using his experience and knowledge to continue to modernize and develop the QJ. Whilst it is a sad fact that the steam locomotive has no long-term future, two vital ingredients for at least a temporary survival in China are present in the availability of both cheap labour and fuel. These factors should ensure that steam will continue to be useful into the twenty-first century.

Modernization has established China's railway system as one of the foremost in the world today. New motive power has enabled long-distance trains to be faster and cleaner whilst modernized steam power economically moves freight weighing 2,000 tons and more using bogie wagons of steel construction and air braked throughout. Changchun Passenger Car Plant, the largest of China's coach-building factories, now produces over 2,000 new vehicles a year, further tracks are being laid and improved and train control methods have been introduced. Unlike those in the West, the huge marshalling yards of China are constantly breaking down and making up long trains of freight, and more passengers are travelling by rail than ever before. In 1949 an agreement was reached between the British and the Chinese to introduce a scheduled service between Hong Kong and Guangzhou on a tentative basis. There are now four first-class express trains every day with a fifth added at busy times like Chinese New Year, and in 1987 over one million passengers used the service. For the present, one still has to change trains at Guangzhou, but the day is not far off when it will be possible to board a train at Kowloon and, without changing, reach Beijing two days later – maybe after the electrification and double tracking of the south–north main line.

Travelling by train in China today offers experiences unobtainable anywhere else in the world, covering vast distances over widely differing countryside, crossing great bridges, twisting and climbing over high mountain ranges. It would take months of constant riding in both soft class and hard even to sample the variety. The progression of the system is a huge challenge for a developing country, and one which China is meeting not only with determination but also with considerable skill.

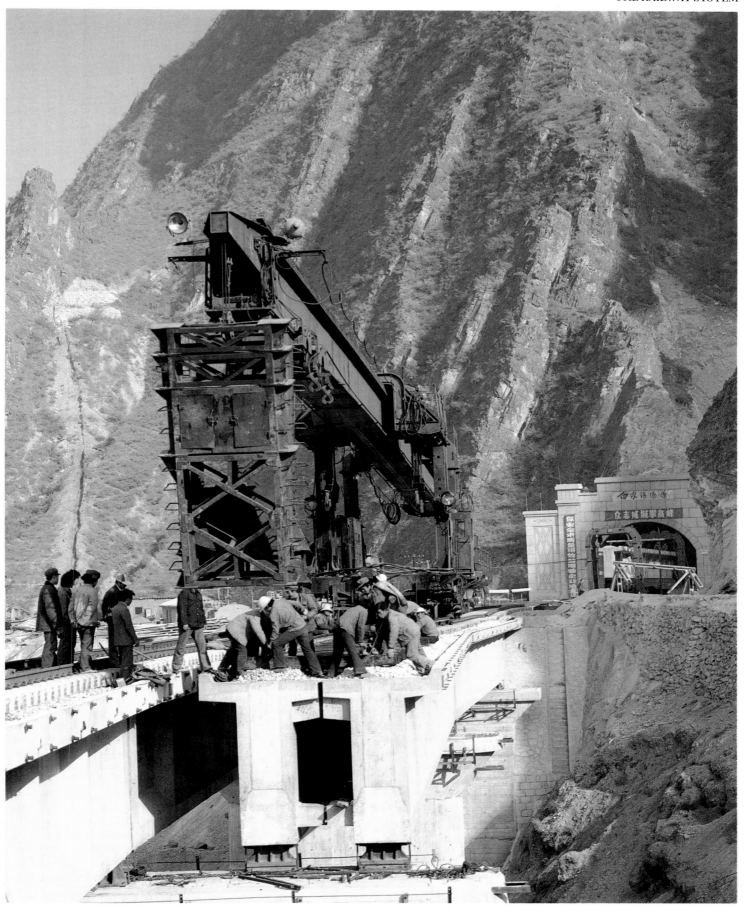

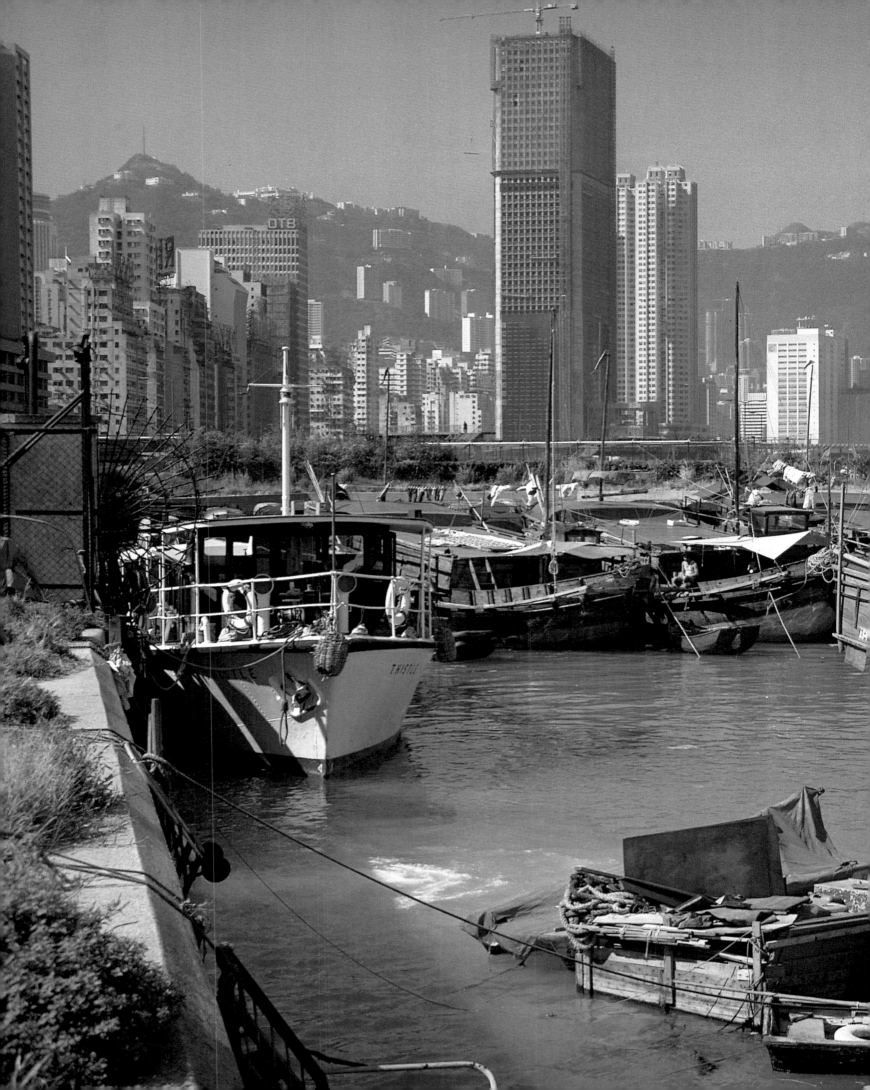

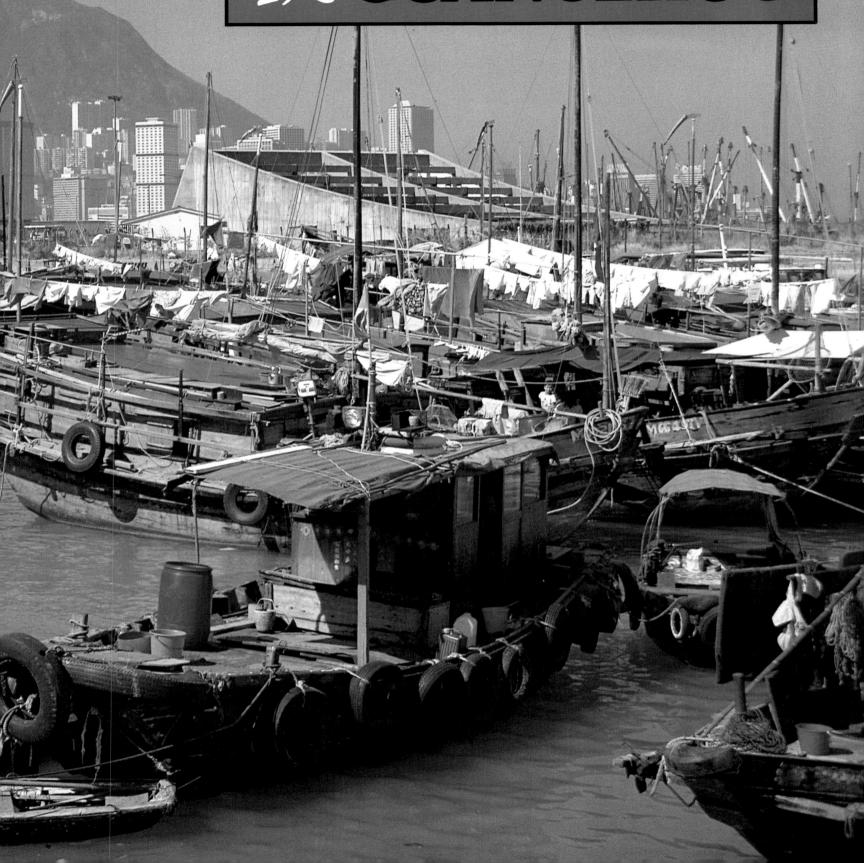

HONG KONG TO GUANGZHOU

Hong Kong, the great bustling metropolis of the Far East, is the perfect starting point for a journey into China by rail. It offers a first glimpse of the structure of Chinese life, tantalizingly screened by a cellophane bouquet of excellent, Western-style hotels, and the greatest variety of cuisines in the world.

Behind the façade are worn-out backstreets where shabbily-dressed people live in great poverty, eking out a living by cleaning shoes, selling papers, cobbling or making furniture. Boat people survive deck-to-deck in a sea of rubbish on the harbour's edge, and great dismal blocks of flats with no air-conditioning or lifts loom above the humid, crowded streets, which are full of neon signs, nightclubs and endless shops. The traveller sees washing hanging over the balconies, and tiny caged finches which sing all day, although similar birds are probably destined for supper. In exotic restaurants one can watch a cobra caught from a writhing mass kept in glass tanks, then killed and served up in a piquant sauce at a formica table, open to the street. Old and hopeful rickshaw men and hideously maimed beggars operate near arcades of great wealth – of emeralds, fur, silk and velvet for the richest and most fashionable, and fantastic treasures of ivory, gold or ebony. Hotels in Hong Kong offer some of the best service in the world, and for the armchair traveller, or the half-hearted, this can seem the ideal place for a visit to China both to begin and end. The city is surrounded by islands and rural areas of great beauty, tiny settlements with paddy fields distributed between the dormitory towns of the New Territories, a landscape peopled with straw-hatted coolies, and fishermen who hunt by wading with their nets or by trawling the azure sea from small boats. The immediate impression is that all of picturesque China is here, including temples, a re-created Ming Dynasty village and day trips by train into the People's Republic itself. More extensive travel will reveal that Hong Kong provides a glorious Disneyland fantasy of China which should not be missed, but equally should never be mistaken for the real thing.

In the last decade or so, visiting China itself has become almost as easy as entry into most Western countries, although the system can sometimes seem rather confusing – some of the more readily available visas give their possessor very limited access. The simplest way is to get to Hong Kong, queue for a visa, and those areas of China which are not closed for 'reconstruction' are open to you. However quite a lot of China is continually being reconstructed and cannot be visited. The place of entry is Kowloon station, on the mainland opposite Hong Kong Island, where the Kowloon–Canton Railway Corporation, despite its outdated name, runs a smart and highly efficient operation, moving passengers and freight through the New Territories and into China. This station feeds Hong Kong; ten freight trains a day roll out of China, packed with pigs, sheep, cattle and chickens, and the resulting reek hangs about the platforms. They roll back again filled with processed goods instead of the raw materials. In all, the freight diesels haul nearly six million tons of livestock and other goods to Hong Kong every year, and return nearly a million tons back over the border.

Kowloon station runs trains which stop at all stations to the border, including one every fifteen minutes to Lo Wu itself, and plays host to the four Chinese-owned trains which run to and from

Previous pages: The gleaming tower blocks of Hong Kong, rearing up between the harbour and the hills leading to the New Territories. In the foreground boats throng the seafront, cruisers and cargo ships mingling with the tiny floating homes of the boat people.

Guangzhou every day. All the trains into China are diesel, in contrast with Kowloon's smart electrified system, but the new electric through-line to Beijing is due to open late in 1988, as China starts to take a stronger hold on the colony which comes home in 1997. Currently, nearly two million passengers take the through-route to Guangzhou every year, to go home, make a business visit, or to see China.

For those who just wish to take a step on to Chinese soil, one of the regular trains to Lo Wu and Shenzhen, its sister town on the border, will fulfil the ambition. It will take passengers smoothly and swiftly through the New Territories, past the new towns and reclamation areas, the shanty towns and the banana plantations, the racecourse and Ocean Park, the waterworld centre, before dropping them at a simple, basic station linked to the Shenzhen River bridge. One side is British and the other Chinese. A walk across the bridge, looking down at the officially-named Shenzhen River – actually a ditch – and ending up, after a fifteen-minute queue for immigration, in a place which looks identical to the other side is a terrible anti-climax for many people, and they must wish they were on the long, green-and-white or blue-and-white trains, which slow for the railway bridge across the river, then dive away into the alluvial plains of the Pearl River Delta which spreads across nearly 250 miles (400 km) of the south coast of China, in the province of Guangdong.

The Chinese train is staffed by the People's Republic, and all the attendants see of Hong Kong is the view from the train, and the platform where they arrive. Each carriage has a smartly dressed woman attendant who stands by her carriage door like a soldier while the train is in the station. Every year, a better-fitting, neater uniform seems to be issued, though on cold days the effect is often spoilt by a startlingly uncoordinated jumper under the jacket. Some attendants will smile and return a greeting; others simply ignore everything but the validity of a ticket. Service is up to the individual in China, and with few incentive schemes, no legal tipping, no training, and little love for the rich and curious people who are visiting their country on holiday, the Chinese attendant may not see why time should be spent on unnecessary courtesy.

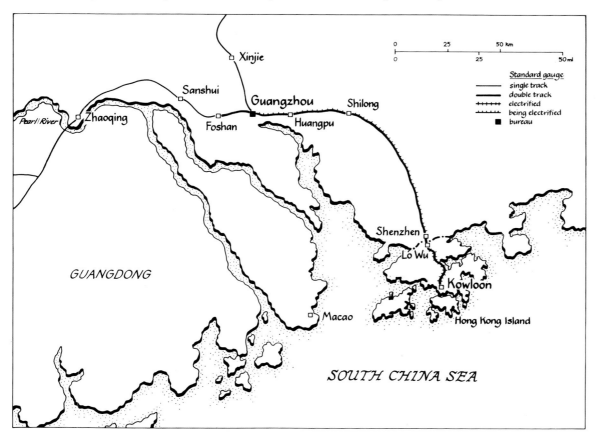

The famous trams of Hong Kong; one of the city's best-known tourist attractions and the only British-style double-decker trams still operating as part of a public transport system.

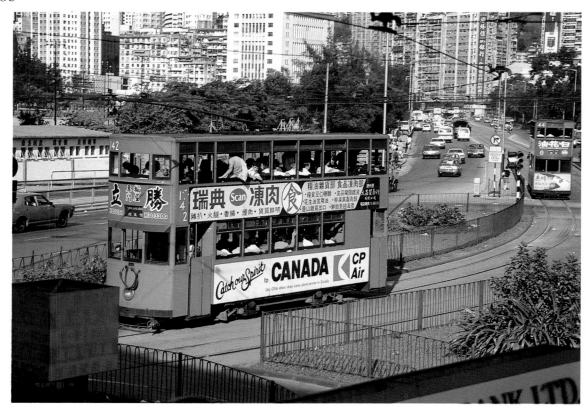

By 1987 passenger traffic on the Kowloon–Canton Railway (KCRC) was three times that in 1983, with 340,000 passenger journeys averaged each day. The new air-conditioned electric trains are fast and frequent, whilst the new stock has its carrying capacity increased by 75 per cent.

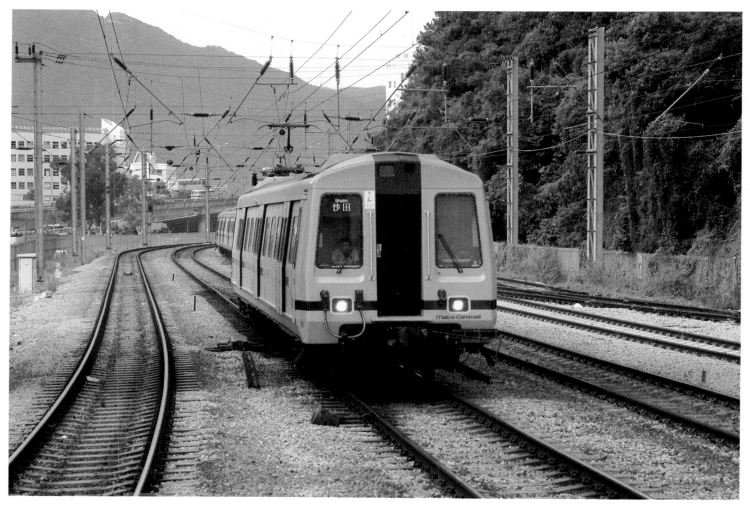

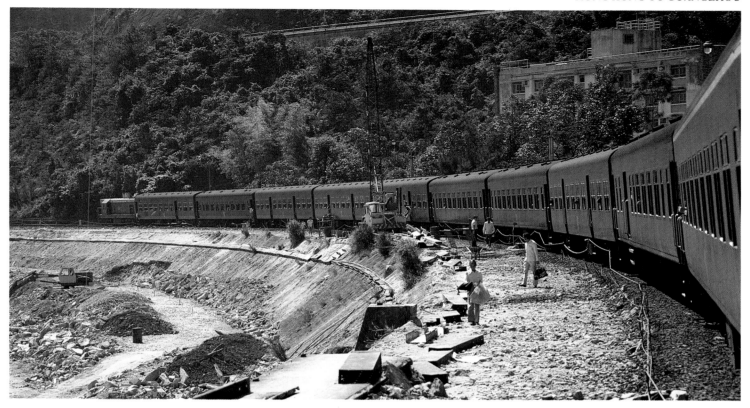

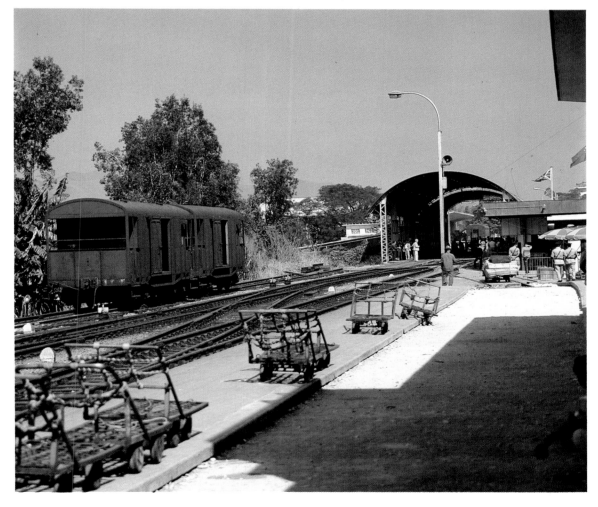

With the opening of China to the West and the continual increase of Hong Kong traffic, the Kowloon–Canton Railway has developed beyond the dreams of its founders. The rebuilding of the railway began in 1979 and the whole 21 mile (34 km)-route was electrified by 1983. The old carriage stock was still in use in November 1980.

Lo Wu, the Hong Kong border station. Both trains and pedestrians can cross the Shenzhen River bridge into China after customs and immigration formalities, but many Western tourists are disappointed by their first sight of modern China – a commercial area similar to but less smart than Hong Kong.

Exterior of a typical soft-class carriage. The lace curtains are woven with designs of bamboo.

Shenzhen station on the Chinese side of the border. A through train from Hong Kong to Guangzhou is headed by a Chinese diesel locomotive. The blue and silver train is air conditioned throughout.

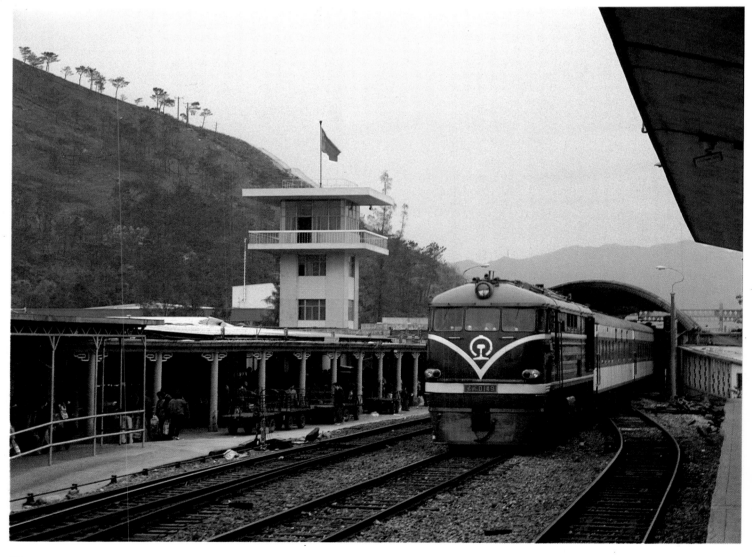

Passengers are seated in a traditional Chinese, open-aisled soft-class sitting coach, with padded seats covered with linen. The windows are shaded by white lace curtains, decorated with bamboo or fish designs, and often torn and dirty. The trains are practical and punctual and no one sees any benefit or logic in doubling or trebling a cleaning bill when the covers and the curtains will do. Great horror stories are told by Western travellers of Chinese dirt and slovenliness, but the country has a strict sense of priorities. The Chinese would prefer to concentrate on technological and social advances and leave lesser considerations to take care of themselves. A buffet service of basic food, served without grace, is offered, but most passengers are content to spend the three-and-a-half hours of the journey looking and learning from their first impressions of China.

The train flashes through the outskirts of Kowloon, following the same route as the local trains, giving brief glimpses of homes and lives, as it dives through alleyways of tower blocks, with plants and washing thickly covering the balconies; past concrete office blocks, to densely-wooded hillsides, rioting with tangled tropical greenery and the deep pink and blue of wild flowers. The hinterland of new towns and agricultural land, where citrus groves almost hide the picturesque huts where the farmers live, is replaced first by paddy fields and fish farms, and then by more urban areas which are continually building and expanding as Hong Kong constantly extends its margins.

Less than half an hour after leaving Kowloon the train crosses the Shenzhen bridge, and the first sight for the visitor is not a Shangri-la rural paradise, but China's special economic zone, a modern, mini-Hong Kong set up to trade with the West and to follow every capitalistic instinct which can benefit mainland China. Certain trade freedoms are found here which exist nowhere else in the People's Republic, and the Chinese have a very efficient system for dealing with Hong Kong, and for merging the two countries. Outside the economic zone the rural landscape begins to emerge, with water buffaloes grazing serenely, or wandering slowly to market, being ridden by their keeper, a small boy dressed in scarlet and blue, and only casually concerned with the passing train full of foreigners or businessmen returning home. Coolies dressed in traditional blue work in the fields but there is evidence of some mechanization – tractors and reapers – which will disappear completely after Guangzhou. The visitor can relish all the sights of China which grace popular impressions, but there is much more to come. Much more unfamiliar beauty will show this apparently typical landscape to be only a poor imitation of China's rural interior.

By now any traveller who intends to explore the country will have obtained a copy of the *China Railway Timetable*. A Chinese–English version is published every year and it is the undisputed bible for all train travellers within China. Not only does it detail the trains, but also their classes, speeds and accurate timings for arrival and departure at every station. It also gives helpful advice on what can and cannot be taken on the trains: 'Dangerous articles, articles forbidden to be transported, articles impiring public health, animal and articles polluting the car cannot be taken into the car' (*sic*), as well as brief details about some of the scenic places on particular routes where there is any space left over on the page. At the back are explanations of what tickets are valid where and when, and if not, why not. Some of it takes a couple of readings to be clear, but it is generally invaluable even if the description of luggage which can be taken on to the trains is a little confusing for the average Western traveller, forbidding as it does the 'smuggling of currency, stock, precious historical records, gold, silver, pearls and jewels, wristwatches, cameras and other valuables, archive materials and dangerous articles'. Despite this travellers do not have to declare any of these things. 'Cock, duck, goose, dog, cat, monkey and snake' are also banned except when bought by the dining car staff for supper. The timetable also makes the difference between fast trains and express trains clear to the careful reader. By Western standards, express trains are fast trains and 'fast' trains are slow.

Guangzhou is a sprawling, lively, Westernized city which lies at the head of the Pearl River estuary. Until the signing of the Nanking Treaty in 1842 it was the only Chinese port open to the

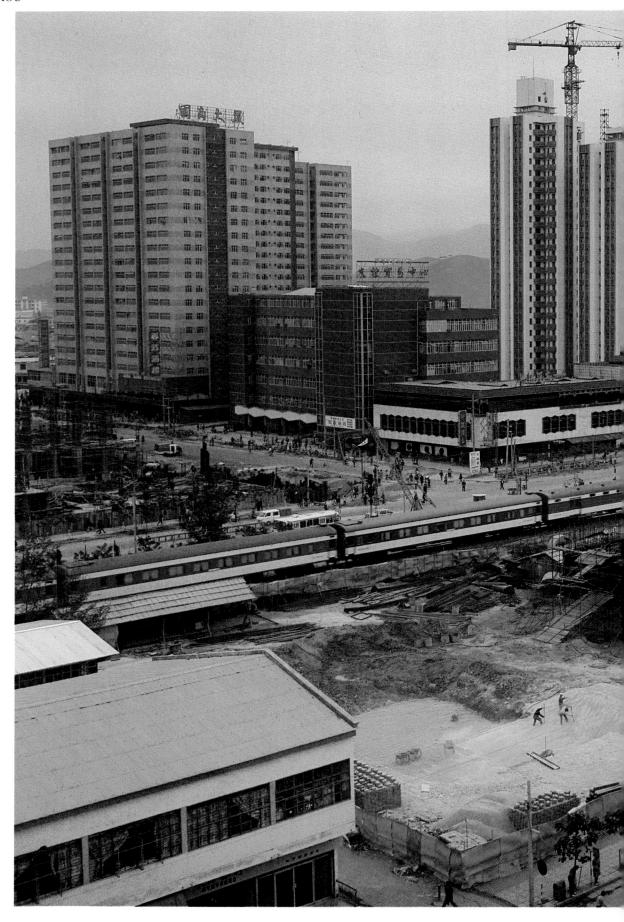

The Hong Kong–Guangzhou train passing through the Chinese economic zone north of the New Territories, where the People's Republic arranges trade between East and West. It is not for some miles into China that the visitor will see the anticipated paddy fields and other signs of rural life.

34

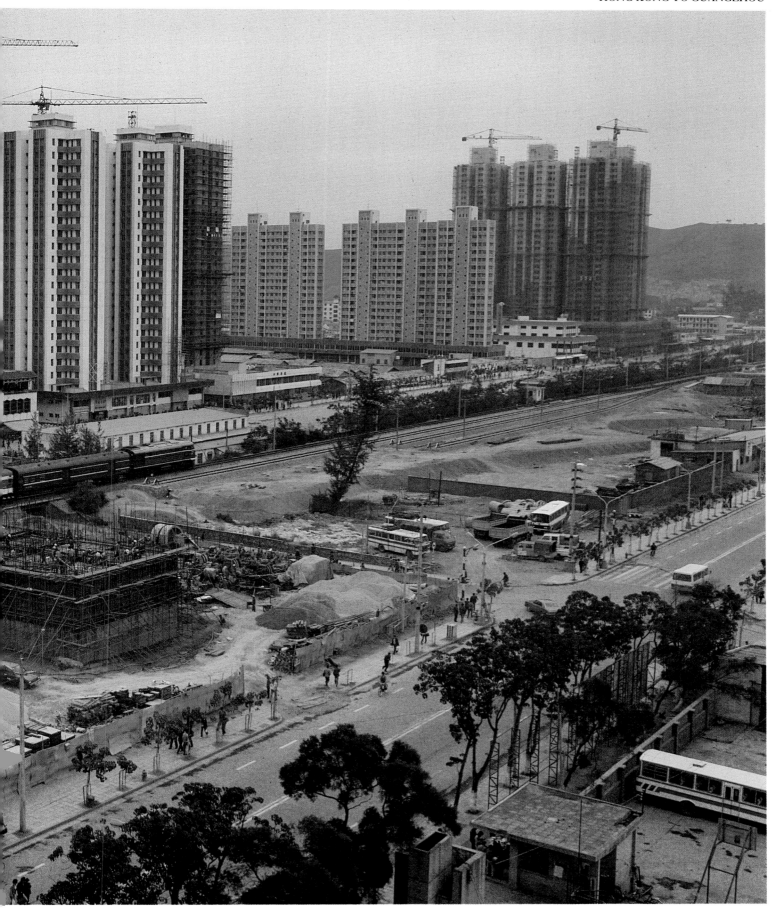

West, so centuries of trade have created an untypical city strongly influenced by the rest of the world. Trade links started in the sixteenth century when Macao became Portugese, and Chinese silk, tea and porcelain flowed out to a ravenous West already fascinated by Far Eastern culture and beauty. Even at the turn of the century, Guangzhou showed how remote it was from the rest of China by ignoring a declaration of war on foreign powers made by the Dowager Empress Cixi, and simply continuing in its capitalistic ideal of foreign trade. Opium was its downfall, when the British poured the Indian-grown drug illegally into China to balance their trade deficits. When local dignitaries burned the British supplies of the drug, the first opium war was instigated. Guangzhou never regained its previous power after the wars with Britain, but trade continued to be steady, if not thriving. The city still has style, and although, like most of China's great towns, it has been spoiled over the last thirty years by extensive rebuilding in unimaginative and fundamentally drab designs, there are still interesting old wooden houses in the backstreets and hidden corners. The shopping areas are unrivalled for tourists, and the restaurants, though scruffier, are similar to Cantonese restaurants all over the world. The people of Guangzhou speak Cantonese, a language which shares written characters with Mandarin, but little else, as it has matured and changed through years of trade with the rest of the world. They pay little attention to Western people because their city is thronged with them all year round.

Guangzhou is a business city first and foremost with its annual trade fair acting as a magnet to foreign companies, but it is hard to realize just how thriving and cosmopolitan the city is when it appears to be simply a copy of any other country's Chinatown areas. The poverty in the backstreets is real enough, but many of the city's residents are frequent travellers to Hong Kong, or have relatives in the British colony, so they can import almost anything they want, travel back and forth, and earn good money by trading foods and silks. Hong Kong television is beamed far into the Pearl Delta and is easily picked up in Guangzhou, offering even more images of the West and adding to the impression of the city as a strange hybrid of what the East believes the West is, and the West believes the East should be.

The lush, broad plains of southern China, with paddy fields divided into easily workable strips and smallholdings owned by farmers whose lifestyles have steadily improved since the restoration of some free trade.

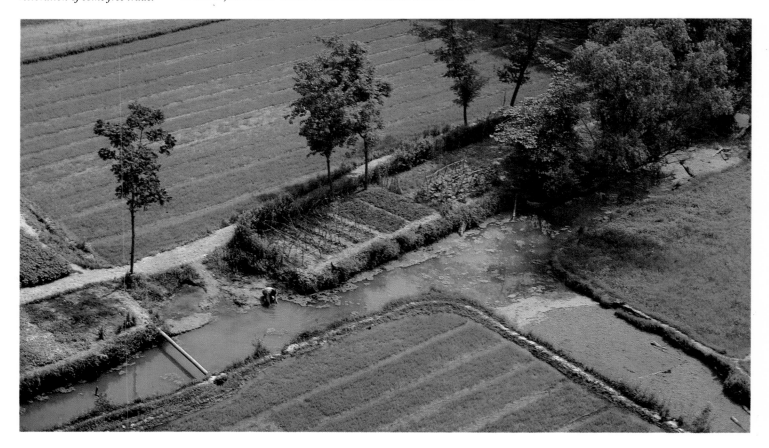

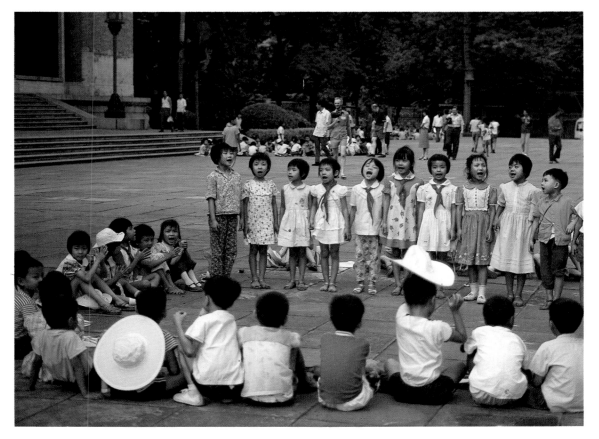

The Westernized and cosmopolitan city of Guangzhou (formerly Canton), with its high-rise apartment blocks and modern basic architecture. It is comparatively easy for Hong Kong Chinese to make the journey into China but the mainland Chinese have limited access to the West, with most having to make do with television programmes from over the border. There is little two-way traffic in people.

Guangzhou primary-school children singing for their classmates in a city park. Chinese children are generally brightly and smartly dressed by proud parents. This group's red neckscarves mean they are 'Little Red Pioneers', the first step towards responsibility.

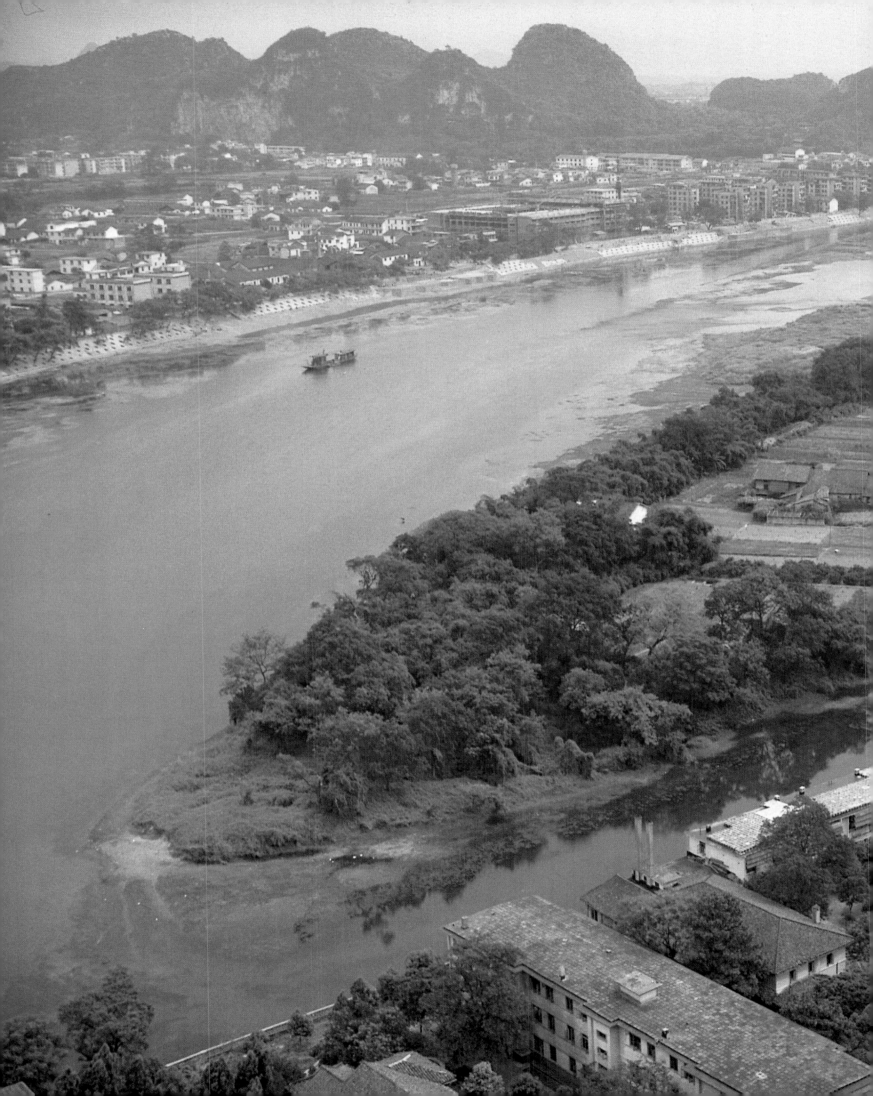

GUANGZHOU TO KUNMING

O
N THIS JOURNEY China will begin to reveal her beauty and her true nature. It is useless to expect a world one has previously encountered because it is not there. Discovering the real China can be a confusing and sometimes even a worrying experience. It is worth it, although a very good sense of humour will prove indispensable.

The first challenge at Guangzhou station is buying a ticket. It is reputed to be one of the busiest stations in China, and it is divided into two parts, one for local and one for foreign travel. Arrivals from Hong Kong have to disembark to go through customs and immigration; then there is a walk across the square to the internal station where trains leave for Beijing, Shanghai, Kunming and other major cities. There should be plenty of time, after the arrival of the Hong Kong train and clearing customs, for a meal in the excellent restaurant on the upper floor of this big, modern station. People constantly hurry here and there, heavily burdened with awkwardly shaped bundles of belongings. There is a roar of noise from massed voices, from train announcements, and from the great, green trains themselves.

Finding the right ticket queue is difficult, although Guangzhou is Westernized enough to have English signs to help. Getting the best deal possible can also be a problem, once one has braved the long, long wait. All foreigners are expected to pay a specially inflated rate compared with that paid by the native Chinese. It is obvious that comfortable class seats will cost more than hard ones, but this is not the only consideration. Nowadays, with the growth of free enterprise, many more Chinese can afford to travel as comfortably as possible so there is far more demand for the more expensive sleeping berths on long-distance runs than ever before. The ticket comes in two sections – one the fare for the journey, and the other the price for upgrading the accommodation from the most basic if required. Some booking office clerks do not mind selling tickets to foreigners at the Chinese price, but this is by no means universally true. Even if one succeeds in paying the right fare, there is no guarantee that the carriage attendant who checks the ticket is going to permit a foreigner to get on her coach with a cheap ticket, and once past the booking office clerk her word is law.

Trains in the south of the country are always packed, so there may not be much choice in what kind of ticket is available, or which train you can catch. The trains come in classes and are numbered in the timetable in batches of 1 to 90, 100 to approximately 350, 400 to 500, and so on. The lower the number the faster the train – and the more expensive. There can be two trains leaving for the same destination within a few minutes of each other, but they will be different speeds, have more or fewer stops, and tickets will be different prices. Trains numbered over 300 should be avoided, as they are extremely slow.

After finding the right train, there is the right class of travel to choose as well. In theory there is no first or second class, but this theory is rarely put into practice. The classes are called 'hard' and 'soft', and there are two sorts of each – hard-class sitting and hard-class lying, and soft-class sitting and lying. Cheapest is hard-class sitting, which is truly basic – tolerable for short journeys, but extremely uncomfortable for more than about six hours. It consists of thinly cushioned seats

Previous pages: *Looking down over the town of Guilin, set in the middle of China's south-western hills. It is largely a tourist area, and prices are generally higher than in the rest of the country.*

built for two or three but usually carrying four, or even five. People also sit or crouch, flatfooted, on the floor, lie under seats and stand in the gangway between the carriages. They use the floor as both wastebin and spittoon, and they do not give way to newcomers.

Hard-class lying consists of slightly padded bunks in compartments of six, with no door or partition wall blocking them off from the corridor. If lack of privacy is not a consideration it is the best way to meet the local people, and it is fascinating at times. However, it can be difficult for a Western woman to undress for bed surrounded by a sea of curious faces and unbashful children who will comment loudly and without inhibition on every unfamiliar sight which cannot be hidden behind the small blanket provided. The Chinese never fully undress for bed on trains and they wear magnificent combinations, like those seen in cowboy films, which are extremely modest.

Hard-class lying is also noisy, with piped music that cannot be switched off and lights that are controlled by the train staff. There are too few washing facilities for too many people and it can get very dirty. There seems no reason to try it this early on the journey. There is plenty of time for toughening up and experiencing the different classes, so if there is a soft-class seat available on a train numbered in the 100s it is probably the best choice.

Soft-class sitting is comparable with the train from Hong Kong, and very comfortable, but it is rarely an option except on short distance trains, so soft-class lying is generally the only choice with any pretensions to luxury. There will only be one soft-class coach on most trains, unless there is a package group who will have their own, and who will be seeing China from their own segregated world. It is sometimes possible to take a spare place on that coach, but otherwise it is a fight for what is available.

Once the ticket is safely bought, one must battle through the crowds to find the right platform, and take the chance of seeing what other trains are about. There will be no steam at Guangzhou, but there is a strong likelihood of seeing some at the various junctions before Kunming which is itself totally dieselized. It is always a good idea if there is time – Chinese trains always leave punctually – to walk up to the front of the train to see the engine. In Guangzhou it will be a home-built diesel, and it may be covered with large red badges. If so, its crew have earned merit awards for safety or service.

There will be ten to sixteen coaches on each train, including a dining car if the journey is of more than twelve hours, a baggage car and up to seven hard-class sitting coaches. There are two carriage attendants each doing twelve-hour shifts on their own coach, senior and deputy chief conductors, two mechanics, two policemen and about ten dining-car crew, as well as up to three men on the engine.

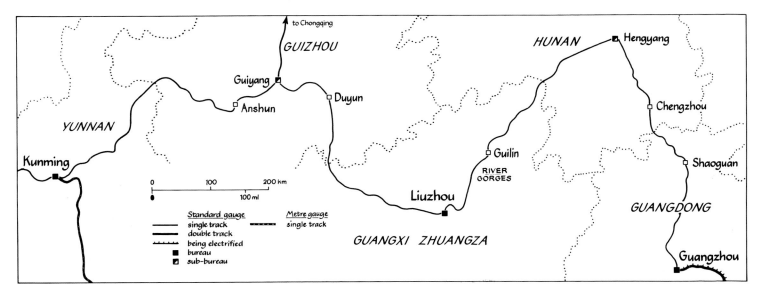

Guangzhou station has a huge and magnificent restaurant serving traditional Cantonese cuisine to a very high standard. Few other Chinese stations have such excellent facilities – even in the larger cities travellers have to make do with that they can buy, either from stalls on the station concourse or from tiny platform buffets.

Opposite: Inside a soft-class sleeping compartment. The sheets are changed every journey, the pillowcases and seat covers less often. Every train seems to have a slightly different design of upholstery.

Guangzhou station, showing the broad concrete platforms with wide awnings so characteristic of modern railway stations throughout China – all built to seemingly similar designs, and with little decorative flair.

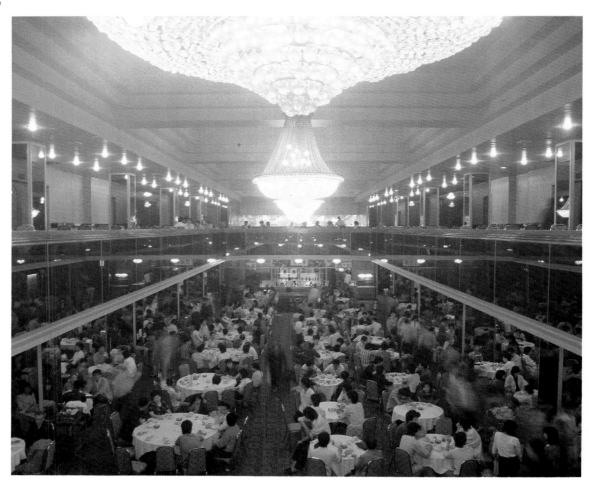

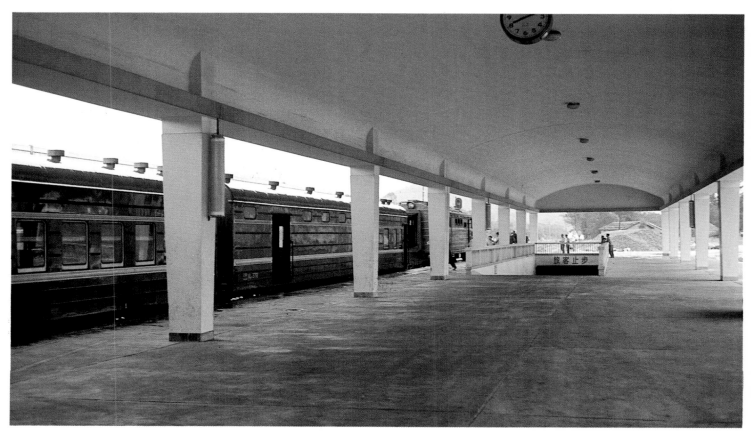

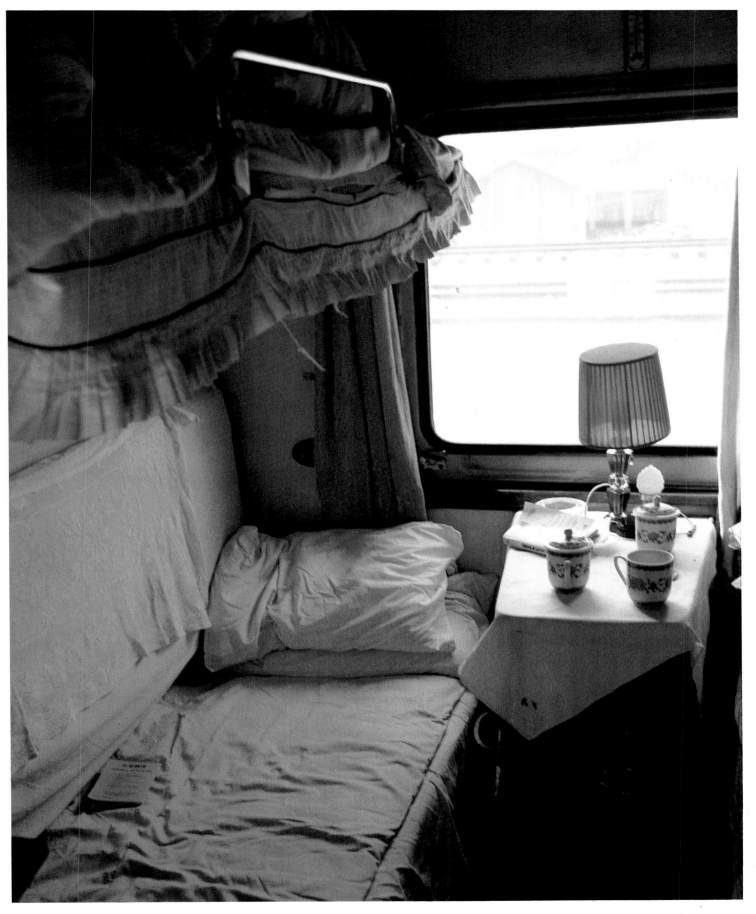

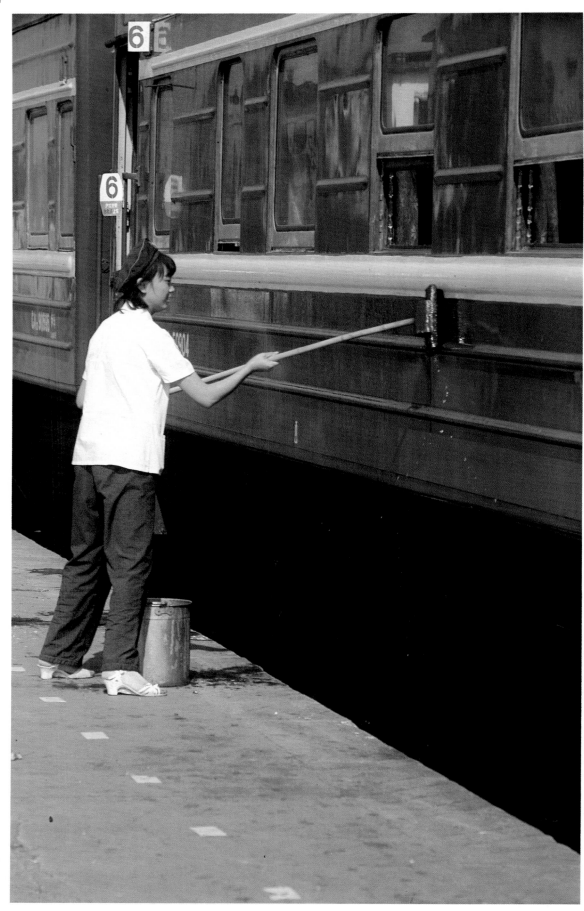

In the summer months the carriage attendants wash down the train at most major stations, so the rolling stock always looks bright and clean. Unfortunately they tend to forget the windows which, over a two- or three-day journey, can get very grimy. Each coach has its own attendant who is responsible not only for its cleanliness but also for its passengers.

44

Tickets are checked before you are allowed to climb up into the carriage to find your soft-class lying compartment. There will be four bunks, each covered in a crisp white linen sheet with matching duvet, two hand-embroidered pillows and a tiny towel for each person. Mugs with lids (for tea) will be sitting on a small table by the window, which also sports a white lace tablecloth, a top-heavy lamp which is likely to fall over when the train starts off and sometimes a plant. Luggage has to be manhandled onto a shelf over the door, which means that one traveller must negotiate the difficult climb on to the top bunk, with a single hinged step in the wall to help, and then reach down for the cases, held over a second traveller's head. The Chinese are generally delighted to help the lone traveller. Below the table there will be one or two highly-coloured thermos flasks, topped with corks, which are regularly filled by the carriage attendant. However, hot water is all that is supplied, and tea or coffee must be provided by the travellers themselves.

Once the whistle goes, the ordered routine of Chinese train life begins. It is a world of its own, complete with discipline and tradition, and no allowance is made for the traveller who wants to do things differently. The attendants, who are nearly always female, will take the tickets and issue plastic tags instead which tell each person which bunk is his. It is a good idea to learn the Chinese symbols for top and bottom, and, in hard-class, for middle too, as the Chinese can become very irate when they find that their allotted bunks are taken.

At some time, during a long and dark evening on a Chinese train, a British traveller invented the nickname of 'Blossoms' for the train attendants. It was used with love for the sometimes incredibly beautiful, fresh and tiny girls who look after the everyday running of the trains. Slowly the name has caught on, and apart from being a compliment to the women, it is an amusing thought to help one keep one's temper when a less blossom-like attendant swipes one's feet out of the way with a mop, berates one at 3 a.m. for using a cushion from an unoccupied bunk, or unceremoniously throws someone off the train for trying to bring on their bicycle.

Pulling out from Guangzhou station is like leaving almost any major city in the world. It is never the best of views, with scenes of industrial premises and the least attractive aspects of people's homes. Travellers from Guangzhou to Kunming would be wise to take the evening train which runs straight through. The alternative is a change of trains and a wait of two hours at Hengyang, and the scenery between the two cities is not the most exciting that China has to offer. When one is given the chance to sleep through, have breakfast and arrive at Guilin where one suddenly finds oneself in a marvellously beautiful landscape, it seems sensible to take it.

Soft-class passengers eat supper before, and breakfast after, the other passengers on the train. Attendants come down with tickets for each sitting and they will take an order from those who know what they want. Generally the best idea is to take what is on offer as one can be very agreeably surprised. Supper can be as simple as thick noodles, soup, a plate of cold meat and some vegetables, but, coming from Guangzhou, it is far more likely to be a feast of different meats and vegetables, spicy fish in batter and some kind of egg dish. Occasionally there is a plate of fresh quail eggs, or a whole river fish, but that is not everyday fare. To finish with, there will be bowls of bottled fruit – pineapple or cherries – and then the first shift of diners will be bundled out of the dining room to make way for the others. Alternatively, there is a basic buffet service of rice and vegetables which comes in a kind of mess tin.

Most people turn in early on an overnight train. Some carriages have televisions, which can prove to be a bone of contention, but most Chinese people seem to have the ability to sleep through any noise. There is also a continuous intercom blaring throughout the train. It is a kind of internal radio station with its own disc jockey, who makes announcements about the timetable, political news and the weather, advises people to remember to take their belongings with them, and sternly admonishes travellers not to spit on the floor. In between there is Chinese music, a continual and tinny irritant to many foreign travellers. The great advantage of soft-class is that it is the only class with an off switch for the radio. It is always advisable to turn the sound off at night on going to bed, if not before, or there will be a brusque awakening in the early morning

The train announcer works twelve hour shifts in her tiny room, playing tapes of cross-talk and music. She also makes train announcements including advice to passengers and political comment.

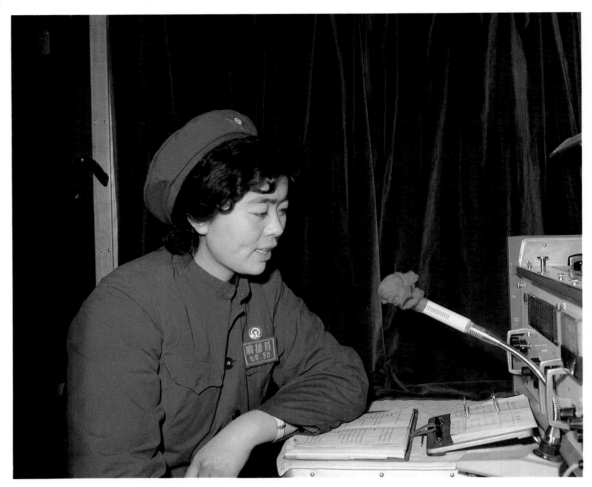

when it starts up again. Unfortunately, there are now some soft-class carriages where the intercom can only be turned down, and not off.

There is not long to wait for beautiful countryside and a first sight of steam on the Guangzhou to Kunming line. The evening train from Guangzhou guarantees that both wishes can be granted almost on awakening. First, there is the landscape. The impression that most people have of the dramatic landscape of China is really that of the countryside around Guilin – great domes and spires of blue-green covered hills and long, smooth stretches of water. It is one of the most beautiful scenes in all of this amazing country, and seeing it is like being transported back in time to some mythical fairyland of childhood.

Guilin itself is a small tourist town, set in the centre of the hills, and has a rather strange and arrogant atmosphere – a pride, perhaps, that its countryside has been immortalized in painting and prose since man learnt to record beauty. There is a fiercely competitive tourist industry, with many boat trips down the Li River to see the exotic scenery and the famous cormorants.

The local fishermen train the birds to do their fishing for them. Nowadays, it is more to catch the tourist's eye and camera than to feed the family, but it is a sight well worth seeing. Depending on the kind of ticket you have bought you may be able to stop off for a day to explore before resuming the journey to Kunming. For the rail fan, and by prior arrangement only, this could include a visit to the locomotive depot.

It is a steamy, tropical area, and often the crags are almost hidden by mists, which adds to the fabulous impression. One of the best ways to look round is to hire a bicycle, but this is only for the more energetic. The famous tors are limestone, and are as beautifully sculptured inside as they are out. The caves of the region are almost as legendary as the hills: deep caverns filled with stalactites and stalagmites, each with its own legend, and often its own name.

The town is an industrial one, with electronics, textile and rubber factories. Despite the impression given by the great river and the deep and serene lakes beneath the misty hills of the countryside, a great deal of practical irrigation work and research takes place here. Water in limestone country has a tendency to disappear underground, and has to be encouraged to benefit the crops before it vanishes.

The food in Guilin can seem very strange to Western palates. The majority of the inhabitants are Zhuang people – of Muslim origin – and their cuisine is based very much on the local flora and fauna, including occasional platefuls of bamboo rat, wildcat, short-tailed monkey or pangolin – a kind of armadillo. Drinks include snake bile wine, so it is always a good idea to get the menu translated if wary of such delicacies.

Guilin is also the first place on this route through China where steam engines are likely to be seen in daylight. As soon as the train pulls into the town, there could be a chance of seeing the huge QJ 2-10-2s on long, maybe over two-thousand-ton, freight trains. These abound in the locomotive shed, where the sidings also contain discarded FD class 2-10-2s, which were provided in large numbers by the Russians in 'Friendship' days. The Chinese engineers regarded these with mixed feelings and, as soon as the native-built QJs appeared in sufficient numbers, they got rid of them. The Chinese generally have no objections to railway photography, provided it is away from the defence areas, and this is a good opportunity to watch these great giants at work. The QJs will probably be young engines, built as late as the 1980s in Datong, the last steam engine construction factory in the world, and an important place on the itinerary of this trip.

If the journey does not include a stop at Guilin, the track in and out of the area will still show enough marvels, and probably a good enough glimpse of steam, to satisfy the newcomer. The fabulous landscape continues for many miles, and then settles down to a steadier, but hardly less spectacular, kind of beauty. All the way to Kunming, through Liuzhou, Duyun, Guiyang and Anshun, anyone with a camera will spend the day running from side to side of the train taking

Following pages: Two QJ class 2–10–2 steam locomotives rest on the shed at Guilin in October 1986. These represent the standard motive power for freights and some passenger trains in the area. All through passenger trains are diesel-hauled.

Important tunnels and bridges on China's railways are guarded – sometimes by the army – for purposes both of safety and security. This photograph shows a flag man at the exit of a tunnel on the line from Guangzhou to Guilin.

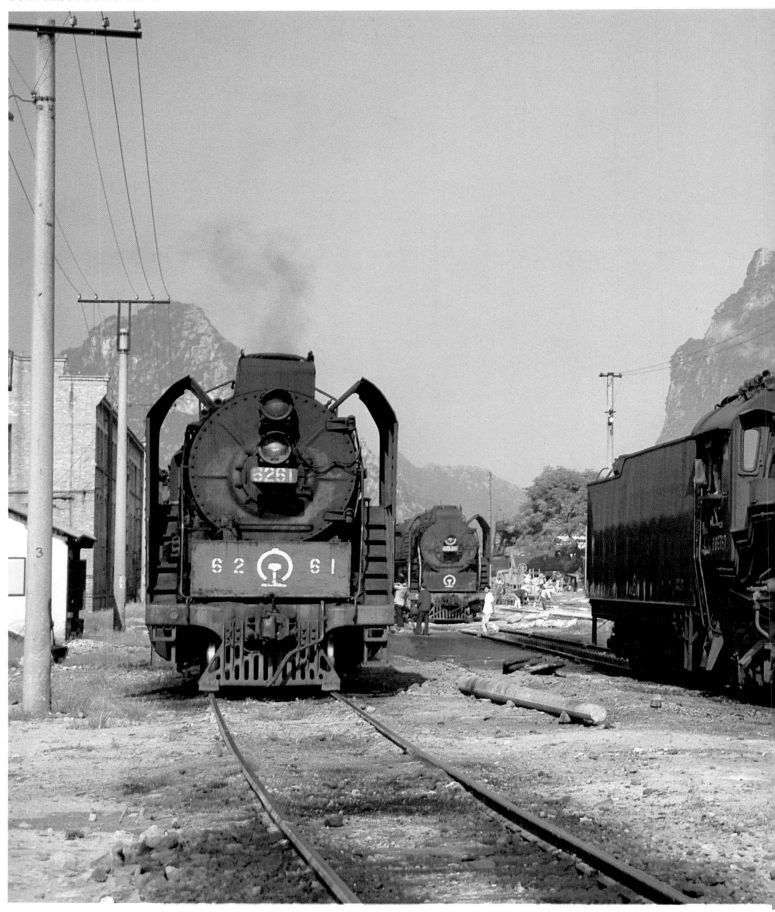

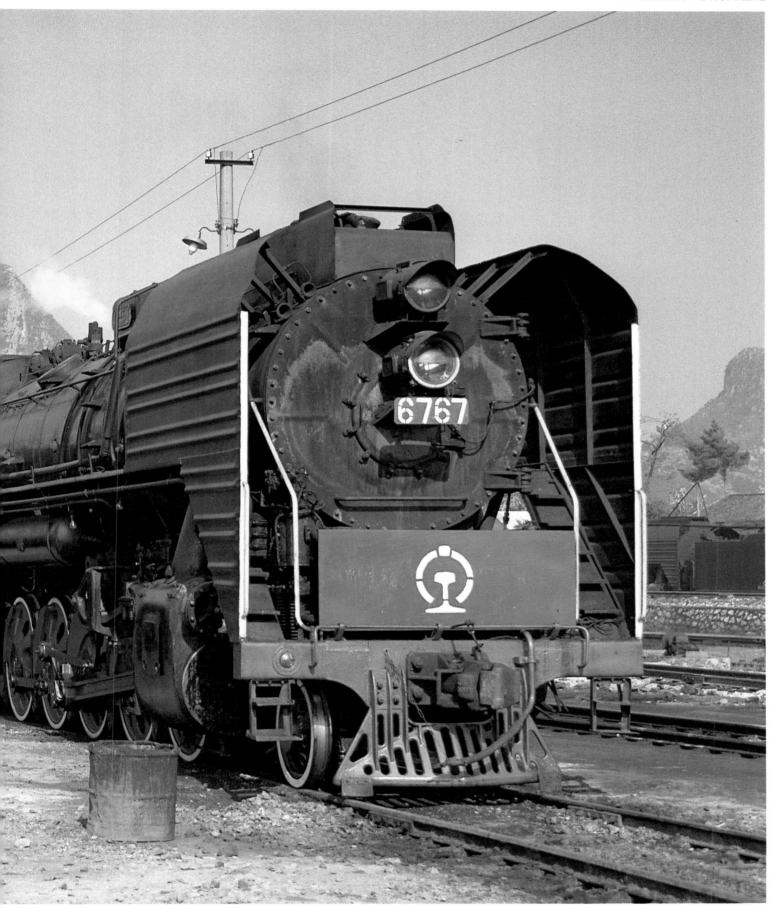

Cormorants do much of the river fishing for the local men – although the practice nowadays is also geared to entertain the tourists. The birds are used like hawks to find fish, but are tied to their owners to prevent their escape.

The limestone tors, domes and gullies around Guilin are usually wreathed in the mists which rise from the rivers and lakes of the region. Deep inside the hills are caverns and potholes, and the countryside is particularly fertile. There is a great deal of fish farming in the area, mostly of carp, which is a valued delicacy.

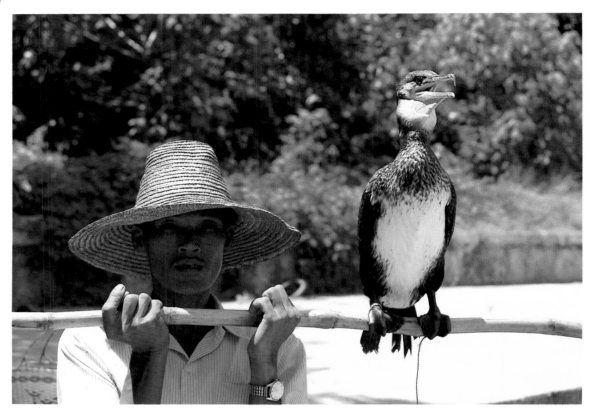

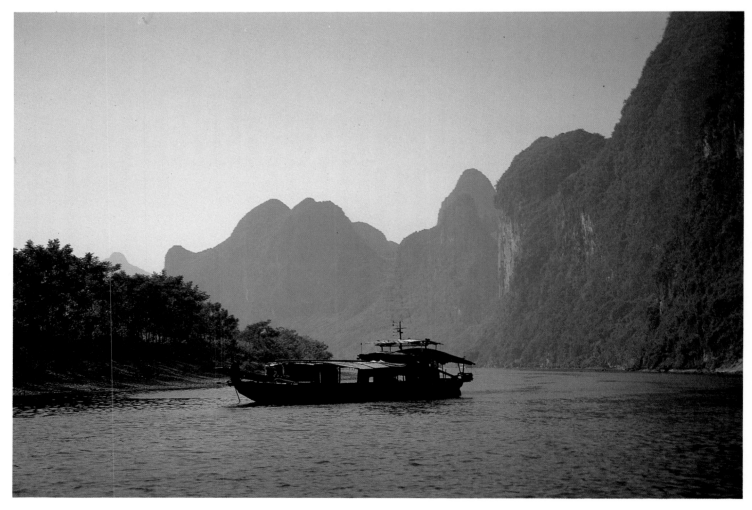

pictures and exclaiming at the views. The Chinese passengers, blasé about their country and puzzled by the enthusiasm, usually give way good-humouredly, and even call out if they think there is something special to photograph. Apart from the landscape, there are farms and villages to see, and in the towns, there are markets filled with animals and brightly-coloured wares. As the train stops at some of the stations, the dining-car staff often buy lunch from the platform – baskets full of cabbage or peppers or Chinese sweet radish, and live chickens and ducks to be killed, plucked and cooked on the train. It is very easy to feel a little squeamish at the treatment of the food before it is killed. Live birds are tied by the base of their wings, and dangled from bicycles or carts, and pigs are packed like sardines in the backs of trucks. But, although it is rather more visible, it really is hardly more cruel than the way any Western country treats its livestock. One certainly knows the food is fresh.

By the time travellers are tired of the strange sights and sounds of the journey, the evening is approaching once again, and the train has left the hills to cross the wide, fertile plain that leads to Kunming, high on a plateau – the City of Eternal Spring.

A row of Russian FD class 2–10–2 steam locomotives, supplied during the 'friendship days' of the early 1950s and now redundant, lie unwanted and semi-derelict at Guilin shed in October 1986.

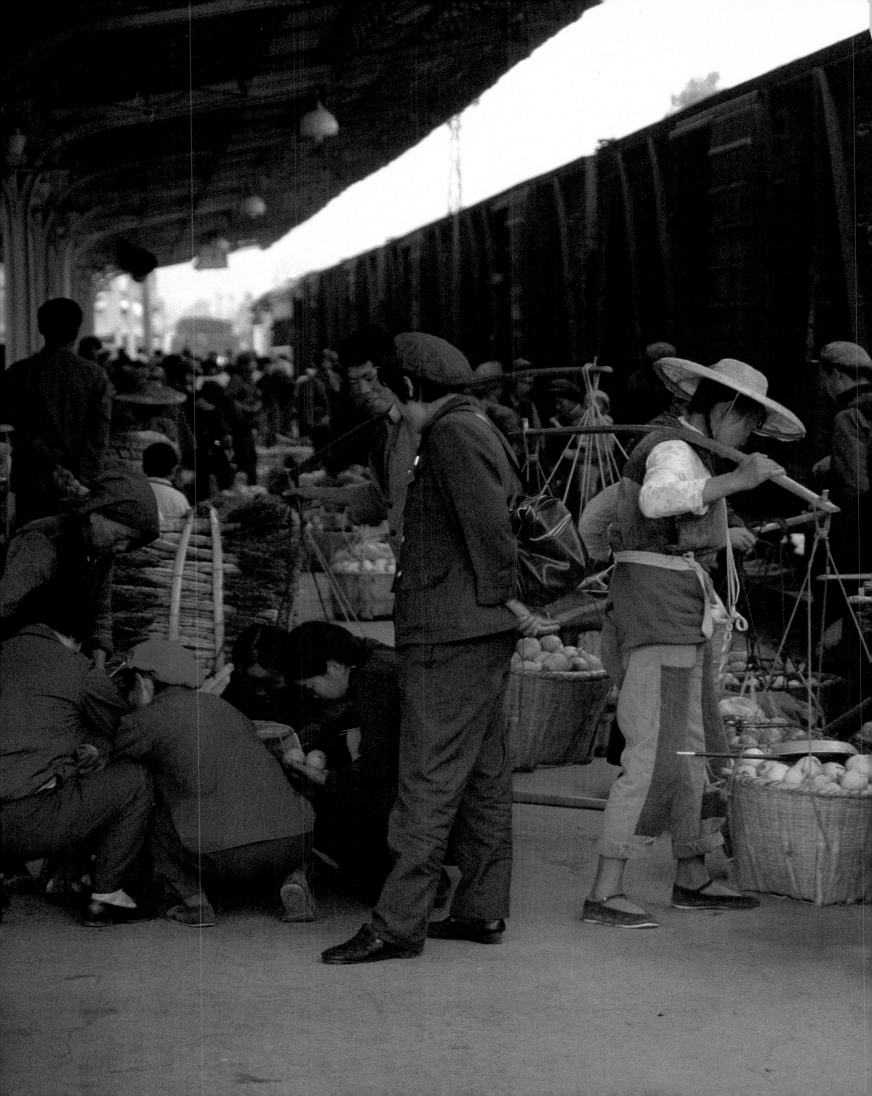

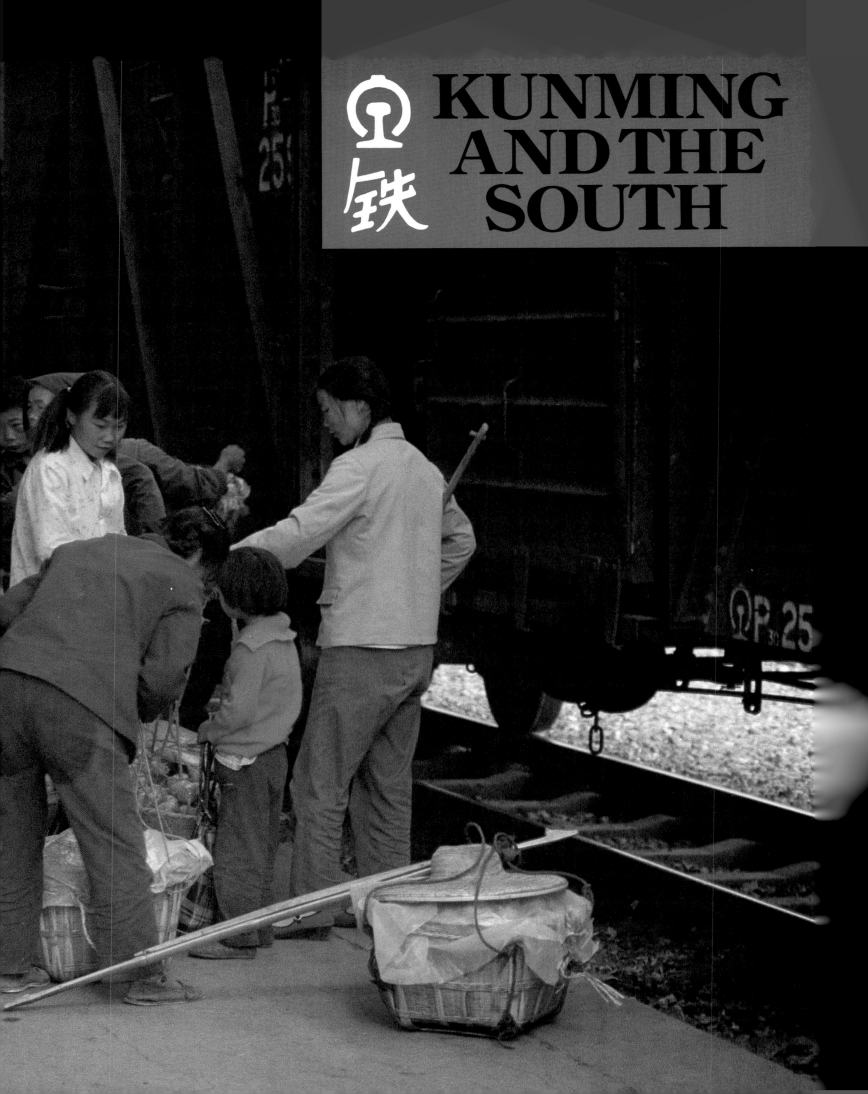

KUNMING AND THE SOUTH

REMNANTS OF KUNMING'S colonial past are clearly visible, and it remains one of China's more attractive urban areas. Behind the standard wide grey roads and dull modern flats are narrow side streets filled with green-roofed and shuttered buildings in the French style. The rural Chinese way of life seems more natural here – the bicycles and pony carts fit into the old-fashioned setting, instead of appearing lost on the huge new roads which seem to beg for more cars, lorries and trucks to fill them. The city is renowned for its traditional tea and coffee shops where storytellers still practise their ancient art and people can sit all day sipping their drinks and talking, listening or playing cards. Slipping into a corner, a Westerner is likely to become the immediate centre of attention and for a few minutes time jerks forward to the twentieth century. Then, slowly, café life starts up again, drifting back to an era before television or radio existed. Storytellers are becoming increasingly scarce and only the luckiest visitors will have the opportunity to listen to a master in the art. Even without understanding a word, the listener will still become involved in the narrative, enthralled by the rise and fall of the speaker's voice and the variations of tone and cadence.

The literal meaning of 'Kunming' is 'Brilliance for Generations', but it is popularly known as the 'City of Eternal Spring'. This description comes from the gentle climate, in which a true winter is unknown – there are flowers all the year round and the deciduous trees never completely lose their leaves. Sometimes this gives them a rather ragged, shabby look, and acid rain from the coal power station to the south of the city is also beginning to take its toll. In spite of its individuality Kunming has always been looked upon as a provincial backwater by the authorities, and during the Cultural Revolution exile to Kunming was thought of as a real disgrace. However, the city is slowly acquiring a more cosmopolitan reputation, and many of the people forced to go there later refused to return because they had come to like it so much. Kunming's earlier history is shrouded in insignificance – no battles or legends, ancient monuments or archaeology. It is just a market town which has traded steadily through the centuries.

Kunming has a locomotive factory, once used for steam repairs, but now employed in overhauling and repairing metre gauge diesels. There is a small shed adjacent to Kunming Bei station where a Japanese KD55 steam engine – the class once prevalent over the whole narrow gauge section – is still kept. Kunming Bei station is a miniature of many modern stations, although the old buildings of the original French terminus are still at the far end of the single platform. Some of the local trains coming in from the south are 'mixed', consisting, perhaps, of a single wooden-bodied passenger coach and a series of vans full of fruit and farm produce, brought to Kunming markets and often unloaded by Chinese using yokes. The sight is in sharp contrast to that of the longer-distance trains which are small versions of their standard gauge brothers or sisters – steel-panelled, with semi-padded seats and even a dining car.

The railway system from Kunming to the south is one of the most interesting in the whole of China. French-built, it is one of the oldest lines in the country. Indo-China came under French control in the nineteenth century, and plans were soon made to turn Kunming and its surround-

Previous pages: Kunming Bei station, with the arrival of a slow train from the south. It is early morning and smallholders and farmers are unloading their produce from the vans at the front. They have travelled in two old wooden-bodied, slat-seated vehicles on the rear – a long and tedious journey, but one costing only a few fen.

54

ing area into the transportation centre of the south-west by building a narrow-gauge line across extremely hostile territory, and improving trade links with Southern Asia. The metre gauge railway was begun in 1898 and completed twelve years later when it linked Haiphong, in Vietnam, to Kunming, through a gloriously beautiful and very treacherous landscape. As well as setting the standard gauge for railways throughout south-east Asia, the line showed a degree of engineering achievement which was hard to follow. The route from Haiphong to the Chinese border was relatively simple, but the greater part of the line then had to climb through great mountain ranges to the Yunnan plateau, crossing the Nanxi and Faux Nanxi river gorges and coping with a geologically unsound area of weak rock, sandwiched between deposits of clay, which would slip and fall under wet conditions. Sadly, Westerners are unlikely to see the incredible bridges and viaducts of this part of the line for some time to come, as it is effectively closed to tourists south of the town of Yiliang, and it is not always easy to get even that far. No official reason is given for the ban, but there is still sporadic fighting on the border with Vietnam and the whole area is treated as a military restricted zone. Proof can be seen in banners strung over the road in the villages around Yiliang, proclaiming a welcome to 'our victorious soldiers'.

Trade on the railway did not live up to French expectations, although the copper industry in the area found it a useful means of transport. Merchants from the south preferred to stick to tried and tested methods, instead of trusting their goods to the iron horse. However, the completion of the line did lead to the building of a second railway in the area, the 600 mm Yunnan–Kopei, which used Baldwin 0-10-0s to transport tin from the mines in south Yunnan to a link-point on the Indo-China line near the border. The French maintained control of the existing line until 1943, but it has become more successful under Chinese management and the 300 mile (480 km) or so length of railway still open carries twenty times the freight it could command under foreign control. Although the line from Kunming south to Yiliang is far from the most dramatic part of the route, it is still well worth travelling. As the train leaves Yiliang, heading north, the tracks twist through tunnels, on a shelf high above a deep gorge. The views are also exceptional – scenes of seemingly idyllic Chinese rural life. Paddy fields are full of workers with wooden threshing machines, pony and buffalo carts groan with produce, women wash clothes in the rivers and flocks of ducks or chickens are herded and guarded by children. The earth is red and fertile and rich with coal, so that many of the houses have their own little mine shored up on the hillside behind them, and there are fields filled with lotus as well as the subsistence crops.

On the train itself there is just one style of carriage, hard-class sitting, where passengers must bring their own mugs with tea or noodles, to be filled with hot water from kettles carried by white-uniformed attendants. The trains are always full and the station bustling, as though it were continuously rush hour. At rural stations the Chinese cross the lines and wander in front of

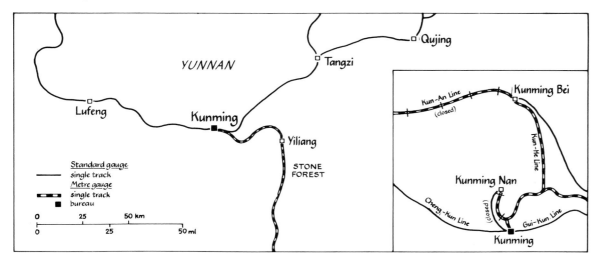

The Chinese are quickly becoming tourist-orientated, and there are stone-laid pathways and pagodas in most places of great natural beauty.

The Chinese are experts in chalk designs. This one, on a wall in old Kunming, reads 'Warmly celebrate the 36th anniversary of the founding of the People's Republic of China'. A reminder of the coming National Day – 1st October.

A street restaurant in Kunming. A Yi woman with a child on her back posts a letter and locals enjoy their rice noodles alongside the white-coated staff.

58

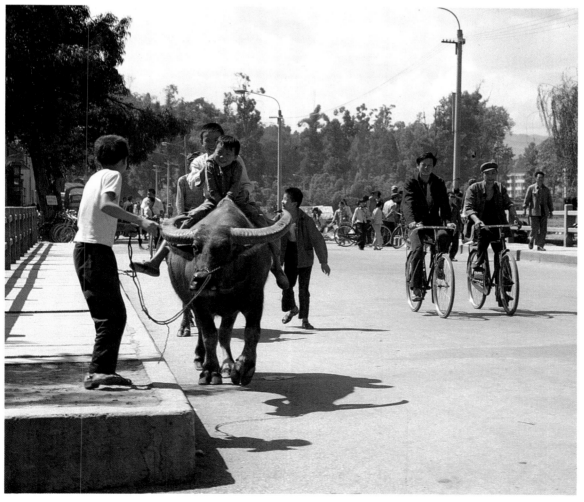

Distinctive buildings line the narrow streets of much of old Kunming, recalling its historic French connections. However the more modern central areas have been completely rebuilt.

Water buffalo are still used as draught animals in much of southern China, but are rarely seen on city streets; these boys are enjoying the warm sun of a September afternoon, making the most of a free if somewhat bristly ride.

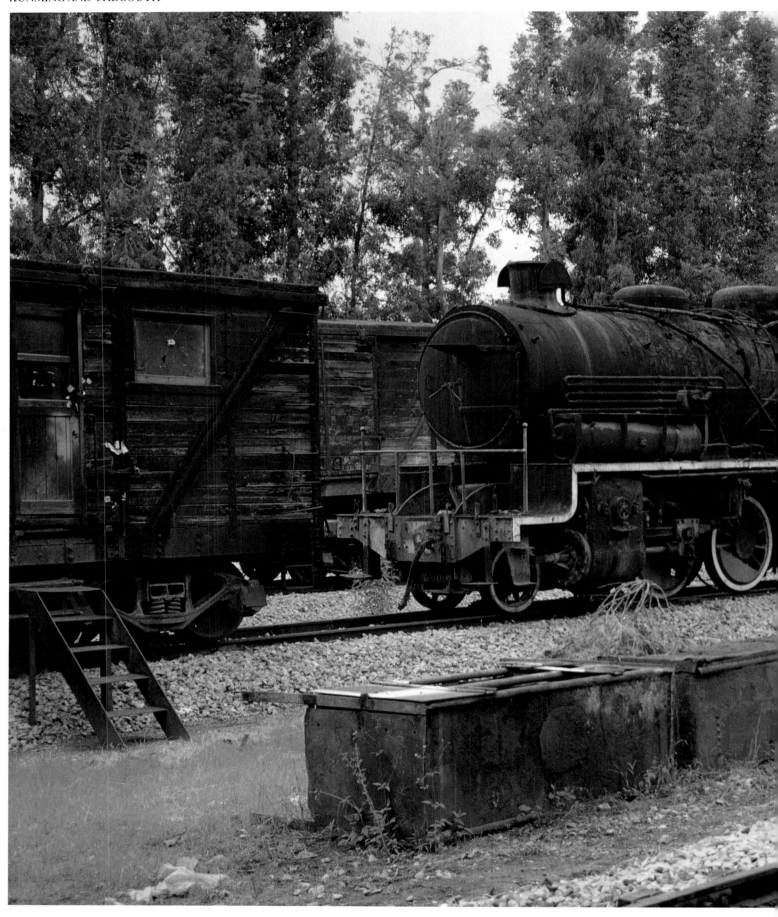

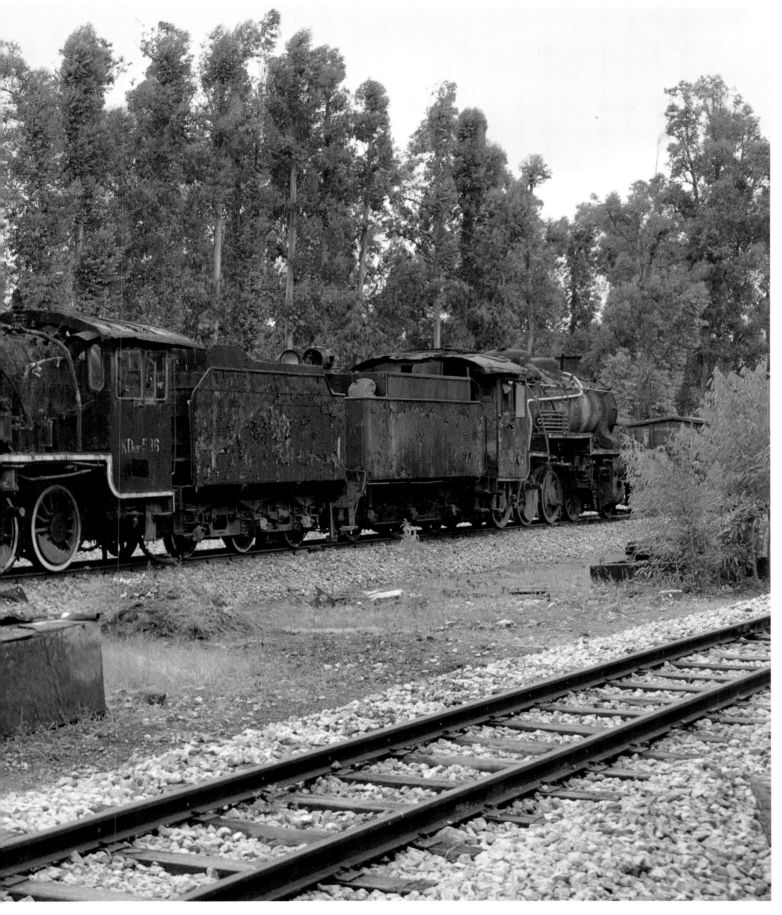

Previous pages: *A pair of derelict Japanese-built class KD55 2–8–0 steam locomotives stand forlornly outside the railway workshops at Kunming.*

A DH21 diesel hydraulic locomotive at the head of a metre gauge freight train, bound for the south and about to depart from Kunming Bei station. These engines are now the standard motive power for all trains on this line, supplanting the Japanese-built KD55 class 2–8–0 steam locomotives from 1979 onwards.

moving engines. People are responsible for their own safety, and if they misjudge the distance of the crossing an accident is generally held to be their own responsibility and not the railway's. The line's steam days were over by the late 1970s and now the trains are hauled by diesel-hydraulic locomotives built specially for the narrow gauge. Last vestiges of steam can be seen at the Yiliang engine sheds where old scrap boilers are still on show, and as recently as 1987, there were two derelict French 'autorails', one a baggage car, left abandoned on a siding next to the Dongfanghong ('The East is Red') diesels manufactured in Qingdao. These vehicles are remnants of the very modern French railcars running on rubber tyres – in the 1930s the latest mode of transport – providing Europeans with fast and adequately comfortable travel from Indo-China to Kunming. The Chinese were not allowed to travel in them but were relegated to wooden coaches on slow, steam-hauled trains heaving their way up the twining and twisting grades. As with most other work complexes in China, staff at the locomotive depot live in unit accommodation with all the necessary amenities on the site.

Yiliang is a dreary, unfinished-looking town of tiled concrete houses and cracked grey streets, but it is worth venturing outside the station to find a street market where shoppers hustle and argue over vegetables, piled carelessly on the pavement or laid out on rush matting to dry. The range of goods available in the unlit, open-fronted shops is very limited but the traders are eager to welcome foreigners inside to look and perhaps to buy at a price which seems very cheap by Western standards, but still will be treble what the locals would pay. In the station waiting-room, a buffet on a table sells a metallic-tasting orange drink and packets of dry cakes. Here, unlike many other areas in China, passengers will move up to let a stranger sit, and sometimes offer a cigarette.

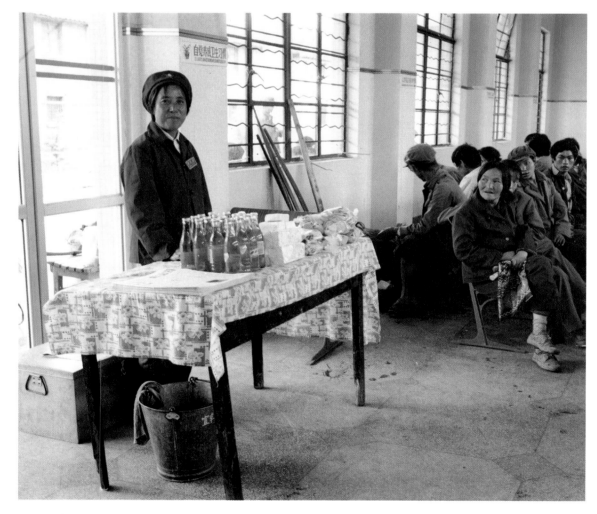

The Chinese deny any military activity near the Vietnam border, but this banner across the road south of Kunming offers a welcome to victorious soldiers.

Yiliang station buffet.

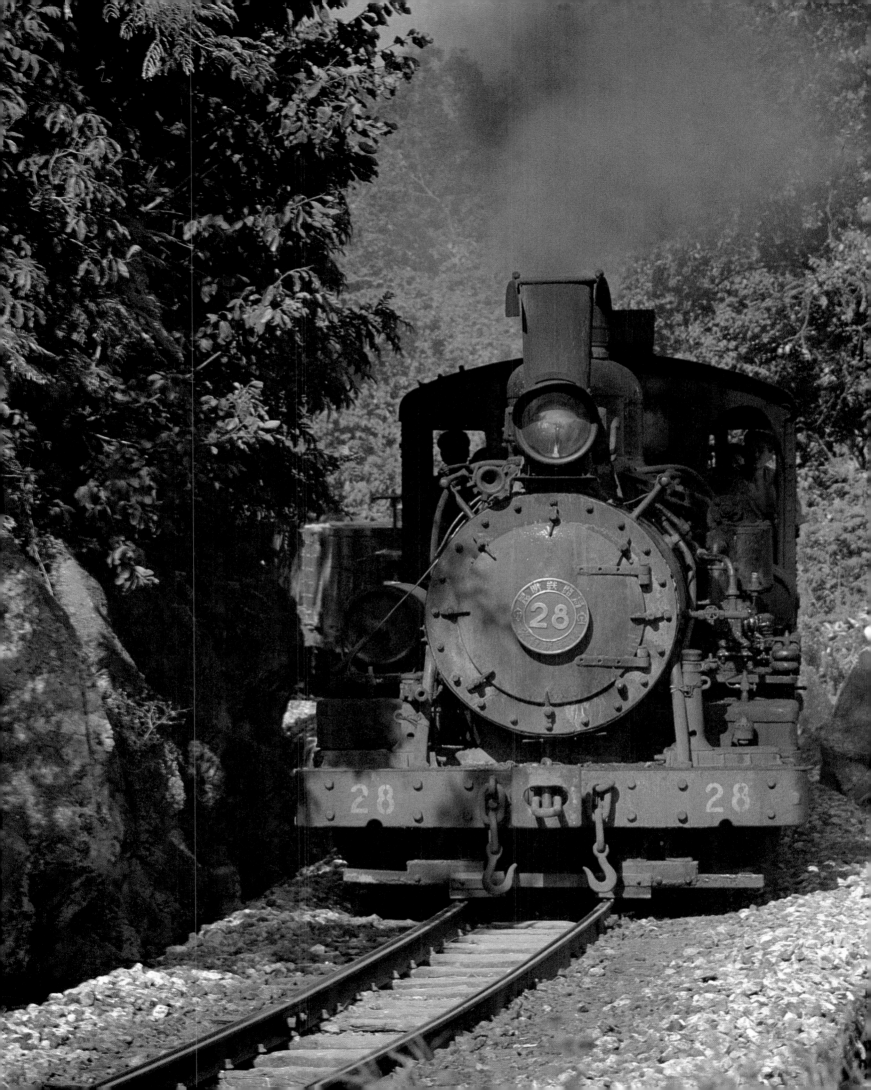

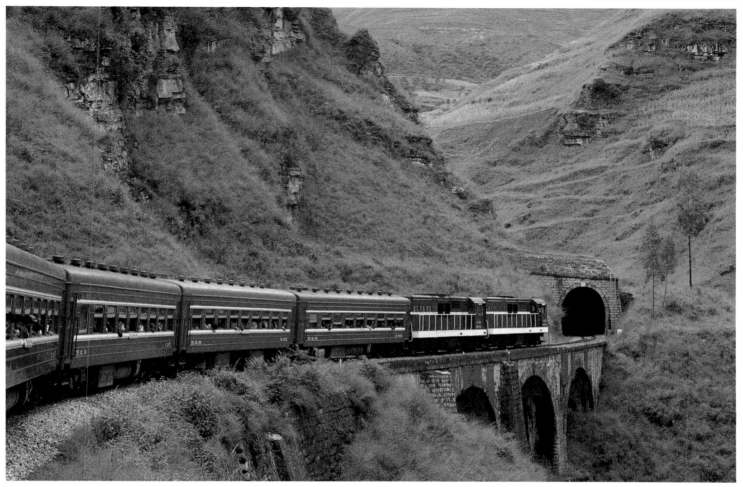

A Kunming-bound train threads its way over ledges and through tunnels west of Yiliang, double-headed by two DH$_{21}$ class diesel locomotives. This is a spectacular section of the metre gauge Yunnan Railway.

Opposite: *A train on the 600 mm gauge Yunnan–Kopei Railway, which links into the metre gauge system at Jijie and uses American-built Baldwin, class SN28 0–10–0s of 1926.*

A country station between Yiliang and Kunming on the metre gauge Yunnan Railway. The very French design of the buildings is still unchanged on this line, which once reached down into Vietnam.

KUNMING AND THE SOUTH

An unusual find at the locomotive shed at Yiliang in September 1986 – a French Michelin railcar and trailer, introduced in the late 1930s for fast passenger traffic. Although it has been derelict for many years, some Chinese staff remember it when it was in use, and reserved for Europeans only.

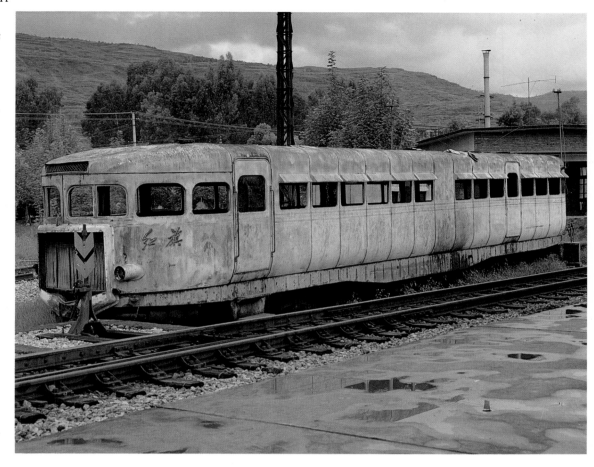

The afternoon passenger train for Kunming arrives at Yiliang station. These metre gauge services coming up from the border of Vietnam are hard-class only, although the faster trains include a restaurant car in their make-up of modern steel vehicles.

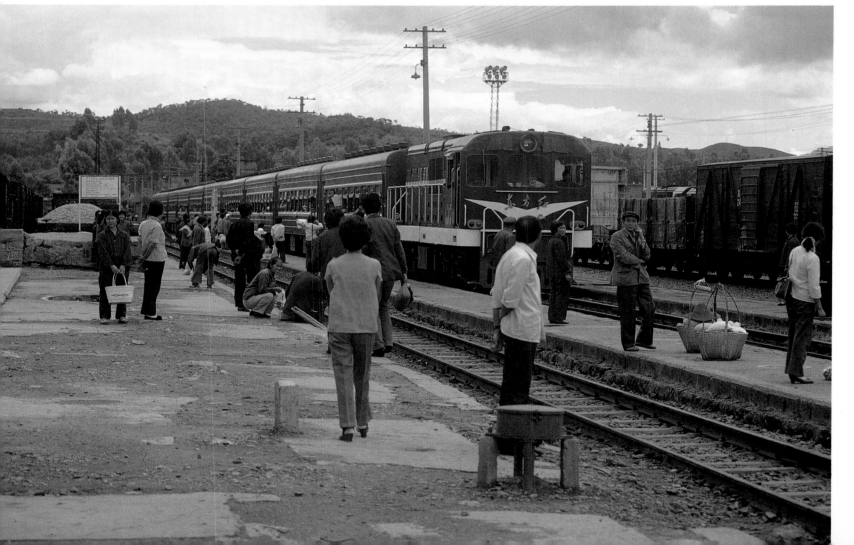

The attitude to foreigners changes dramatically at the magnificent stone forest of Shilin, just south of Yiliang. This is Yunnan's greatest tourist attraction and it is exploited by the local people. China's population is principally Han Chinese but this province has more minority peoples than most others, including Hui, Miao and Baai. However the ones who seem to hold the tourist franchise are the Yi, who roam the stone forest in colourful national dress, selling embroidery and souvenirs with a tenacity and a ferocity which has to be experienced to be believed. They also charge for photographs and once paid will pose on horse- or camel-back, looking spectacular against the strange and wonderful backdrop. The forest itself is a huge garden of limestone tors, covering miles of land and giving the impression of a landscape from another planet, or a glimpse back to prehistoric times. Some of the more impressive outcrops have been given names, with red Chinese characters engraved into the stone, and there are paths and bridges to help visitors climb around the rocks and up to specially-built pagodas where they are ambushed by embroidery-sellers. The best time to see the area is in the early morning, or at dusk when peasants drive their oxen through the ravines or wash in the lime-green primeval pools, believing all the tourists to be gone.

The Yi put on nightly shows for visitors where they demonstrate strange old musical instruments and perform ritual storytelling dances with a commentary in English and sometimes German. Some of these can be exciting viewing, but they are more usually carried out with expressions of intense boredom on the part of the performers and a total lack of attention from the chattering audience.

With the exception of the stone forest, Kunming and Yunnan have no traditional tourist areas. Many of the Yi people still take great exception to being photographed, believing that the camera can capture a piece of the soul. It is a rich, gentle region where life in the main continues unchanged, and few people here feel the pull of the bright lights of Beijing.

This pony's days are spent posing for tourist cameras. Every morning his owner rides down to the Stone Forest and hires out both his mount and Yi minority costumes to visitors.

Opposite: *The Stone Forest.*
Crags and tors of immense
height and complex structure
form petrified forests which
cover more than a hundred
square miles of Yunnan
Province.

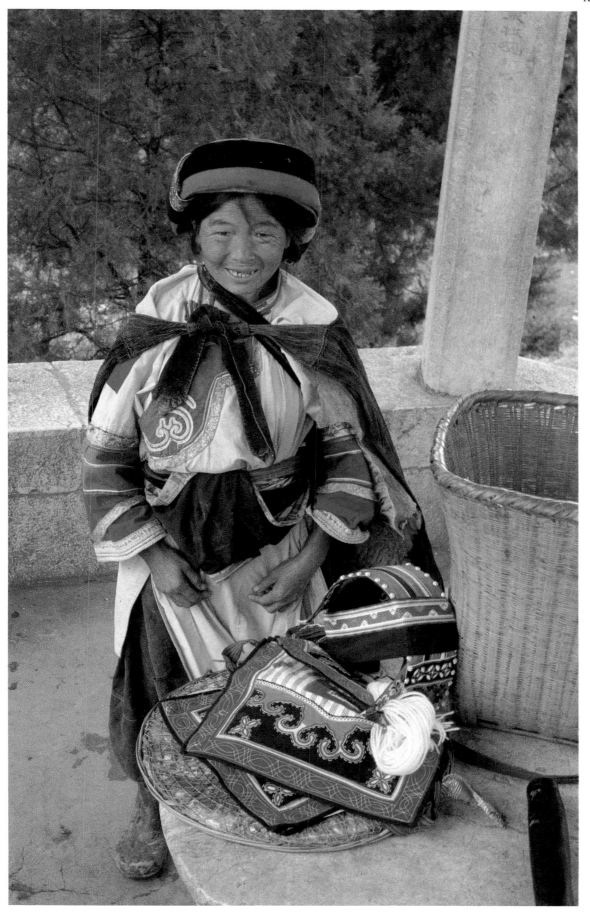

A Yi woman showing her
embroidery. The Yi still wear
national costume all round
the Stone Forest area. They
have already learned the art
of salesmanship.

69

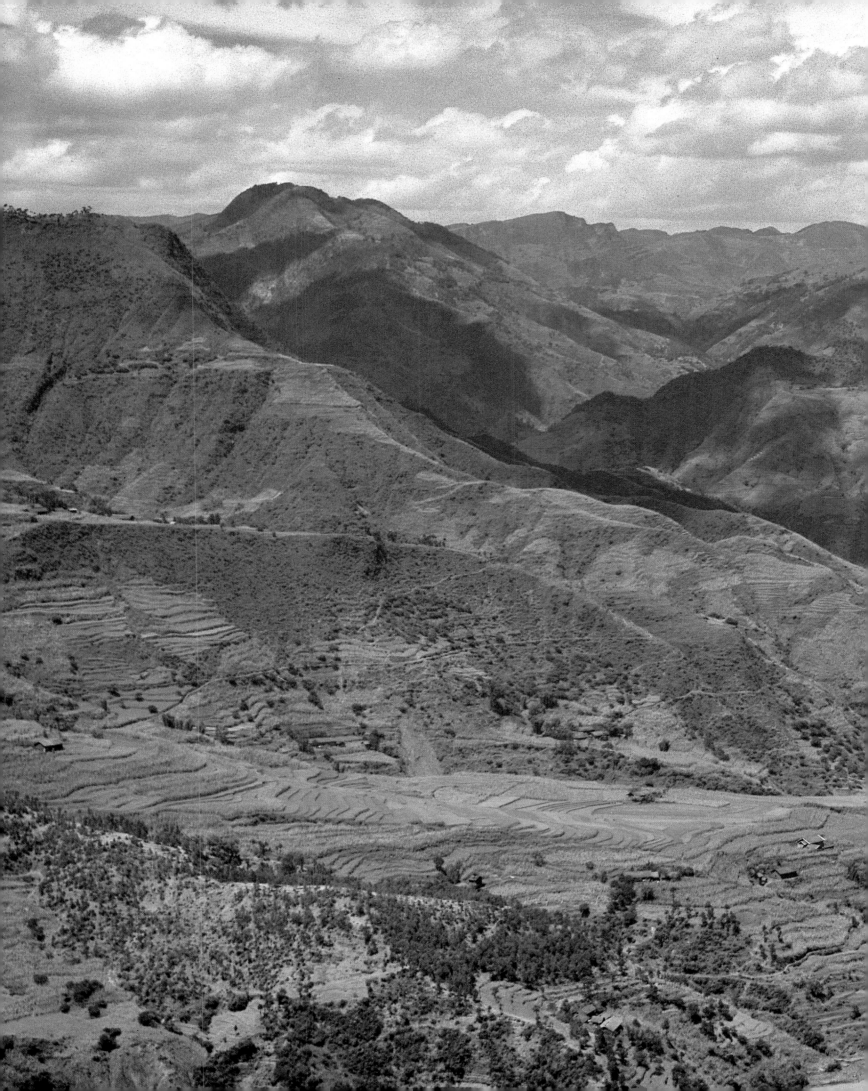

KUNMING TO CHONGQING

A S RECENTLY AS 1970, the almost impossible mountains and plateaux of the west meant that the only way to make the long journey between the major cities of Sichuan and Yunnan Provinces was to take a great detour south from Kunming to Kaiphong in Vietnam, go by ship to Shanghai and toil up the Yangtze River to Chongqing, before a final and more comfortable trip by rail to Chengdu. The opposite journey was somewhat faster, as the river flows east to meet the China Sea, but this was of little use to the northbound traveller. One of the real civil engineering miracles of the 1960s changed the situation. Despite the upheavals of the Cultural Revolution the Chinese drove a line of railway through this hostile territory, battling against floods and earthquakes, huge cliffs and fast-flowing rivers; it took them twelve long years of back-breaking work. Over 40 per cent of the new line lies through tunnels or runs over bridges, all of it through breathtaking scenery.

The route offers tantalizing glimpses of distant, inaccessible hills and valleys and settlements clinging, seemingly impossibly, to hillsides which are terraced to the last inch to provide just enough food for survival. In the many river valleys, where the water flows orange and yellow from the soil it brings down from the mountains, there are larger villages with brick houses as well as the more usual daub and wattle. Here, the local people can bring their wares to other markets, travelling by water. It is a hard and simple life, and the pleasures are basic – a pig-killing, or a cigarette in the dark of the evening before bed. Most of the people of this area will never even see Beijing, never travel further than the nearest town, nor learn any more than the minimum laid down by law. As with all classless societies, some are inevitably more equal than others, with larger houses, more land and a greater number of animals, either through luck, a larger family able to do more work, or more fertile soil. Most houses huddle together as if for protection from the wild excesses of the landscape, but the occasional smallholding stands alone in a corrie, surrounded by as much cultivation as possible, maize drying on the crazily constructed roof – tiling, home-made from the soil, woven rushes or even strips of plastic held down by stones. The people still regard the passing green dragon of the train with fascination, and stop work to stare, or even wave. The children lurk by the railside, playing the same games as children anywhere, and their faces change from amusement to amazement or even horror if they see a Western face at the window. All these sights are frequently cut short by the tunnels, as the train dips and dives in and out of the light and dark and the traveller's ears pop incessantly, conversation is difficult and reading impossible. The sudden climbs and falls spill the soup in the dining car as passengers hold on to their seats or beds. There are no major towns on this route, though trains stop off in the passing loops from time to time, and travellers can stretch their cramped legs on the platform, gazing at the great vistas of hills and valleys, stretching out for hundreds of miles of unconquered landscape. The only Westerners that will ever be seen here are committed backpackers with a year in which to travel.

This fantastic route is not, however, the only way to Chengdu. The second is a little less spectacular, although there is still quite enough drama for the average visitor, and it has the added advantage of taking in one of China's old capitals, Chongqing, scattered on hillsides

Previous pages: As the train climbs into the foothills of the Guizhou mountains, fast-running rivers brown with silt score their way down the valley bottoms. Every square metre of land that can be cultivated is sown with crops.

stretching down to the Yangtze River. For the next few years at least it also promises a ride behind steam on the last leg of the journey. It is a much longer way round: the train has to return east for some hours before branching north to Chiang Kai-Shek's old capital, a journey of twenty-seven hours. By now the committed traveller has had to wrestle with the vagaries of the Chinese railway system alone, away from the reassuring guidance previously available from the English signs, and many English-speaking people, in Guangzhou. The *China Railway Timetable* remains invaluable; carefully attended to, it will rarely let anyone down. It cannot, however, stop the Westerner being charged at a very much higher rate than the Chinese, or help a backpacker who wants to travel hard-class when the clerk in the ticket office believes he should travel soft. An ability to speak basic Mandarin or the services of an interpreter are the only ways to avoid this problem, because officials either will not understand, or may comprehend only too well and refuse to move outside the guidelines set down for foreigners' travel.

Once on the train, passengers in soft-class will be left strictly to themselves, apart from the changing of water in the thermos flask, and the dining-car attendant calling for orders for lunch, dinner or breakfast. Normally a set meal is available at a cheaper price, but foreigners may not be told this; there is little or no malice here, for all Westerners are extremely rich by Chinese standards. On an overnight train, or one which sets out in the early hours of the morning, the

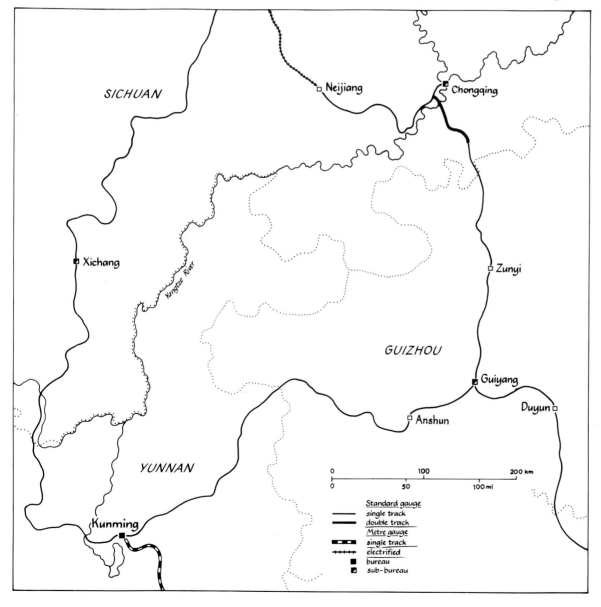

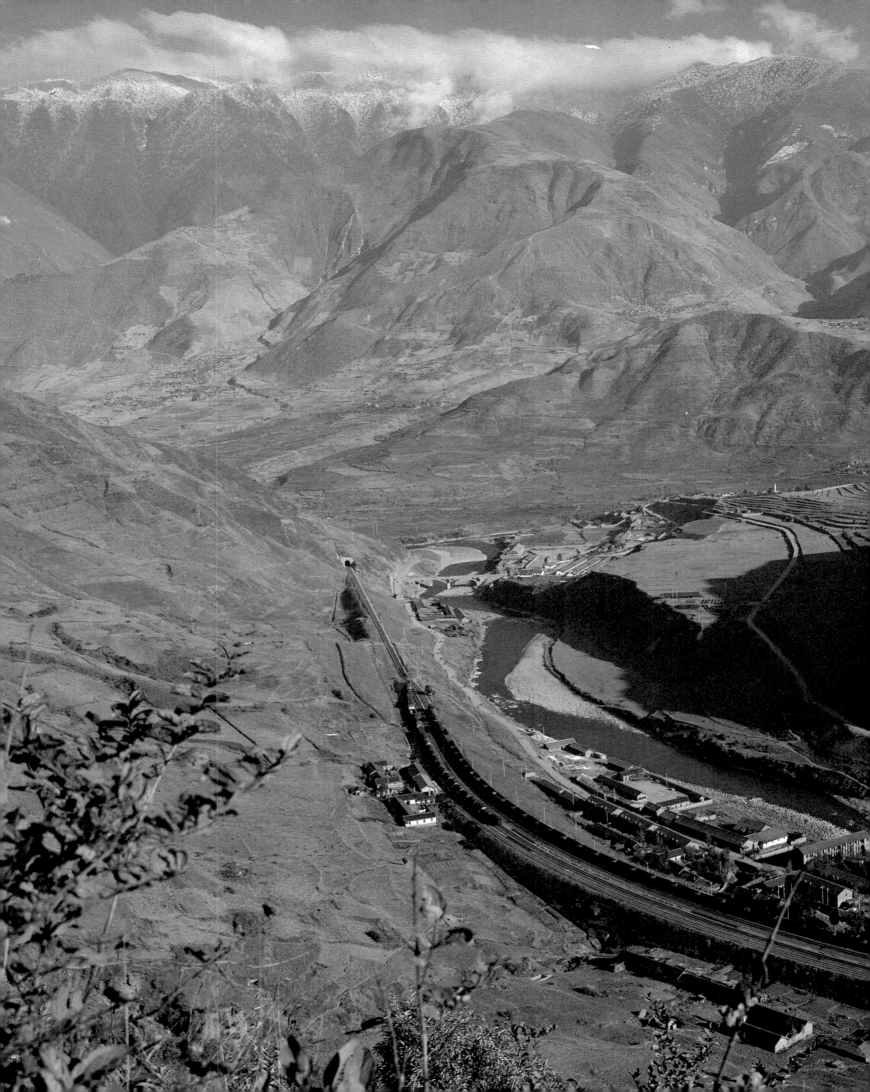

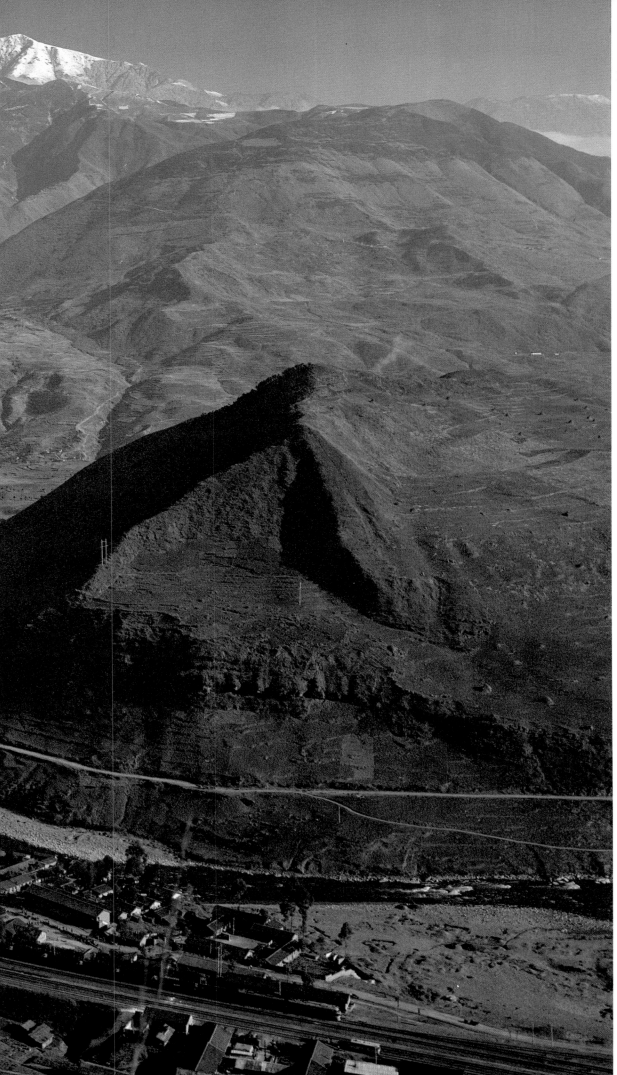

The new line running north to Chengdu is even more dramatic, battling its way through hostile countryside into the foothills of the mountain ranges which lead to Tibet. The camera looks down on a long freight train standing in Ganluo station, with snow-capped mountains as a backdrop.

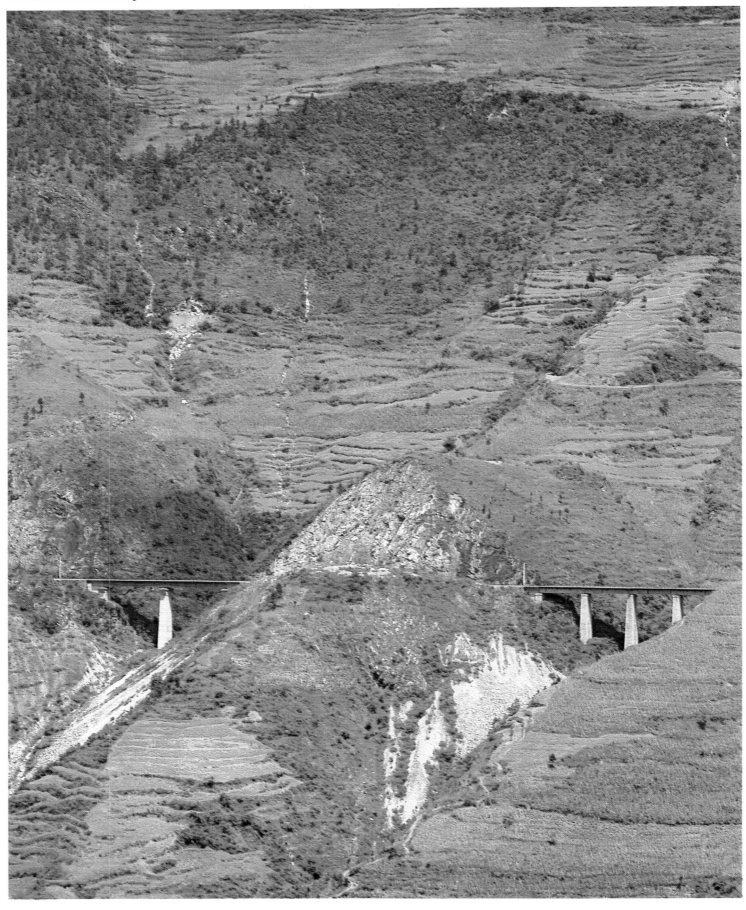

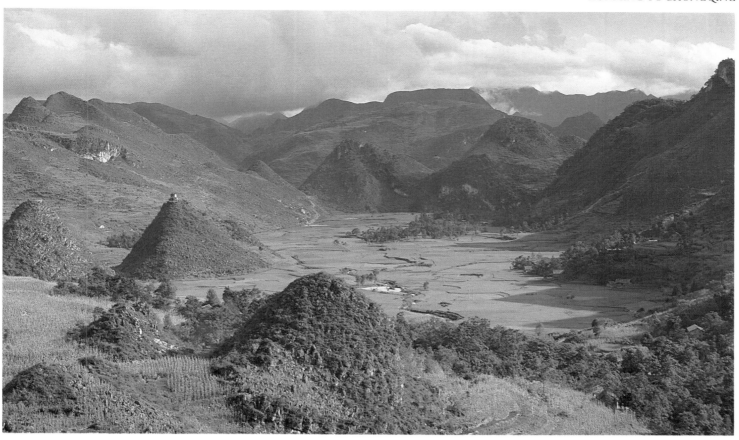

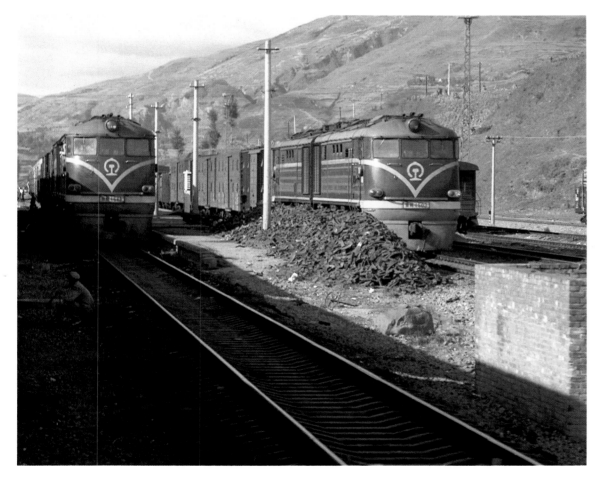

As the train reaches a green plateau, limestone tors like small replicas of the Guilin mountains come into view, and in the west the tree line begins to recede as the mountains get higher.

Opposite: *To gain height, the line from Anshun, in Guizhou Province, to Guiyang twists its way down one side of a valley and up another, giving splendid views of concrete viaducts from the train windows.*

A Kunming-bound passenger train passes two freights on the route to Chengdu.

The kitchen area of a modern Chinese dining car, showing lunch dishes in preparation. The stoves are coal-fired, making total cleanliness a problem, especially towards the end of a busy shift.

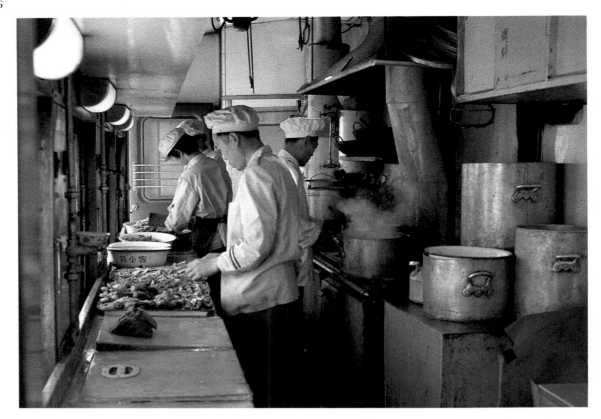

Even in the mountain wilderness of Sichuan trackside vendors appear, apparently from nowhere, to sell their wares.

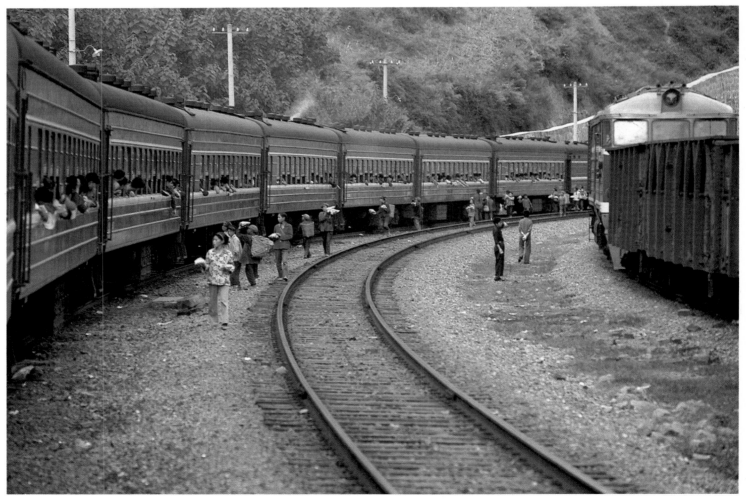

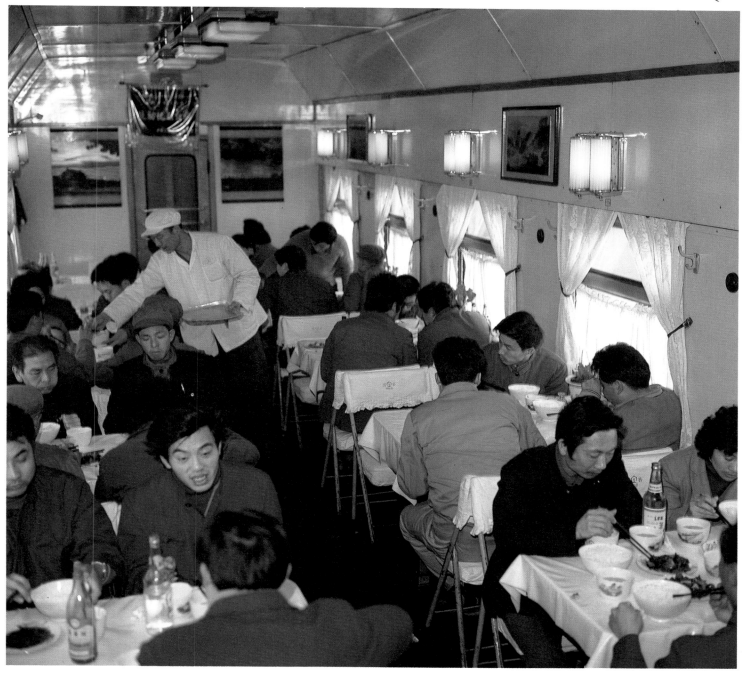

best way to start the day is with the Western breakfast available in the dining-car. This may provide a gastronomic highlight for anyone craving a change from the more usual Chinese fare of rice, meat and vegetables. Different chefs have different interpretations of the meal: the most likely consists of two fried eggs, corn bread in varying stages of freshness, sometimes very slightly heated and called toast, and various jams. Nowadays there are some tart and delicious jams available, but occasionally something which tastes like pork fat mixed with sugar will still be served. The more adventurous chef will provide delicacies such as deep-fried eggs, bread fried in beaten egg, sandwiched with jam and covered with more eggs, fried, or even a little ham or bacon. Most tourists find they cannot cope with the sweet-and-sour taste of egg and jam for the first few days, but they quickly become accustomed, and even learn to enjoy it, as a change from the otherwise rather unvarying diet on the train. Sometimes passengers will also be offered hot, sweetened milk, green-leaf tea, and occasionally black coffee.

The interior of a typical Chinese restaurant car. Rice is the staple food, accompanied by perhaps two or three vegetable or chicken dishes. Like dining cars the world over, service and food vary from crew to crew.

The scenery for the first part of this journey is a gentle, undulating landscape with fertile plains, paddy fields and maize crops, and the same clusters of dwellings which can be seen anywhere in southern China. Every available corner of land which can grow food is used, and animals are herded along the tufts of grass which mark the divisions between fields, or fettered on the mud track verges which are used for the passage of carts, oxen and ponies. After four hours travel in this fertile, alluvial land, the train plunges unexpectedly into a great hinterland of mountains and valleys, just as lovely and dramatic as the famous scenery of Guilin. Huge, dome-shaped hills, crevasses and cliffs appear in flashes of colour; dark spruce trees race by, interspersed with leaf-green sloping fields, golden maize, yellow silt-filled rivers and startlingly red soil revealed in great gashes of erosion. The fight to live entirely off the land forces the Chinese to bleed it dry without replacing the minerals and richness, and the earth retaliates with soil slips and low crop yield. The poorer farmers cannot stop this vicious circle as they must plant every inch of space to live, but every year the day comes nearer when the land will be too barren to farm. Their homes are tiny one- or two-roomed single-story cottages, built in the same way over hundreds of years, with the mud of the daub and wattle replaced as it cracks and splits, and any gaps filled with maize husks, plastic or stones. The richer or more fortunate have bricks, either bought and transported from the nearest river-bank town, or simply hewn from the sandstone and mudstone rocks of the hillside where it is too steep to cultivate.

The train spirals round and round, up hills, across bridges, through tunnels, and down again to another plateau and another hill. The route is surrounded by these breathtaking ranges, some sparkling with snow and ice in the spring or autumn. It can be very tempting to lean out to catch the views in front or behind, and to snatch pictures of the engine as it curves and climbs the line ahead, but the watchful train crew usually guard their Western passengers against the risk of miscalculating and smashing into the narrow-fitting wall of an unexpected and unlooked-for tunnel by keeping the window tightly shut.

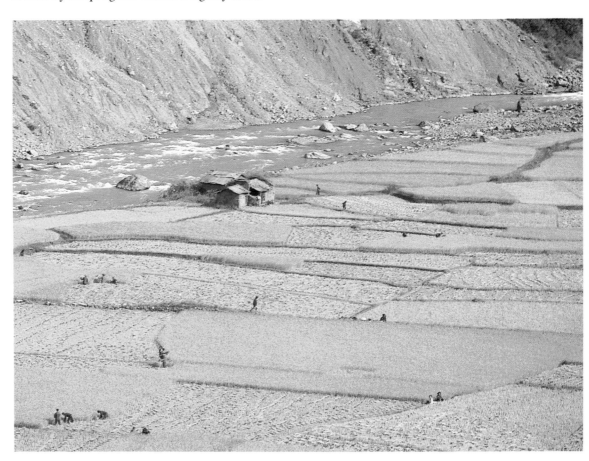

Yi minority workers farm their rice fields alongside majority Chinese Hans.

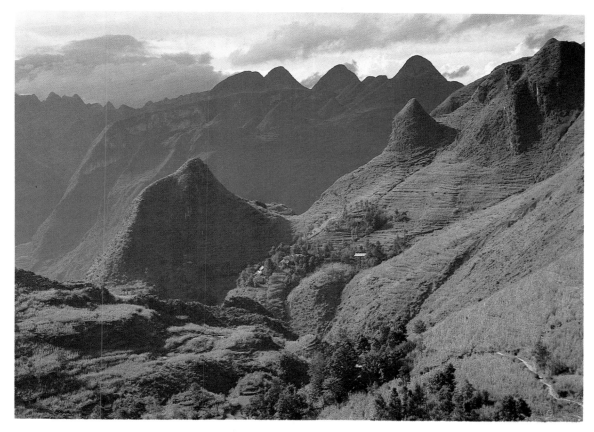

A day on a Chinese train passes swiftly when there is so much to see and to take in. Meals, mugs of tea and snacks of apples or watermelon seeds break up the time, and travellers in hard-class will find themselves absorbed into the life of the coach, offered food and tea and expected to take what is given. A refusal will often give offence, but it is wise to wash and then peel all fruit, and perhaps tactfully to dispose of grey, fingermarked dumplings or more dubious offerings. A moment's lack of thought and a mouthful of unblanched watermelon seeds can mean days of discomfort, and a Chinese train is not the ideal place for such suffering.

In the middle of the night the train stops, and the diesel is replaced by a vast and powerful steam engine, probably an SL Pacific, one of the two such classes still working passenger trains in China. By morning smuts and smoke will have infiltrated the tightest-fitting windows to leave a film of grey on the bedding and grimy dust in the nostrils and ears. There is a definite art to washing in the tiny basins of the communal washroom at the end of the carriage and although it is possible, it is not easy and rarely pleasant to get clean. Tours of Westerners will have their own soft-class coach with soap, lavatory paper and possibly even hot water, but the solo traveller will be mixing with the Chinese, and there are no such luxuries for them. In soft-class towels are provided, though they are intended for use as clean pillowcases on the often grubby pillows. Western men can join fellow passengers in the washroom, where they will be tolerated with little more than sideways looks and muttered comments, but Western women are generally not welcome because their presence is embarrassing. Even the few Chinese women who travel soft-class will not wish to share with a Western woman, finding her washing too revealing for modesty. The general tourist only has to spend one night on the train before stopping off at a hotel to recover, but the serious traveller may face up to four nights in a row, and learns to take opportunities when they present themselves. Sometimes passengers from hard-class infiltrate the soft-class washroom, preferring it to the single basin in the corridor of their own carriage. Very occasionally a carriage has no washroom at all, and travellers will have to wash at the tiny basin in the lavatory.

An empty freight train makes its way over one of the numerous concrete viaducts near Tiekou station on the Kunming–Chengdu line.

83

A passenger's view of a fast-flowing river and a storm ahead, as a Chengdu–Kunming train moves slowly up into the high mountains.

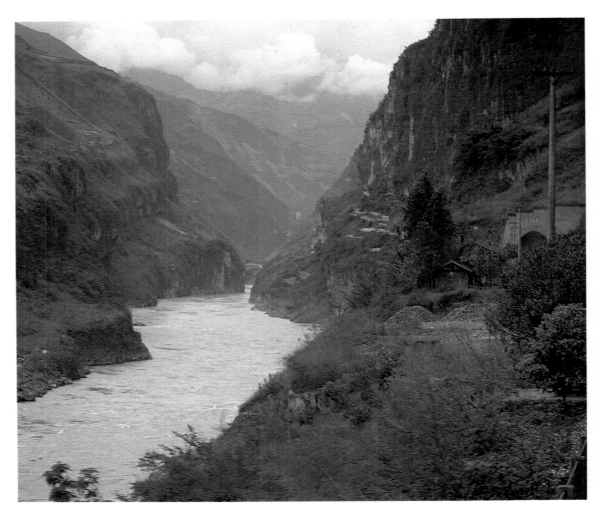

By first light the train is already approaching the great Yangtze River valley in a steamy, tropical-looking area of palm and banana trees, with darker, richer soil. The river is following a 1,650 ft (500 m) high plateau after rising in the heart of Tibet and meandering first south, then north across the westlands, before swelling into the broad trade-route which transports minerals (mostly coal), food and animals across the 1,500 miles (2,400 km) of China's heartland to Shanghai and the sea. As the train races towards Chongqing, the river flows deceptively lazily through a broad but steep valley, littered with log floats, sampans, tugs and barges. The outskirts of the city are muddy and scruffy, crowded with yards full of twisted corrugated iron and rusty machinery heaped in sprawling piles. The smog of coal pollution rests as a film on grey grass and grey trees, and all the buildings, mostly single story, are dim concrete with cracked or missing windows. Men in dirty overalls sit smoking on the doorsteps or load piles of broken bricks into old-fashioned blue lorries which park, precariously angled, on mud tracks filled with ruts and puddles.

Chongqing is situated where the Yangtze and Jialing Rivers merge, and is called the furnace of the Yangtze because of its humid climate – it has one of the highest levels of rainfall in China and is built on the steepest hillsides of any major city. It is also the only town where the traveller will see very few bicycles, as they are impractical on streets so hilly that they often include steps. The main highways are broad and grey, and crammed with concrete apartment blocks, each window and balcony smothered with dusty-looking plants and the ever-present washing line. Chongqing has been a major port for three thousand years and it is a frenetically busy place with a cable car for crossing the Yangtze. Until 1987 the old car was still in use, appearing to consist of no more than six sheets of metal linked by rust, but the new car is much less nerve-racking.

Opposite: By now the diesel locomotive has been replaced by an electric one. The extra power available to the SS locomotive enables the train to make steady progress as the line clings to the hillsides from tunnel to tunnel.

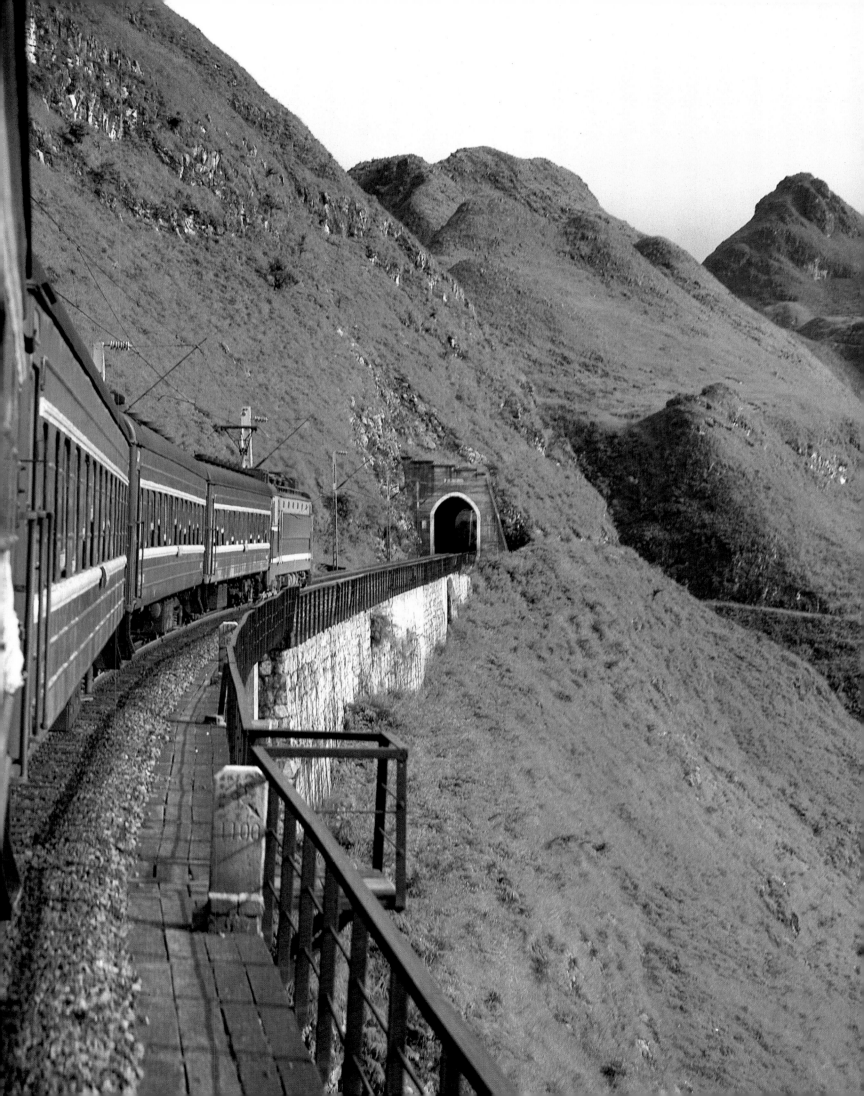

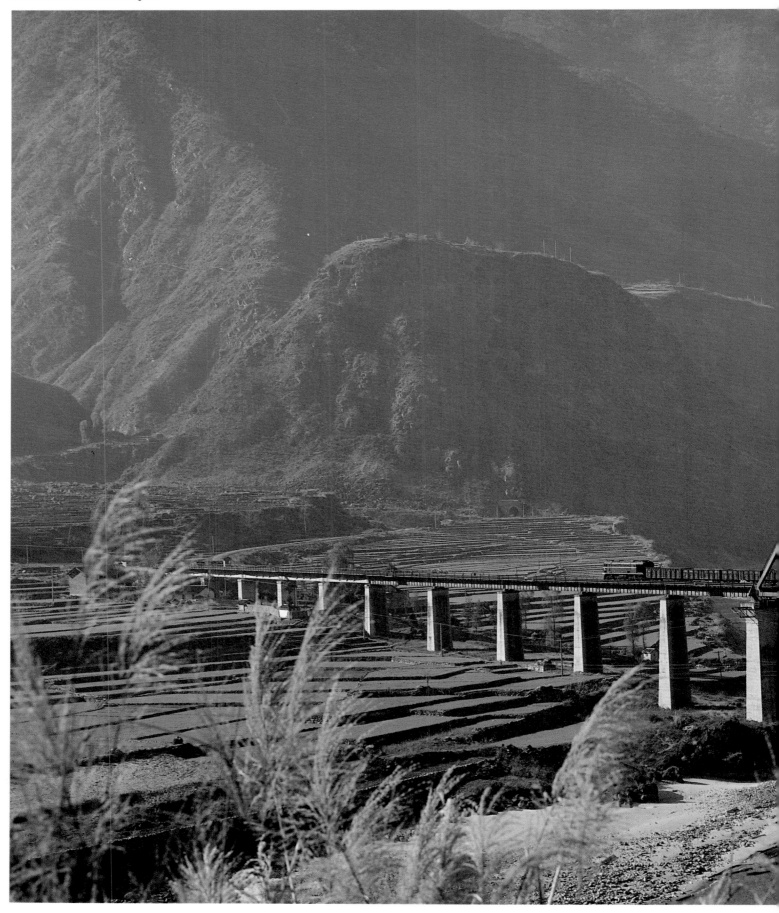

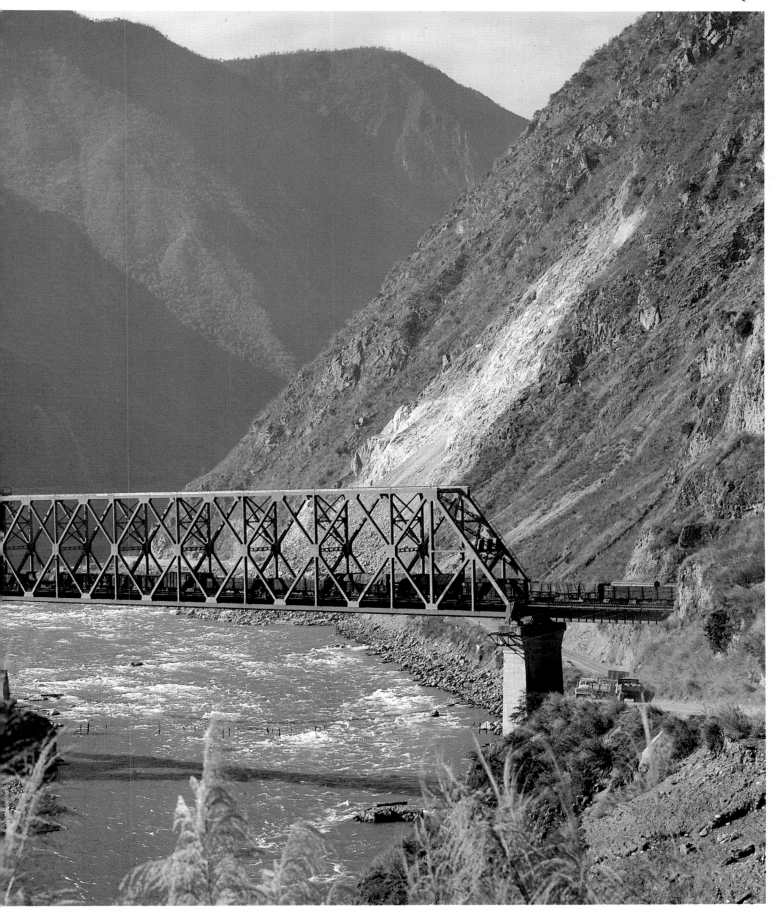

The wharf on the Yangtze, where river steamers from Lo Wu drop their passengers and farmers from up river wash the dust from their goods before walking to market.

Previous pages: *Miniscule in scale beside the great girder bridge and the towering hills, a diesel-hauled freight crosses the Dadu River and makes its way southwards towards Kunming.*

A scene looking down from the depot master's office at Chongqing locomotive shed, taken in September 1986, and showing SL class Pacific locomotives still in use on passenger services north and south.

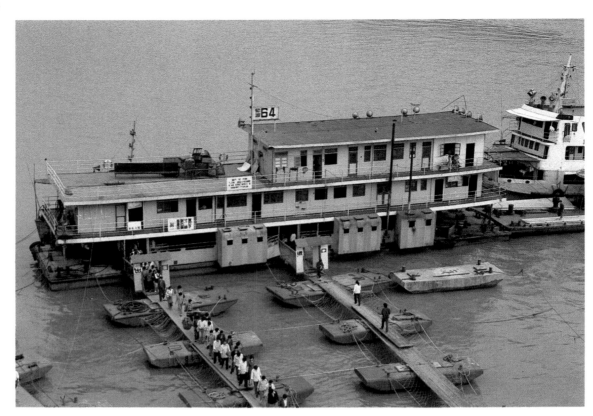

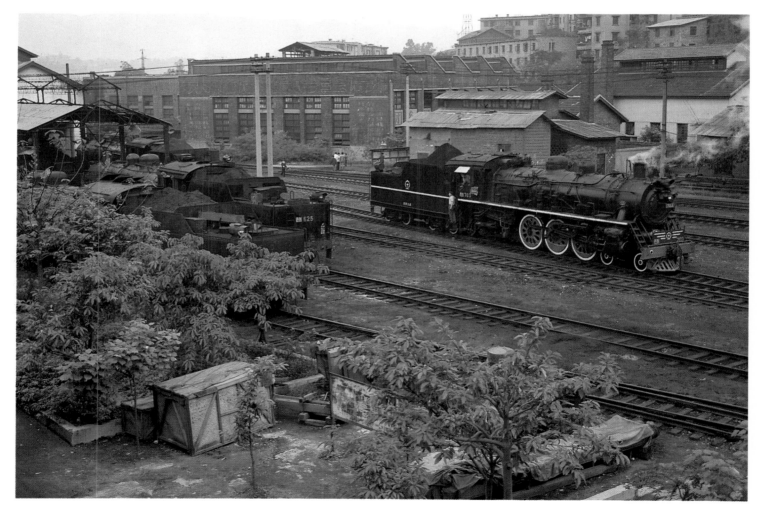

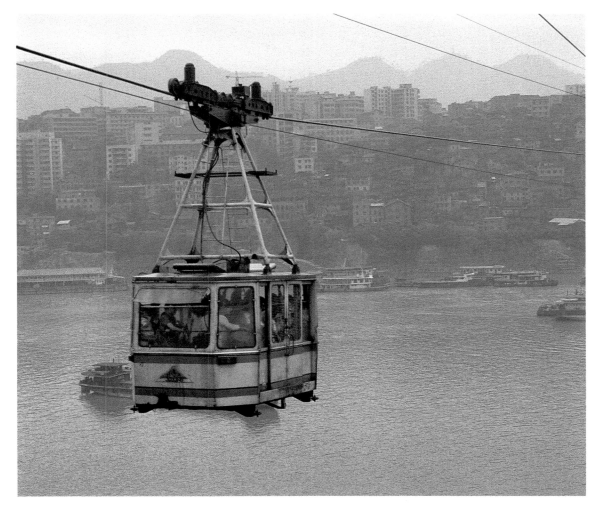

Chongqing steam locomotive depot award board. Each year 'model workers' are chosen by a special committee composed of management and shop floor staff and given suitable awards for industry, safety and production. These can be cash, consumer goods or holidays.

The old cable car at Chongqing, packed with passengers. A new car came into operation in 1987 – the old one was becoming frighteningly rusty and decrepit.

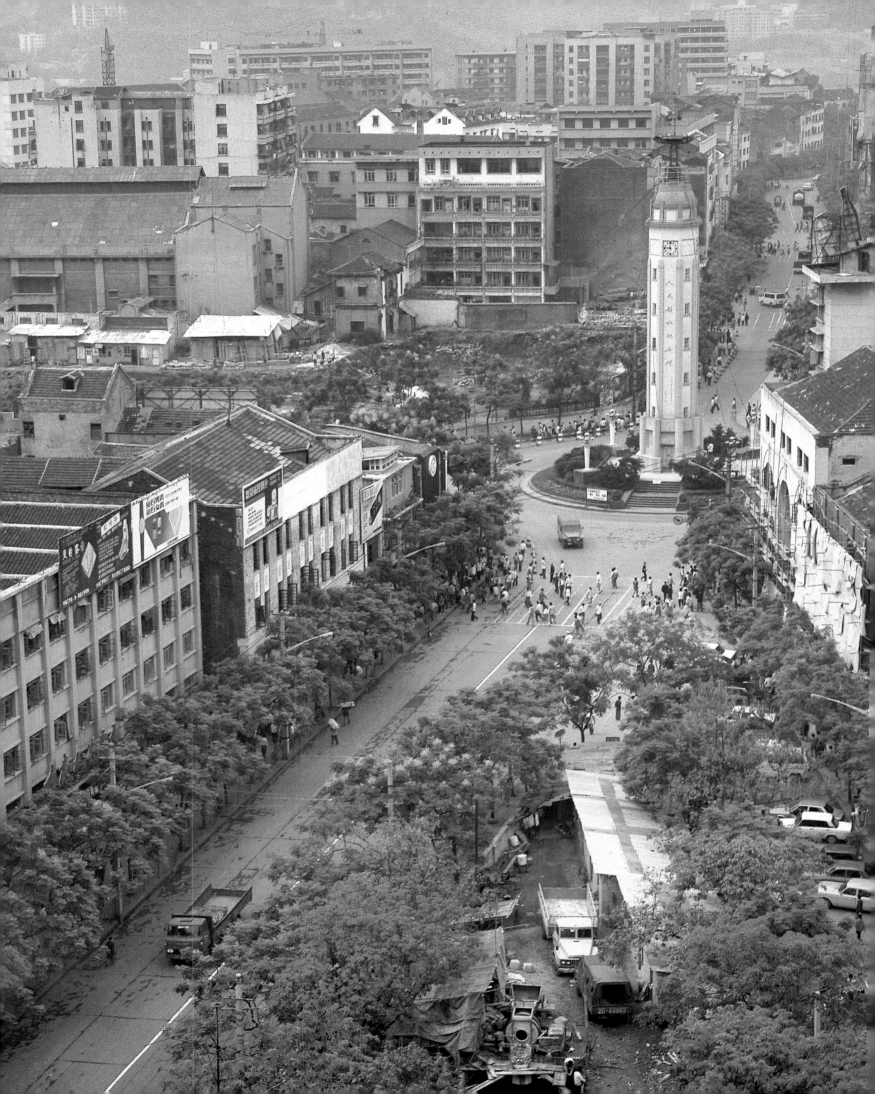

Opposite: *The green, wide concrete streets of Chongqing.*

In the backstreets dozens of small markets perch on the pavement or on the steps between the rows of tiny stone houses which rise out of the slopes. Goods for sale include fruit and vegetables, live eels and river fish gasping in shallow bowls of murky water and wicker cages stuffed with chickens, ducks or piglets, legs tightly tied so they can be carried home on people's backs or, in the case of birds, held in one hand by the base of the wings. Great wobbling slabs of beancurd, or tofu, are weighed cautiously on hand-scales, and the price calculated ferociously by abacus and argument. If the buyer disagrees with a decision he can walk to the public weighing-scales and test his purchase before returning for another raucous shouting match until an acceptable deal is struck. The tourist who is part of a small group is readily absorbed into this brightly coloured world and can roam freely, looking at the merchandise and haggling good humouredly as crowds gather round to see and hear the negotiations. A foreigner will always be asked for a price which seems vastly inflated by Chinese standards, but is still ridiculously cheap to the Westerner, so both sides can come away feeling pleased with the bargain.

There are two locomotive depots in Chongqing. One is used wholly for steam and is where the SL Pacifics and the ubiquitous QJs are maintained and serviced. The older Japanese-built JFs can still be seen there, although these are being withdrawn wherever possible. Local steam is scheduled to be phased out altogether in the next few years, when the south-west of China will become diesel and electric only. The other depot is a new one, serving the electrified lines out of Chongqing, but it also acts as a turnaround point for QJs, and will do so until steam is extinct here. Outside the building is an old Chinese-built SL which is used as a stationary boiler for heating the depot. When the steam is replaced the city may become slightly less polluted and dirty, although the river traffic is the main contributor to the heavy atmosphere. On the waterfront a succession of ferries carries traders up and down the river to buy and sell, as well as a few tourists. The farmers take their wares off the boat – usually walking across a rickety plank – and wash them in the filthy waters of the Yangtze to get rid of the surface grime. Chongqing makes little allowance for tourism, with its new and ugly buildings and unpleasantly humid climate, but a visit here gives the traveller a chance to see a typical industrial city where tourism has made little impression.

Street-corner vendors, pushed almost into the road by the crush of people on the pavement. They are selling vegetables and fruit, including knobbly brown lychees.

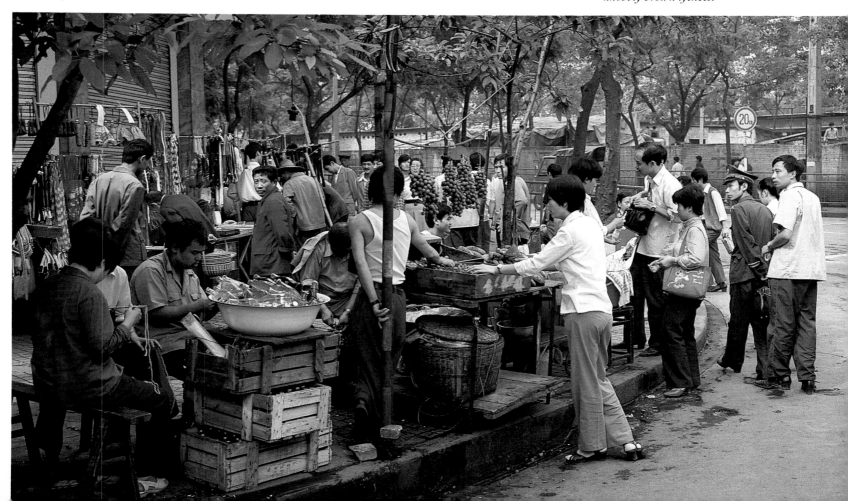

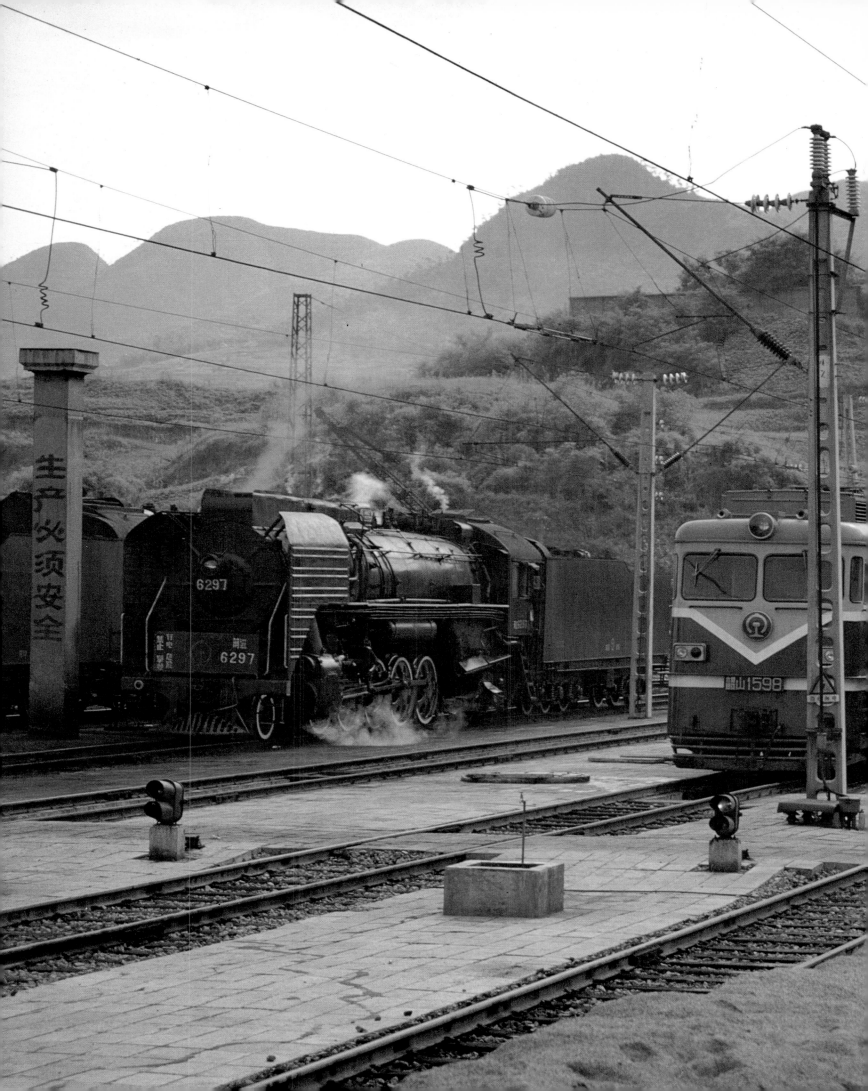

CHONGQING
CHENGDU
LANZHOU

IN CHINESE TERMS the train journey from Chongqing to Chengdu is brief – about ten hours across a landscape which, while still beautiful and rugged, is much less spectacular than the route to Chongqing. The steep hills and panoramic views are still there, but the mountains are not quite so colourful or dramatic, and the settlements are identical to those further south. Tributaries of the Yangtze cross and re-cross the valleys between the triangular peaks, and the train stops regularly at stations in small market towns where the traders wait patiently for transport to the next town, and fresh fields for their goods. Sometimes a young mother will suckle her child openly on the platform, and men will throw dice or play cards to pass the time, their wares – bamboo pipes, cabbages or fruit – piled in wicker baskets beside them.

The line to Chengdu is solidly electric and most travellers prefer to take the route overnight, as is reflected in the times of the trains, so less working time is wasted. After the hills of Chongqing, Chengdu seems full of bicycles, and the early-morning rush hour is a mass of wheels, accompanied by the sound of shouting and the screech of brakes. There are few road regulations in China, although most cities now have bicycle lanes, which simply make the sudden chaos a junctions even worse.

As is usual in China, Chengdu has its own descriptive title: the Brocade City. It is the centre of the Sichuan silk-manufacturing industry, and keen-eyed travellers can spot mulberry trees on the route into the city – the sure indication of a silk farm. The silk produced here is made up into garments in places like Shanghai, and Chengdu's role nowadays is generally not well known. The city was never located on the Silk Road but nonetheless its place in history was earned through the silk which travelled westwards as far as Imperial Rome, more than two thousand years ago. The resulting riches led to the creation of gold and silver work and lacquerware in the region, and in the eleventh and twelfth centuries, Chengdu was also renowned for its printing of books and the first Chinese paper money. Unhappily, many remnants of the past were destroyed in the Mongol invasion of the late thirteenth century, and in war and revolution since, and Chengdu is now better known as an industrial centre and as the capital of panda country.

North-west of the city is Woolong Panda Sanctuary, where international surveys are being carried out into the animal's habitat and lifestyle, and desperate attempts are being made to train captive pandas to eat a different diet before they are sent to zoos or released back into the wild. Over the last few years the failure of the bamboo crop has removed much of the pandas' sole food and it is only in captivity that the animals can be taught to eat other things. Bamboo is possibly one of the least nutritious foods in nature and the panda in the wild will spend twelve hours a day hunting for enough food just to survive. Breeding is now going on at Woolong, but the sanctuary is not generally open to visitors. The pandas which can be seen in Chengdu Zoo are housed in concrete dens which look drab, despite their blue climbing frames. The entire zoo seems a rather dismal place at first sight, but the pandas housed there are also breeding which, with such a notoriously difficult species, is a reassuring sign.

Chengdu is a city of great enterprise filled with markets and street stalls, including those of the candymen, who spin fabulous animals and birds from caramel on a marble slab, and attach them

Previous pages: The new electric and steam depot at Chongqing, with a pair of SS₁ Co-Co electric locomotives, and Q J 2–10–2 No. 6297 outside. This is a brand-new shed with extremely modern facilities, including a laboratory for testing locomotive water supplies for impurities.

to sticks to put on display. Each one has to be won, not bought, by gambling on a hand-painted roulette wheel which shows pictures of the animals that the caramel silhouettes represent. It is an old tradition which vanished during the Cultural Revolution, when any kind of betting, even something as innocent as this, was strictly forbidden. The city's parks are laid out around museums or temples, and are lush and green and scattered with lotus pools. The museums display objects of cultural and religious importance, including calligraphy and brass rubbings. There are temples too, including the Monastery of Precious Light whose dim chapels are filled with huge figures of Buddha which are surrounded by lighted joss-sticks and offerings of food, money and cigarettes. It is a teaching temple, where novices are trained, and monks wander silently through the courtyards in their plain brown habits refusing, with an unassailable courtesy, to be photographed. It is difficult to imagine the glory of the old temples before they were pillaged in the Cultural Revolution, as they are now mere shells of their former selves. Throughout the vastness of China, the temples remain virtually identical, with the same figures portrayed in the same ways thousands of times, the same brightly coloured prayer mats, and the scarves draped across the icons as gifts from the faithful. Now that people can worship openly it is not just the old, who remember the days when religion was fully accepted, who do so. Young people who are searching for spiritual as well as political answers also throng China's temples to meditate and pray.

Chengdu station is a monument to commerce, boasting an indoor shopping precinct on two levels which fills the broad, open space characteristic of nearly all China's main station buildings. Many are hard to tell apart, with their vast wooden- or green-seated hard-class waiting-rooms, the smaller, white-seated, carpeted soft-class waiting-rooms, the uniformly grey and cream walls, and the white-tiled underpasses leading to each platform. The Chengdu–Lanzhou route does not always carry soft-class accommodation, and the next stage of the route may not offer any choice but hard-class.

There is little privacy in hard-class lying, and nothing to separate the six bunks in each compartment from the corridor. If there is a choice most Chinese travellers book the middle bunk, as it is a steep climb to the top one and the lower one is everybody's daytime seat. Foreigners who have piled their luggage on a spare bunk may face a severe argument with the

The Chengdu candymen are a popular sight around the city's parks. Their caramel creations are both intricate and delicious.

Opposite: *Lighting joss-sticks at a temple in Chengdu. Nowadays it is not only the older people who worship at the ancient shrines.*

Red pandas are more common than the better-known black-and-white variety, because their diet is more varied. They are mostly arboreal and are similar in appearance to racoons.

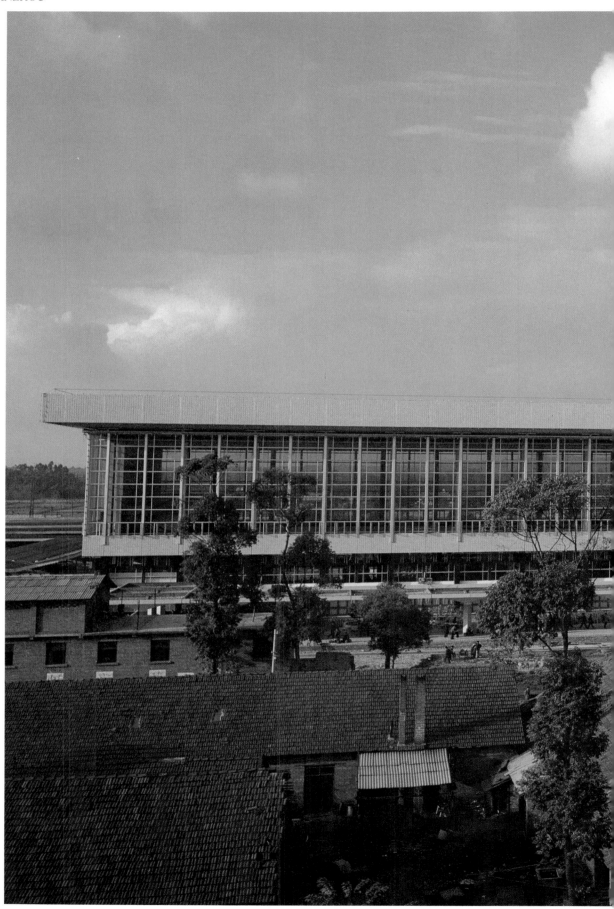

The modern façade of
Chengdu Station.

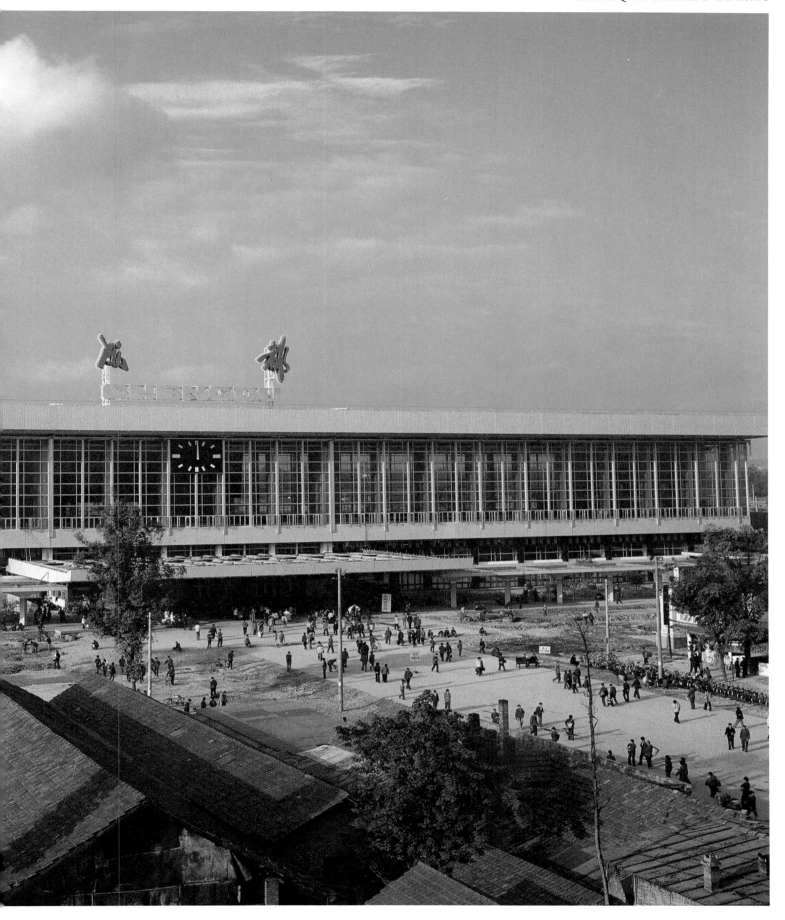

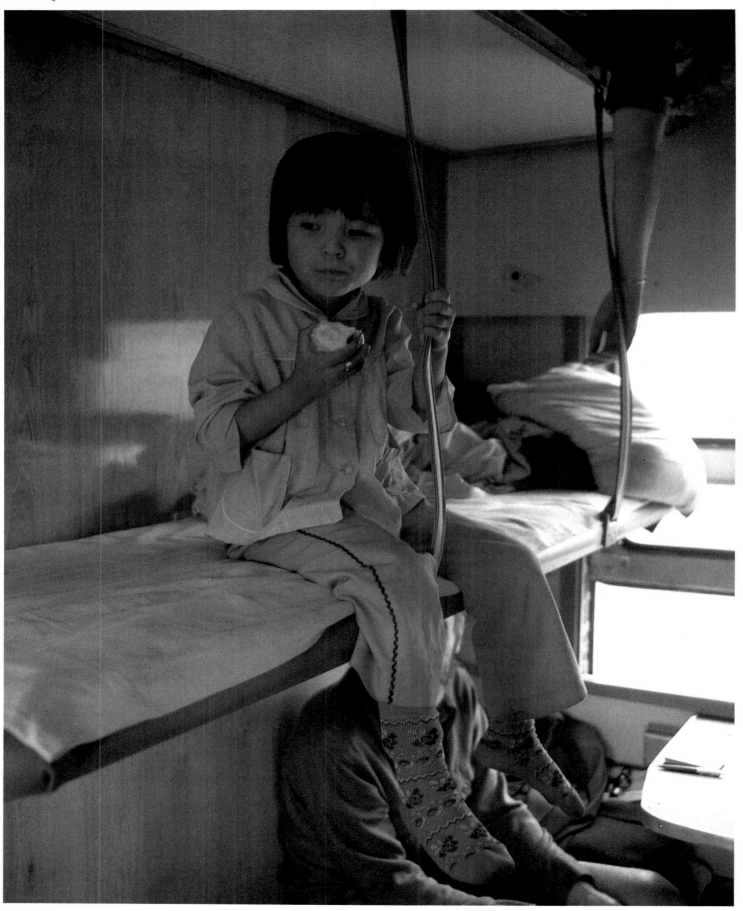

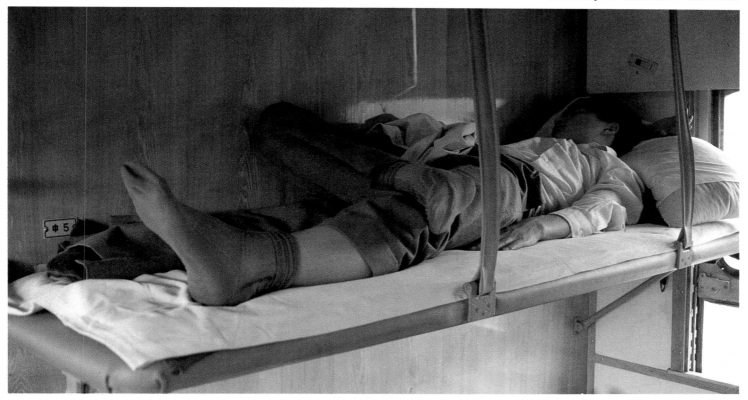

carriage Blossom, who will insist on payment at the full foreigners' rate for the extra space used. There is a tiny table by the window of the compartment, and a thermos of hot water, but no mugs and no lamp. The only light is in the corridor, and this is switched off at the same time as the music of the public address system – at about 10 p.m. The Chinese are not always delighted to be placed next to a 'Foreign Devil', as Westerners are still sometimes called, and will often demand to be moved. They are unlikely to be lucky; even if there appear to be any spare bunks, they will have been booked by passengers getting on at a later station.

Some hard-class carriages have a washroom, but many more have only a basin in the corridor, and the number of people in the carriage ensures that no one would be permitted to lock themselves into a washroom to the exclusion of others. Conditions can quickly become squalid with up to sixty people sharing two lavatories and a couple of basins, especially as little disinfectant seems to be used in the Blossoms' regular but slapdash mopping sessions. 'Lights out' is also seen as an inconvenience by foreigners but no one stays up being noisy, so it does make it possible to sleep. The atmosphere is very like that of a school dormitory, and the bunks are surprisingly comfortable. There are only two straps to ensure the sleeper on the top bunk does not fall out, so one can feel precariously placed, but barring accidents and despite the train's jerky progress it is relatively safe. Hard-class has no duvets, only thin towels for a covering, but the proximity of so many bodies is generally enough to keep everyone warm until the blaring of the radio operator starts up again at 6 a.m. The lack of privacy is usually enough to stop most Westerners from undressing for bed, and those who do risk seriously offending their fellow passengers, especially if a woman shows too much leg or shoulder after changing into a nightdress. However attitudes are slowly altering and nowadays Chinese women will approach any Western one who is using make-up and ask to see, discuss, and even to try her cosmetics.

Travelling hard-class is one of the best ways to meet Chinese people. The journey from Chengdu to Lanzhou takes about twenty-two hours and most Western passengers will find that time passes swiftly once the Chinese have plucked up the courage to try out their English. It will be assumed that anyone travelling hard-class is approachable, unlike those in soft-class, and

Chinese passengers spend much of their time dozing. This is as much as most travellers will take off in hard-class, even at bedtime.

Opposite: *Apples are staple diet on the train.*

101

Opposite: *Hard-class lying. Daytime window seats are at a premium and people allotted the lower bunk get no peace or privacy. The Chinese are gregarious people and will offer to share their food or play cards with fellow travellers.*

news of a Westerner will spread quickly along the carriage grapevine. Generally only the younger people will have enough language and interest to strike up a conversation, and their attitudes often come as a revelation to the visitor. The young Chinese are far more class-conscious than they appear. The country has its own system of Cadres, or party leaders, and the peasant classes tend to be looked down upon by city dwellers, but the strength of feeling between groups is marked. Students and officials moan about the noise and the disgusting manners of the farmers, saying that they should be relegated to hard-class sitting – if they are to be allowed the luxury of travel at all. The students know that their main chance of advancement within the system rests on the acquisition of as much knowledge as possible. They are fluent in at least one other language because their text books are often in English or German, instead of Chinese. Many are happy to talk about their home lives and families although they usually steer clear of political discussion, but, once a friendship has been established, they tend to ask very personal questions in return. Affection in public is still not popular in China, and what the young Chinese see and hear about Western attitudes, youth and culture fascinates them. Standards are so different that a married Western woman can be asked if she has had an abortion – they are very common and universally accepted in China – but the listener will be amazed to hear of the freedom in the West to have had more than one partner. Clothes and jewellery may also come under close scrutiny, and a smartly dressed Western woman is an object of great fascination to her Chinese equivalent. Chinese clothes have updated themselves considerably over the last five or six years, but a woman wearing short skirts or shorts or anything more than the most basic make-up is still censured. The children are the most colourful sight, as the one-child rule means that parents lavish all their love and spare money on their one offspring. This has led to a whole generation of much-indulged children who are fully aware that they are the apple of their parents' eye. Westerners often frighten very young Chinese children – they look and sound wrong and are much too big. However, once their tears of horror and surprise have dried, a day in hard-class with a couple of Chinese children will nearly always turn out to be a total delight.

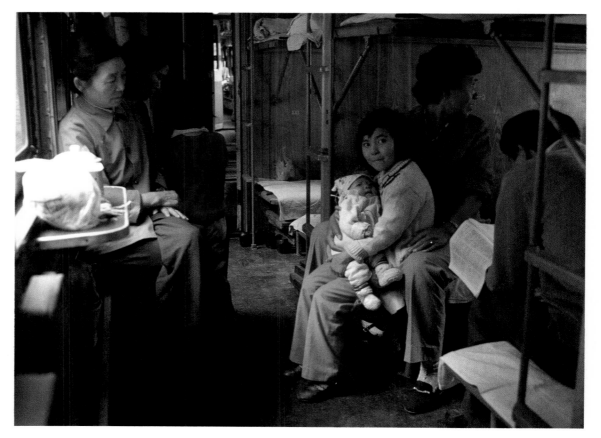

This family are Chino-Russian from Manchuria. They are unusual in having more than one child, and the parents have probably been penalized by the State by withdrawal of benefits or lack of deserved promotion.

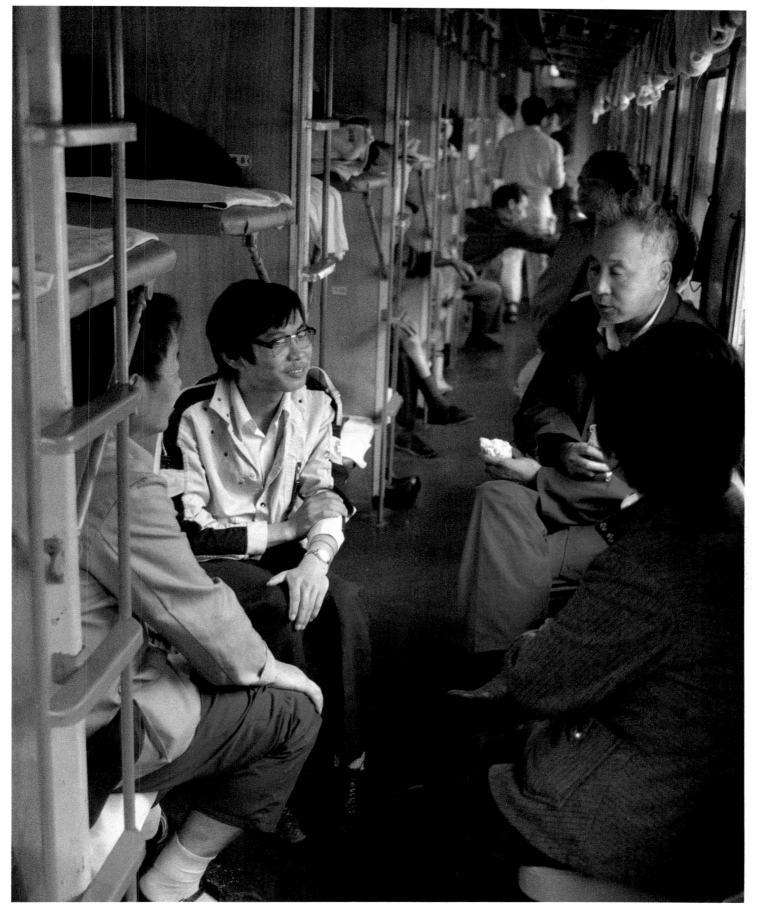

Behind the scenes in Lanzhou ticket office. The abacus is still in regular use throughout China and the ticket rack and date and station stamps may be seen in the picture. There are eager faces at the window – tickets are not always easy to come by.

Most hard-class lying passengers bring their own food for the journey, and additions are bought from hawkers, who reach up to the carriage windows with their wares at every halt. Kebabs, fruit, biscuits and cakes are the most common offerings, and the carriage takes on the aspect of a wastepaper bin within minutes of the train's starting up again. The Blossoms wage a constant but hopeless battle against discarded paper and rubbish, striving to keep everything tidy inside and out. At each station there are cleaners to pick up whatever is thrown from the windows, and the coaches themselves are lovingly scrubbed with a broom and water throughout the summer months. Oddly enough, no one ever seems to clean the windows, but the paintwork is kept spotless.

Watching the scenery from hard-class lying is not very easy. Only those who have annexed window seats on the bunk or the tip-down seats in the open corridor have any chance of a good view and the corridor seats are uncomfortable, as people regularly push past and the spit and debris which gather on the floor, despite the radio operator's regularly repeated instructions, are unpleasant. However, lucky observers can watch the countryside outside changing slowly from lush, fertile lands with green and lovely hillsides to barren mountains with cliffs, ravines and dried-up river beds. The transformation is most apparent in the autumn when the spring and summer waters run underground and the arid land seems to gasp for nourishment. The only crops are those which can be regularly irrigated using artesian wells, and there are huge tracts of bare, beige earth – the first sign that the great Gobi Desert is not far away. This is Gansu Province, the beginning of the ancient Silk Road, and the home of China's Muslim peoples, whose religion originally came eastward with the traders. Most settlements in this area follow the route of the Yellow River but many of the inhabitants are itinerant herdsmen who roam with their animals wherever they can find water. The train arrives in Lanzhou while it is still dark, but one can hear the hissing, clanking steam engines in the station, preparing for the long journey into the mountains of the far west.

Opposite: Waiting for his connecting train; an afternoon scene at Lanzhou station. In the background is a painting of the westernmost fort of the Great Wall at Jiayuguan.

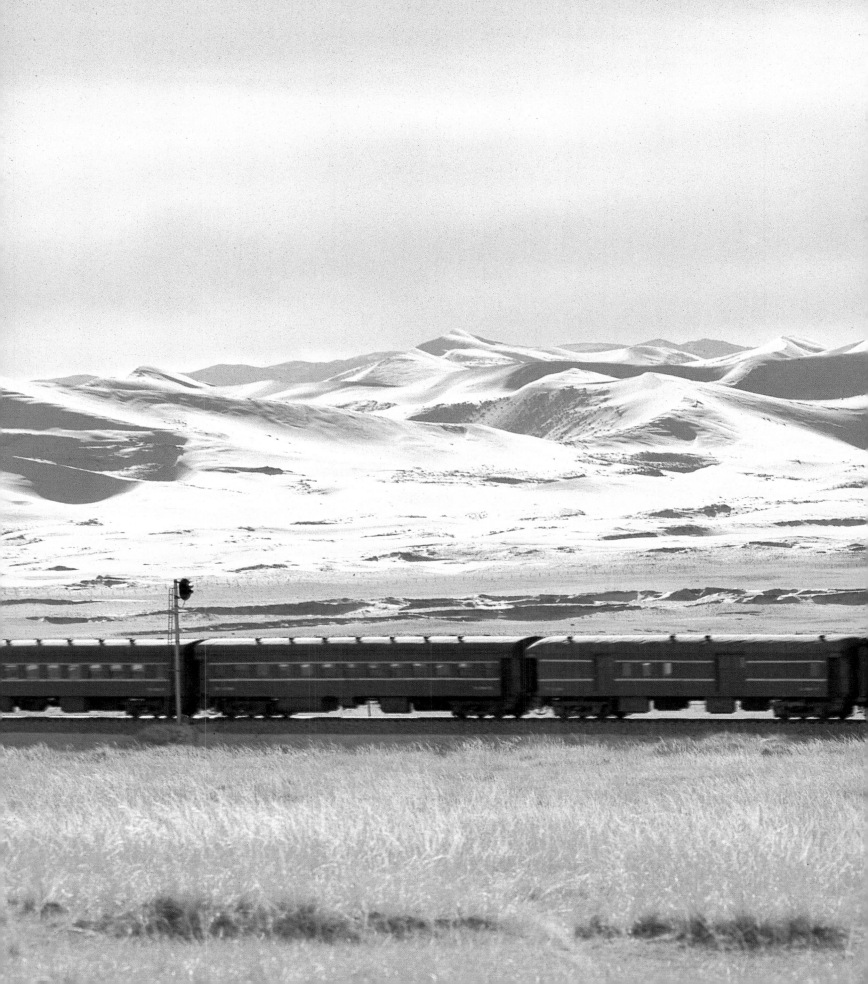

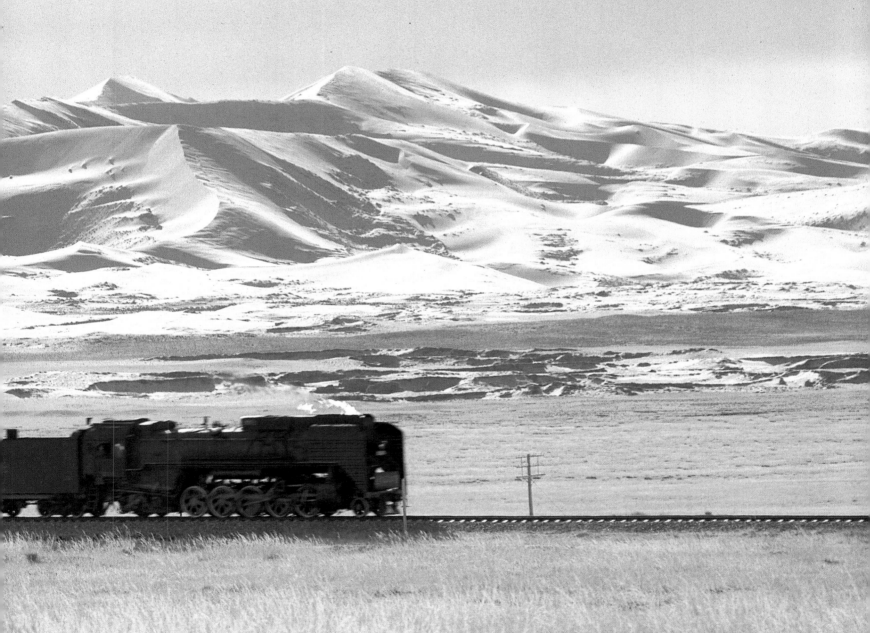

LANZHOU AND POINTS WEST

LANZHOU SPRAWLS, UNKEMPT and grimy, along the southern bank of the Yellow River as it turns from its eastern path to run north into Inner Mongolia. The capital of Gansu Province lies in a pall of dusty smog from the petro-chemical factories in the western suburbs, and even on the clearest day there is a taint of pollution in the air. It is sometimes claimed that without the swift-flowing river and the channel of wind which races through the valley pass across Lanzhou, the city would be too poisonous to live in. The Silk Road was the main reason for Lanzhou's development, although it was always a transportation centre from the first days of trade. The silk would be brought from the fertile lands of Middle China into the narrow, barren province of Gansu, to be divided into caravans bound for Lhasa, Siberia, Europe or India, while other goods from the west would be dispatched to Beijing, Shanghai or the south. Not all the goods were silk; gold, lacquer and exotic spices found their way to the rest of the world, and in return China received a strange legacy of religion from the traders who passed through or settled on the route. Islam and Buddhism came to the Far East in this way, although only the latter spread throughout the country. Gansu was the accepted borderland of ancient China and this is where the Great Wall ends, but different dynasties extended and contracted the boundaries over two thousand years and Lanzhou was the last reliable trade centre before the 17,000 ft (5,200 m) Qilian Mountains and the Gobi Desert claimed the land.

The Yellow River transported coal, oil and iron ore from Lanzhou before the coming of the railways, but the city's importance doubled with the Communist takeover and the building of the first lines across the desert lands. By the early 1960s the railway at Lanzhou branched off, reaching to Urumqi in Xinjiang Province, more than two days travel away, and to Xining in the western state of Qinghai. The plan was to extend both railways – the first into Russia and the second across to Tibet. By 1984 the Xining line reached as far as Golmud – another day's travel – but it has since stopped there, and currently the only way further is by road or plane. Urumqi, too, is a virtual dead end, although there are still plans to extend the railway to the Russian border at some time in the future. However this desolate area is so rich in minerals, oil, iron and even gold that the city is thriving, with a military airport to take care of any matters needing faster service than the train.

More than two million people now live in Lanzhou and although it is not generally accepted as a tourist city, its mosques, parks and markets make it interesting and a little unusual to visit. The river's role as the bringer of life and trade to the area is acknowledged by two vast sandstone statues. The first, on the forecourt of the city's bulky and impressive station, is a representation of horses and waves, and the other, 'The Mother of the River', set in its own small park on the riverbank itself, shows a mother and child. Just across the water is Baita Shan, the White Pagoda Park, which leans into a steep upland with a series of eighteenth-century Qing Dynasty pavilions where local artists display their pictures and calligraphy. At the top, on the highest vantage point, rests a much older Yuan Dynasty building which has been restored and consequently looks very much like the others. The view should be magnificent, but even on the brightest day the air is tinged with a yellow-grey haze. Two traditional mosques with minarets give the north bank a

Previous pages: The desert is never more than a few hundred metres from the railway line all the way from Datong via Lanzhou to Urumqi, a journey of about three days.

distinctive style, and the city's free markets have a huge range of exotic foods. Chipped enamel bowls are filled to the brim with baby sea-cucumbers, silk-worm chrysalises, hundred-year-old eggs – really only a few months old, but already changed to black and green inside – and dried frogs, tiny, quicksilver river fish, still flapping in the mud of the street, and cooked, glazed rat. Cooked meats are on display in the bright blue booths, but most of the goods are laid out on wooden trestles or on the ground. Behind the makeshift shops are the noodle restaurants where young men and women, in grey-white outfits liberally covered with ash and blood, prepare simple meals for the public, spinning and swinging the fresh pasta into long, thin noodles and flinging them accurately into vats of boiling water. Whole animal carcases hang outside, ready to be chopped and stir-fried or steamed in the multi-layered bamboo steamers which are piled haphazardly on top of a coal brazier, some already filled with chickens' feet wrapped in beancurd pancakes, or whole chickens' heads, considered an even greater delicacy. Sometimes, hidden between these little cafés, is a tiny art shop filled with exquisite paintings and calligraphy, mostly the work of retired people hoping to earn a little extra money. One of their friends will be deputed to do the selling for them, but unless a foreigner arrives business is generally slow. Most traditional Chinese art uses few colours, preferring basic black and white with the occasional vivid splash of scarlet or crimson in a single flower or a spray of berries. Some pictures show landscapes – mostly in the style of Guilin – in grey and faded green, with colourless rivers and black slashes for boats or rocks, visually dramatic and often stunningly lovely. Bamboo is also a popular subject, and many paintings will feature a tiny, bright insect or a baby bird, smudged with the fingers to give a lifelike impression.

Lanzhou station, too, is surrounded by free-trade markets. There are tea stalls where rows of thermos flasks are replenished by boiling water from iron kettles on an open fire, and cooked-meat cafés, with their heavy, spiced-meat smell wafting past on the wind from the nearby river, where customers sit at broad, wooden tables, spitting what they cannot eat on to the pavement beside them. The station itself is a huge complex of square, flat-topped buildings, paved courtyards and underpasses with steps up to each platform. Several small soft-class waiting-rooms are used for foreigners and VIPs, decorated with a series of three-dimensional wax pictures showing ancient legends, but the hard-class waiting-room is a vast, dim cathedral, full of green seats covered with bundles and packets tied with string, and people dozing upright, or stretched out along the seat if there is room.

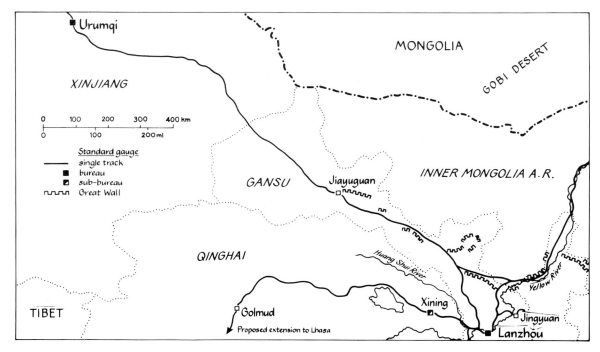

Opposite: *The driver of Q J 1359 looks down from his cab at his bicycle, a prized possession. Late that morning No. 1359 went off shed with the bicycle carefully strapped to the boiler handrail.*

Steam under the wires. A dramatic picture of the railway scene at Lanzhou emphasizing elemental power. The wires carry a lethal electrical pressure of 25,000 volts while the steam engine runs at a pressure of 200 pounds per square inch, although in China this is recorded metrically. The red signal light glows in warning.

Because of its vital position as a junction, Lanzhou is of considerable importance to the railway system. Its Railway Bureau has offices as far west as Xining and as far north as Jiayuguan respectively. The locomotive depot houses the great Q Js which now work the passenger trains over three routes – to Xining, Jiayuguan, and east to Zhongwei, on the line to Beijing via Datong. Southwards, to Baoji, the powerful SS electric engines are in use. There is also a large steam-locomotive factory, capable of the heaviest repairs.

There are up to six services per day in each direction to and from Xining, but trains to Golmud are much less frequent. Although the town is allegedly open, people are actively discouraged from taking this route because of the labour camps and military bases surrounding it. Xining is only five hours or so from Lanzhou, and it is worth visiting for a sight of the local people. It is the capital of Qinghai Province which is geographically an extension of Tibet, and the people of the area dress and look just the same as those in the Himalayas to the south-west. Trains to Xining are hauled by one of fifteen Q Js still based at Xining locomotive depot, although all freight to and from Lanzhou is powered by diesel, and steam is due to be phased out here by 1990. All trains to Xining are hard-class sitting with only one soft-class carriage, but this route is a rarity in that it is usually better to travel hard-class than soft. The trains are seldom full, and the one compartment which is bound to be packed, smoke-filled and noisy is the soft-class section. Travellers can find peace and the room to stretch their legs on the harder seats, and the lack of net curtains at the windows makes it easy to watch the scenery. The train follows the

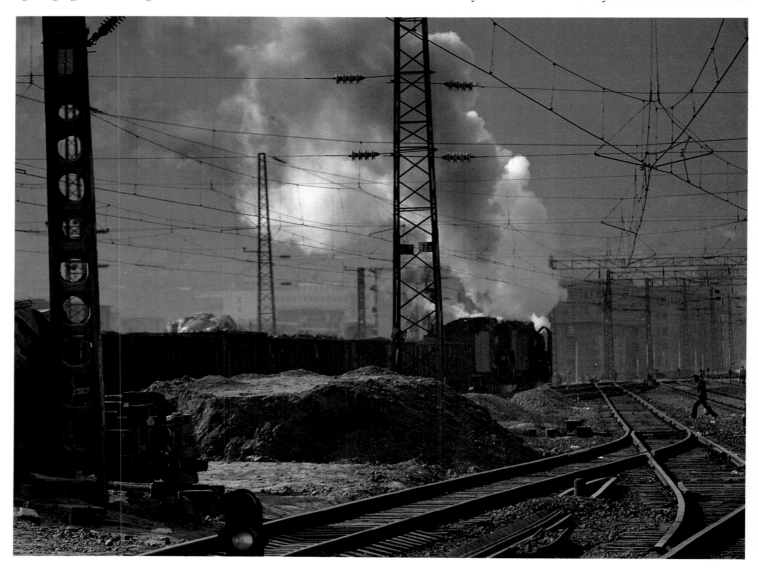

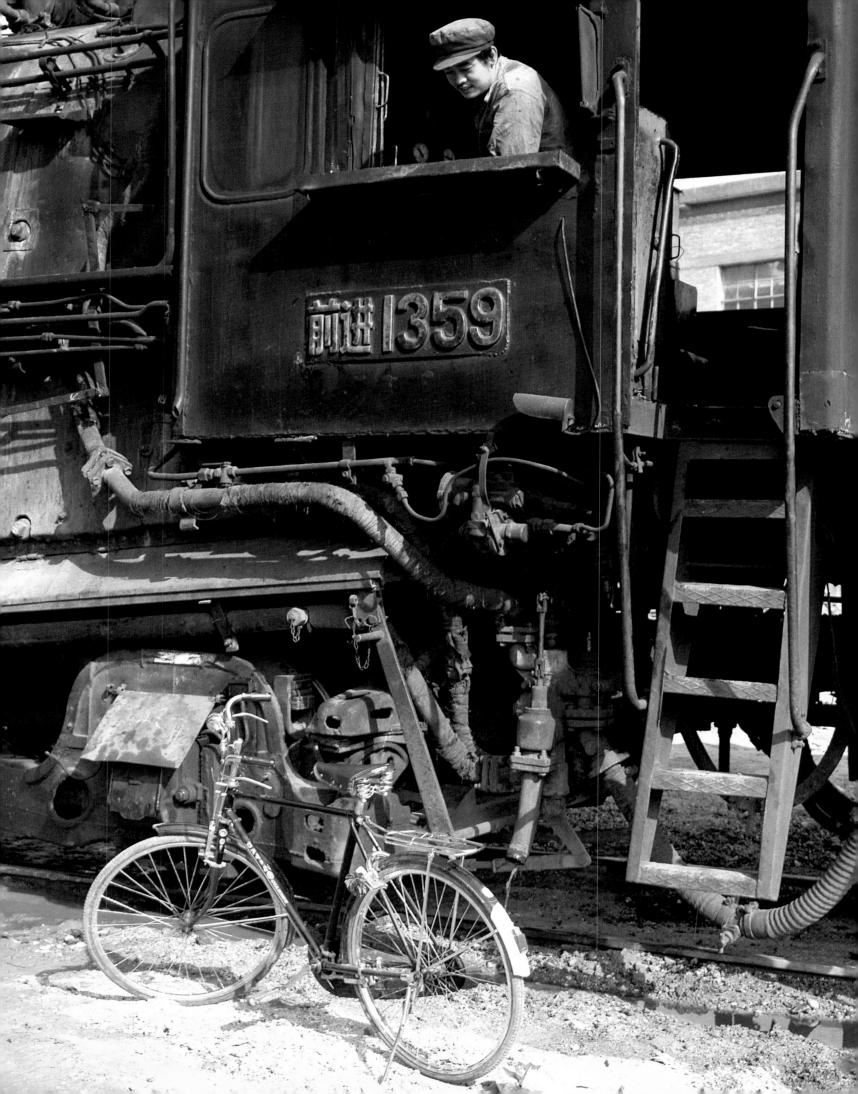

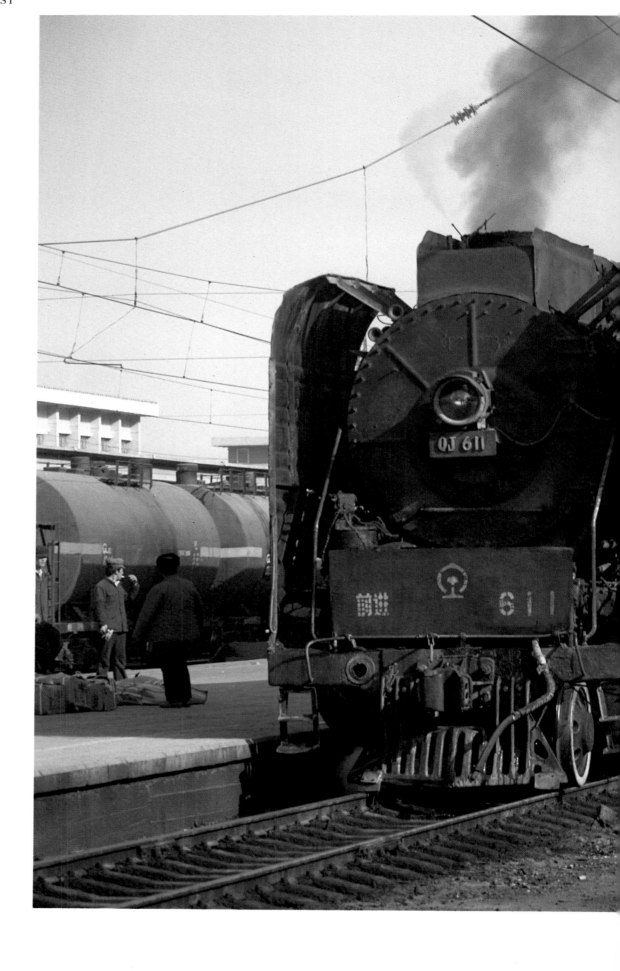

Train No. 91, the 1518 to Xining waits at Lanzhou behind QJ 611 in November 1987. There are fourteen coaches in all and only one composite hard–soft vehicle offers anything but basic accommodation. Steam works all the passenger trains to Xining, with diesels taking over for the twenty-hour journey on to Golmud.

112

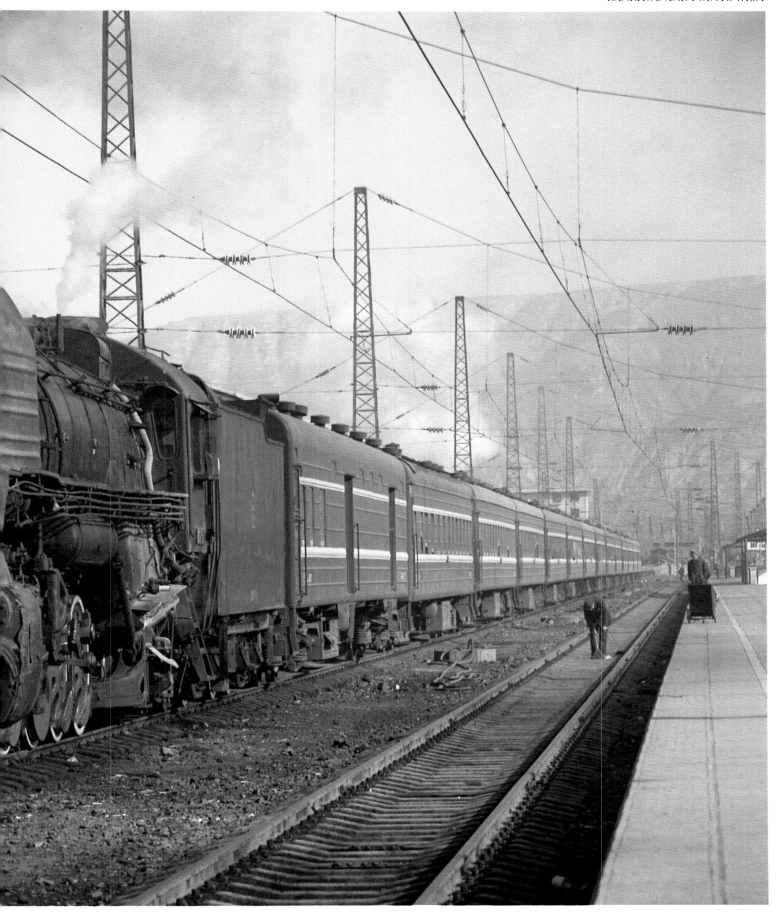

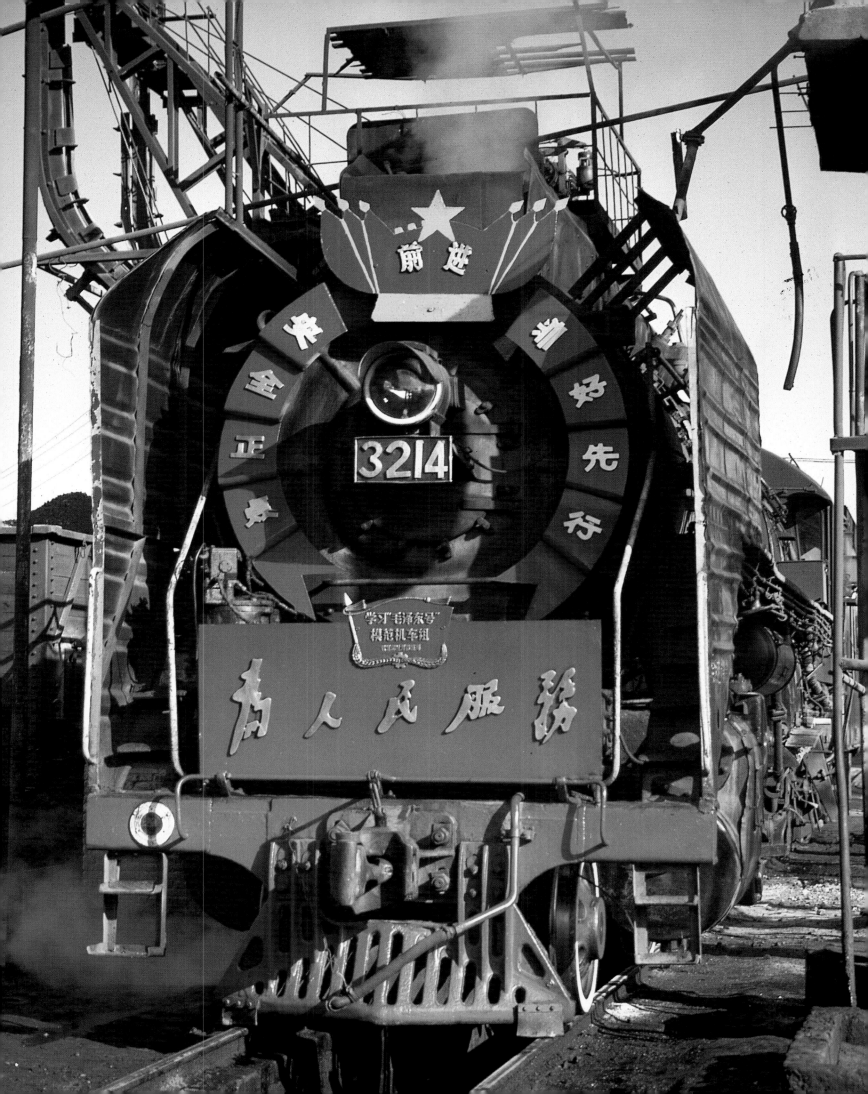

Huang Shui River valley all the way, running between ridges of peanut-butter coloured mountains, veined with slate-blue rock. The alluvial plain is very fertile, used mostly to grow cabbages which are dried and stored for the long, harsh winter. It is worked by peasants using horse or ox ploughs, and the only automation is a kind of lawnmower-engine on two wheels, which pulls trailers loaded with goods, spewing out choking fumes as it goes. Young birch and maple trees dot the edge of the arable land where it joins with the bare rock of the hillsides, and the tributaries which feed the river gush throughout the spring, fade to a dribble in summer, and vanish altogether by the autumn. The people live in clusters of houses, walled around by sandy brick which is laid dry and covered with mud which sets like clay. A single carved doorway leads into each group of houses and their stabling, and maize, cabbages and hay dry on the ground and the roofs of the cottages. Small herds of sheep and goats forage on tracks around the crops, tended by little boys or old men who cannot manage the harder labour of tilling the soil. The sandstone and mudstone hills twist and turn, the train crosses and re-crosses the river and the light flickers and changes, showing rainbow colours in the rock one second, and dull, brown stone the next. Now and then kilns can be seen, in which the local people process their basic bricks, and any excess is carted to the nearest settlement for sale in the market. Most of the people seen on the route are Han Chinese, but evidence of the Tibetan race can be seen here and there, even on the train. Boys are employed to stoke the fires at the end of each carriage, so that hot water can be distributed for tea. They look ten or eleven years old, with strange, flattened, wise little faces, but they may be anything from sixteen to twenty, short-statured and speaking a dialect that is almost Tibetan while still hundreds of miles from Tibet. Qinghai was

Opposite: *Prize locomotive. Lanzhou locomotive depot with QJ 2–10–2 No. 3214, specially decorated by its crews. Each QJ has three crews, each comprising three men: a driver, assistant driver and fireman. Where outstanding merit is shown in coal saving, time keeping or freedom from accidents 'model crews' can be designated. Their presence is usually indicated by a plaque, showing a red flag, attached to the cabside as well as other decorations and slogans. Those on No. 3214 read 'Serve the people', 'Safe and punctual' and 'In the lead'.*

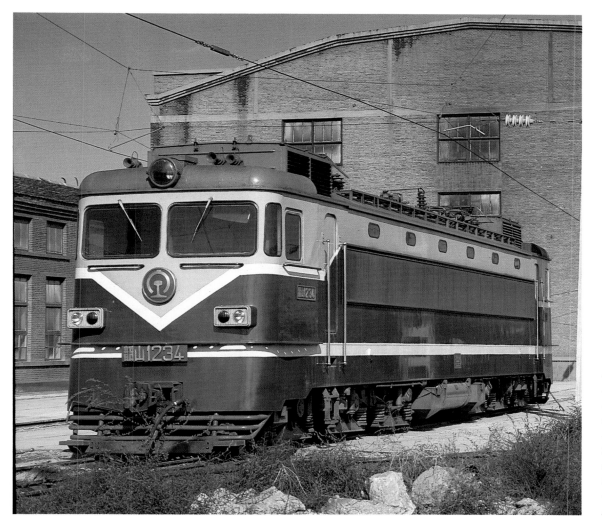

Modern motive power at Lanzhou. SS₁ Co-Co electric locomotive No. 1234 (the class is based on the Russian N60) waits outside the maintenance depot. These engines are used on trains south to Baoji and Chengdu – as well as east towards Xian.

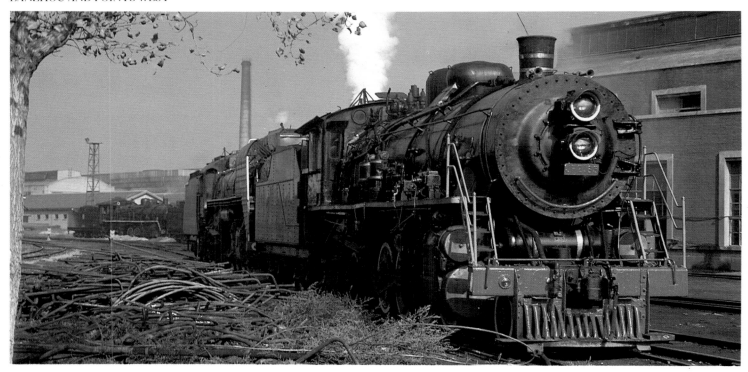

A QJ 2–10–2 on the western outskirts of Lanzhou.

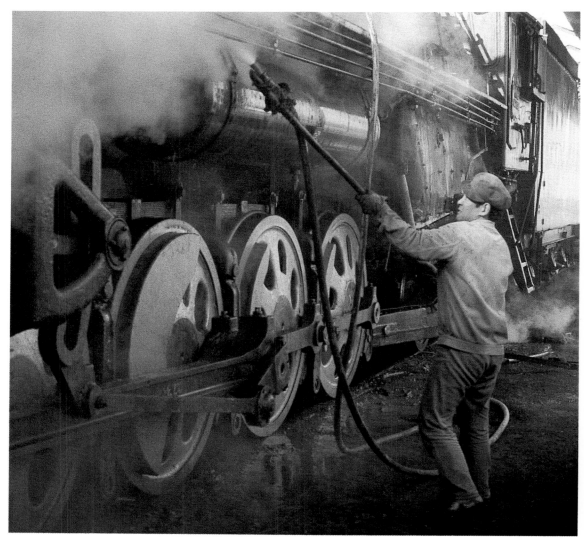

Steam-cleaning an overhauled QJ class 2–10–2 at Lanzhou locomotive repair factory, prior to repainting. Lanzhou is one of several heavy-repair works in China dealing with major overhauls which are decided on a mileage-run basis.

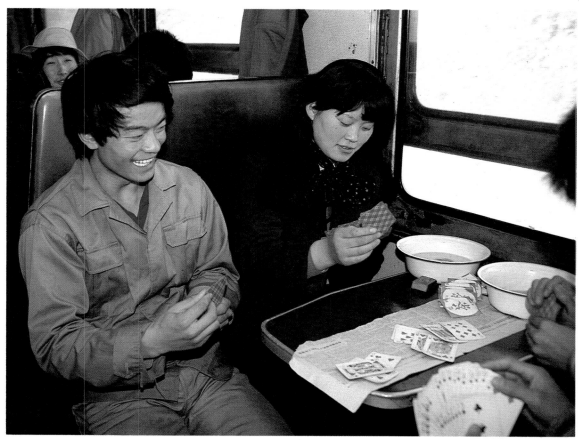

Playing cards is a popular pastime on the train.

The land grows increasingly barren to the north-west, with layered chalky strata in the hills and little cultivation even when water is present.

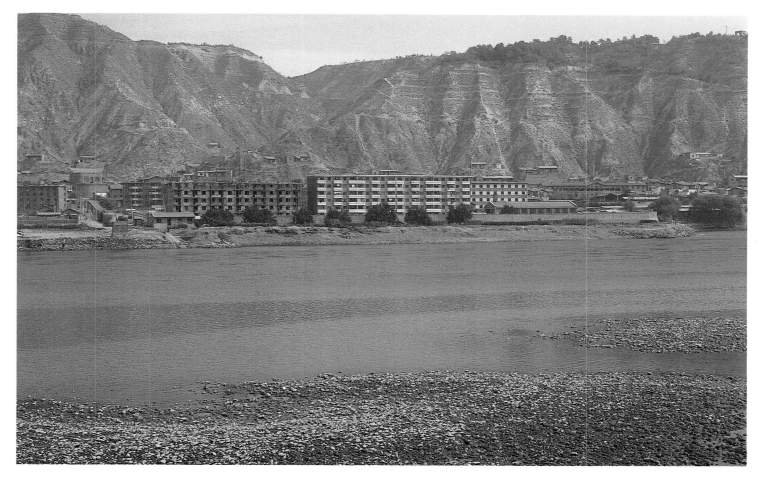

Xining station. Five thousand feet up in the mountains the trains begin their journey into the foothills leading to Tibet. An old JF 2–8–2 shunts in the winter sunshine.

118

Opposite: *Visitors to the exotic Ta'er Lamasery often buy colourful prayer scarves as an offering to the Buddha.*

once part of Tibet, but it is now completely under Chinese rule and generally viewed as the Siberia of the Orient. No Chinese would come here voluntarily unless it was on a rare tourist trip to see a Lama monastery. The area as far as Golmud was opened up in 1985, but instead of finding a fabulous citadel, modelled on those of Tibet, most people see Xining as another stereotypical, concrete Chinese city. The town is filled with Tibetan people, and can offer a visit to the Dong Guan, a spectacular and ornate teaching mosque. It was built in the fourteenth century, almost two hundred years before the Ta'er Lamasery, an hour's drive to the west, which is Xining's greatest treasure.

The monastery is set on a hillside by the village of Lusha'er, which is crowded with shops of trinkets for the visiting pilgrims to buy. Strange objects and materials vie with cheap metal rings and knives, and leopard, polecat and wildcat skins are on sale. At the top of the village street is a row of cafés where the devout can break their fast on rice and wheat noodles, after worshipping in the Lamasery's several shrines, or buy white wisps of material, sold as offerings to the god and his guardians. The Ta'er is the most revered lamasery outside Tibet, and although it is remote it is often thronged with pilgrims, come to prostrate themselves in front of the buddhas and icons which are housed in the compact and colourful buildings and courtyards. The Lamasery was built in honour of the founder of the reformist Yellow Hat sector of Tibetan Buddhism – the Yellow Hats crushed the ruling Red Hats in the sixteenth century and imposed a far more stringent form of Buddhism, with stricter rules and a stronger monastic discipline. The leader of the Yellow Hats took the name Dalai Lama, or 'Ocean of Wisdom', and the Ta'er Lamasery was built in his memory, in the region of his birth. Postcard-sellers crowd the gate of the religious

Tibetan people with their bright traditional costumes and elaborate fur hats gather round a stall at the Xining Ta'er Lamasery.

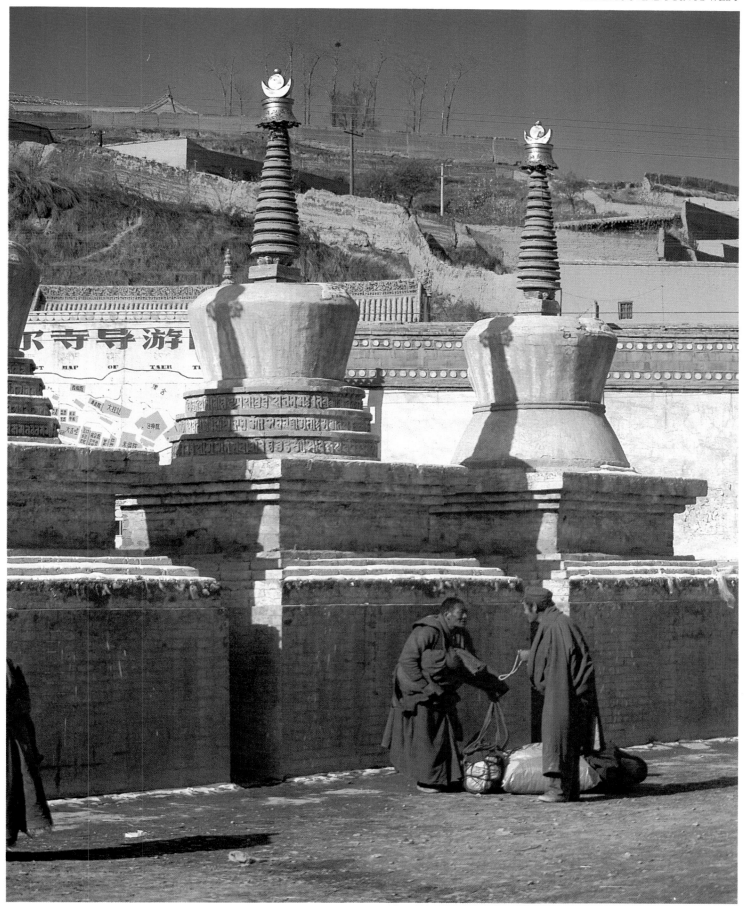

buildings, but their wares cannot prepare the visitor for the unpredictability and strangeness of the sights inside. Basically the Lamasery is constructed to a design similar to that of the Chinese temples and pagodas, but the buildings seem more solid and the carving is more basic, though with a wider range of each colour – light and dark green, turquoise and red – on the ornate doorway to each temple. Inside is a courtyard, usually roped off to left and right to give privacy to the monks, and a prayer wheel for the devout to spin while they pray for good fortune. Beyond this point each temple is different, some with trees inside the courtyard and simple icons draped in coloured scarves, some with more ornate buddhas coloured in gold. One temple is devoted to the glory of animals, with eerie mummified and stuffed oxen, goats and monkeys leering down from an upper gallery. The most famous hall is full of yak-butter sculptures depicting ancient legends, a sight which must be one of the most bizarre in China. Behind the prayer mats and the icons are half-hidden passages of carpeted pillars where the discreet are permitted to wander, viewing the cabinets containing a hundred gold-embroidered silk parcels of holy books, and ornate, multi-coloured tapestries and paintings.

A QJ 2–10–2 takes a long passenger train over the Gulang River bridge, against a backdrop of snow-sprinkled mountains. It is November on the Lanzhou–Urumqi line and the countryside is beginning to look bleak.

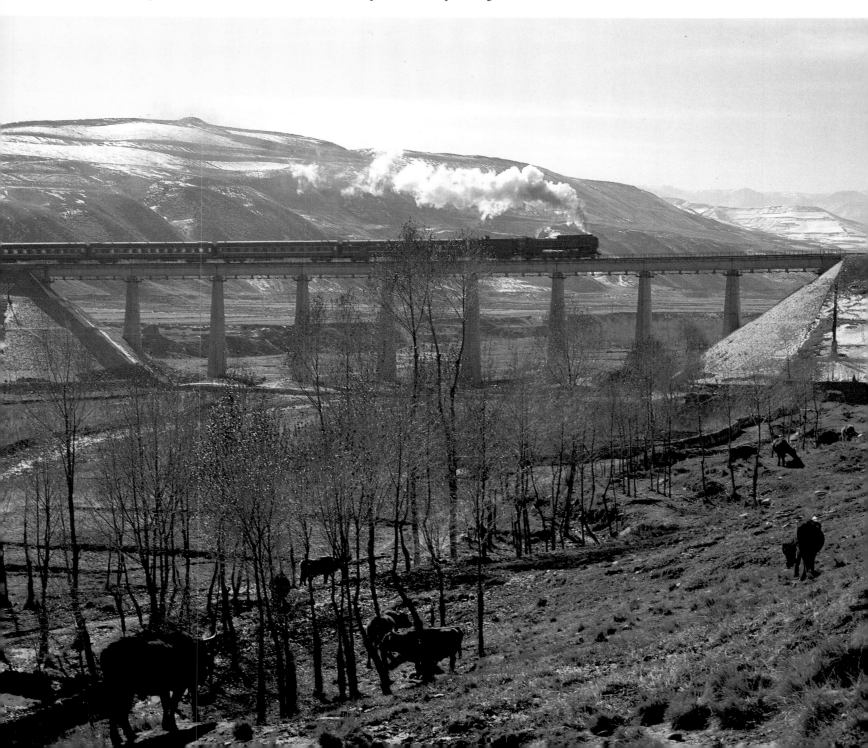

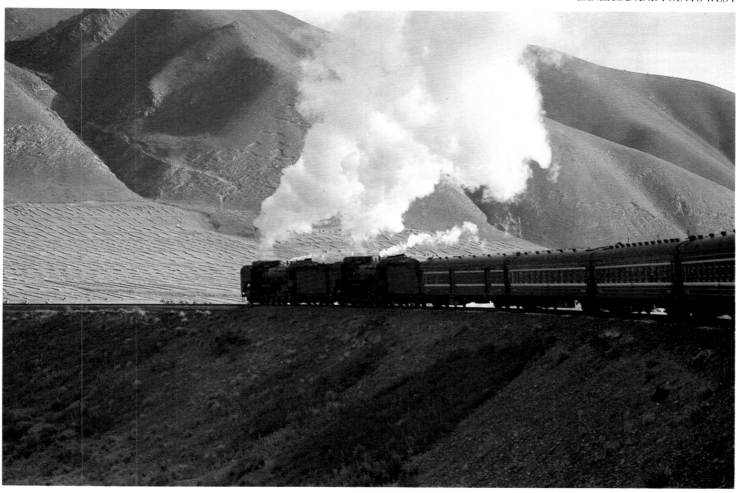

The Tibetan people are very much in evidence at the Lamasery and although they are as fascinated by Westerners as the foreigners are by them, they take their religion very seriously and neither they nor the crop-headed, purple-robed monks will tolerate any lack of respect to the holy place. Photography inside the temples is looked upon as a serious breach of etiquette. Pilgrims often approach each temple on all fours, prostrating themselves fully before and after entering, lying face down in the dust praying aloud. The Tibetans are not unlike the North American Indians in appearance, with braided black hair and clothes which reflect both their hunting ability and the intense cold of the Xinjiang winter. Their main outer garment is a fur- or wool-lined coat with extra-long sleeves, generally worn off one shoulder. Babies are tucked inside this and carried, heads just showing, until they can walk. Then the children are dressed like their parents, with fur or ear-flapped hats, sheepskin muffs and coats with brightly embroidered borders. The Tibetans are filthy, their clothes are stiff with dirt and their hair is often louse-ridden. They are exceptionally poor, living in a hostile landscape under an even more hostile overlord, but they are a fascinating and beautiful people.

The whole area around Xining stands at 5,000 ft (1,500 m) above sea level and it is bitterly cold in winter, the first snows coming as early as October. The land is being re-forested and the otherwise barren hillsides are rich with young silver birch, but the lowlands are the most fertile areas in the province. Xining grew up as a market town, but even two thousand years ago it was recognized as a co-ordinating centre for travel between China and the far western states. By the sixteenth century it had become a military garrison and trade centre. Much of the food grown here is transported further along the line to Golmud to feed the unfortunate prisoners in the labour camps, and on, by road, to the markets of Lhasa.

As the October sun climbs over the peaks of the high mountains, two mighty QJ class 2–10–2 locomotives heave their fourteen-coach Urumqi–Shanghai train up the gradients short of Wu Wei.

Golmud stands 430 miles (700 km) west of Xining across rugged, rocky and mostly unfruitful country. The area is seen at its most beautiful either with the first blooming of wildflowers in the spring, or after the first snows of winter when a sheen of ice transforms the landscape into an eerie, unreal fantasy and the great Himalayan ranges loom behind the smaller, snowcapped hills like an approaching army. Very few people are allowed to take the train on from Xining unless they are with a recognized tour group, and anyone, Chinese or Western, found too near the forbidden labour camps or army outposts will be arrested immediately. Outside the towns, most of the population consists of nomadic horsemen who herd cattle, goats and sheep from oasis to oasis as the land gets steadily bleaker and less able to sustain life. Golmud is like a colder, grimmer version of Xining, but it too is a transport centre, and has its own airport, as well as a passable road with regular buses travelling direct to Lhasa, a journey of thirty hours.

Lanzhou is also the starting point for travel to the far north-west, along a route which follows the narrow boundaries of Gansu Province to the end of the Great Wall, then goes on through Urumqi in Xinjiang Province to the border with Russia. Generally trains in this direction are a pleasure to travel. The services are only crammed to bursting point at the times of the great festivals, such as National Day in October. At other times the traveller in hard-class sitting is almost guaranteed enough space to stretch out across a whole seat for the night, and the soft-class carriages are almost empty, the lavatories locked and opened only on request, and the washroom offering the sort of privacy almost unknown in China. Trains run regularly from Urumqi to Beijing and back. There is oil as well as gold and other precious minerals in the far north-east, and in order to make use of these resources a kind of brain-drain operates from the Chinese capital, ensuring that the area is supplied with the necessary knowledge and technology.

Camels are used as draught animals in the desert, but this one is acting as a film extra.

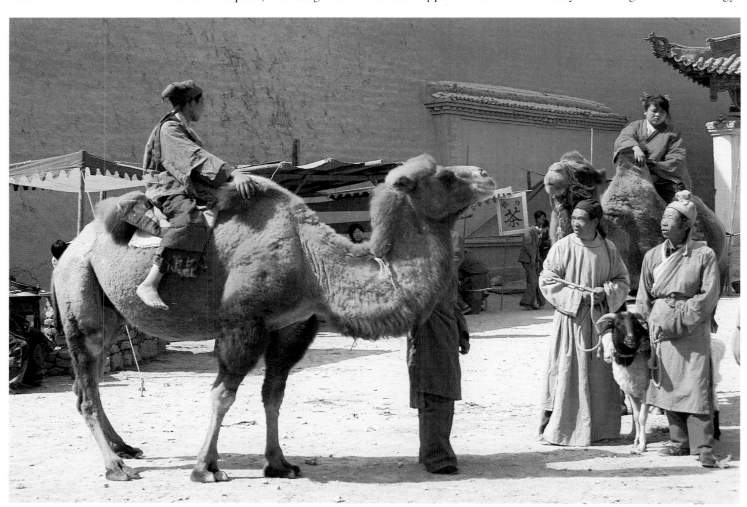

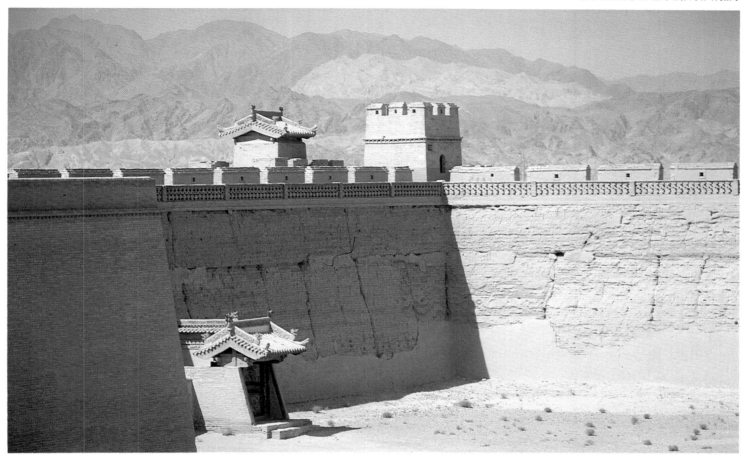

The four-day journey, steam-hauled to the Great Wall's end, offers train staff only one night in Beijing and one in Urumqi on each eight-day rota, so family life is almost impossible. However, some of the trains offer the luxury of television, and the staff may while away the boring hours by inventing different dishes for supper, using camel meat, fish or pork, and creating new and various sauces. A pudding of bottled cherries or pineapple is also sometimes provided. On a bad train the food can be even worse than in other areas, because of the scrawny meat raised in the desert.

All the village settlements in the north are walled with mudstone, originally to deter marauders, as well as for protection from the harsh winds which rage across Inner Mongolia and down the dried-up valleys of Gansu. The train follows the valley of the Pingfan Ho River, along the edge of the Gobi Desert, passing regular plots of irrigated and cultivated land and water-gashed, cream-coloured hills. The desert is patchy sand, shale and gravel, becoming greyer and less golden as the train climbs to the north. Any kind of motor vehicle is rare here, and donkeys, horses and camels are a common sight, carrying vast quantities of maize husks or straw on their backs, or hauling a motley assortment of carts and carriages, with un-matched wheels, shafts made from rope, and the whip as the only form of steering. The animals roam free when they are not working; they will not wander when their owners provide the only food and drink to be relied on in this exhausted landscape. Eighty per cent of Gansu Province is pure desert, less than 4 per cent oasis, and the rest of the land falls somewhere in between. Of the twelve annual inches of rainfall most comes in early spring, resulting in a brief but vivid flowering, and replenishing the underground water table, enabling the artesian wells to work for another year. Occasionally, as the steam-hauled trains stop at a tiny halt, it is possible to get off and gaze at the desert, which runs empty, flat and gravelly for a hundred miles or more. On the other side of the train the Qilian Mountains rise, 17,000 ft (5,200 m) high, and snowcapped all the year round. They are still!

The fortress is huge and bare, built mostly of stone but with some parts of wattle and daub, like the original Wall.

Following pages: *Diesels take over from steam for the twenty-hour journey from Jiayuguan through the Gobi Desert to Urumqi.*

distant images this far east, but they become steadily clearer and brighter as the train moves west towards Urumqi. Two major towns mark the western end of the Great Wall, Jiuquan and Jiayuguan. The first is an hour's drive from the Wall and has been an administration outpost for more than a thousand years. Now it is a trading point for the oil and minerals which come down from the north, and the average pay packet is higher than its equivalent in Beijing. A better standard of living is one inducement to people to live in such a remote area, with no chance of moving elsewhere. The people in the cities of Gansu and Xinjiang are rich in comparison with the rest of the country but many, the young people in particular, would rather be poorer and nearer to Beijing. Even the brightest and most hard working will be very lucky to leave. Jiuquan's name means 'Wine Spring', and is taken from a legend which tells of the general, Ho Qubing, who was given a glass of wine to celebrate a great military victory. Instead of drinking it, he poured it into the local spring so that all his men could drink with him. Jiuquan offers the visitor one big surprise – melons and water melons. In such an inhospitable climate such a crop may seem very strange, but the desert lands have long, hot summers and the lands by the river are ideal for raising water-based fruit.

Travellers often stop at Jiuquan and take a bus to the Wall, but it is easier to take the train on to Jiayuguan, looking out at the shattered remains of the old barrier, which are clearly visible from the track. Even so, this part of the Wall is so different from the familiar and accepted view that many people mistake it for something else.

Jiayuguan was built in 1372 – at the start of the Ming Dynasty – as the final outpost of the Wall. The battered mudstone hump continues for a mile or so further across the desert, towards the distant Qilian Mountains, but the Ming generals decided that they had gone far enough, and erected a great fortress to mark the end of the Wall, and a city named 'Earth's Greatest Barrier'. They thought, with reason, that there was no need to move further west. Any invader would have to cross the formidable mountains and then trek for several days across dry desert, a challenge which would deter the sturdiest of armies, and the outpost at Jiayuguan would form a final barrier against any survivors. Once beyond the fortress, anyone travelling west was considered beyond the bounds – and help – of China. The fortress has been reconstructed many times over the ages, and the smart, strong stone of the most recent works seems a little incongruous beside the wattle and daub structures leading to and from it. Nevertheless it is a magnificent monument to a past which was probably bitter, lonely and boring for the people who maintained the garrison. All that can be seen from the 65 ft (20 m) high towers and walkways is the desert, the railway line, the mountains and the busy steelworks just outside Jiayuguan.

Travelling northwards to Urumqi the train – now hauled by diesel – passes out of the Gobi and into the Taklimaken Desert, the same landscape under a different name. Still on the path of the old Silk Road, it crosses from Gansu into Xinjiang Province, an area of revolution and unrest for many centuries. The land is partially populated with minority tribes, principally the Uygur, racially more European than Chinese, who are devout followers of Islam, speak a Turkish dialect and write in Arabic script. Relations between the Uygur and the ruling Chinese have been bad for nearly two thousand years, and even now there are scuffles and incidents, despite the heavy presence of the Chinese military and the clumsy efforts made to absorb the minorities by making their script illegal. Considerable damage was done to friendly relations during the Cultural Revolution, when all the mosques were closed down and the people forced to work in communes, growing crops totally unsuited to the landscape.

The Great Wall Fort at Jiayuguan, the last fortress before the Wall fades away into the desert. The fort is a popular television and movie location.

The Chinese conquered the area in the first century AD because they wanted full control of the Silk Road and wished to suppress regular raids by bandits into their lands (the Great Wall was then still under construction). The region was lost and re-won regularly through the centuries, but even during the periods when the Chinese had been ousted from the area, the warlords of the province were continually in conflict. Now that the land is valuable for its oil and other mineral deposits, the Chinese will make sure it is theirs for good.

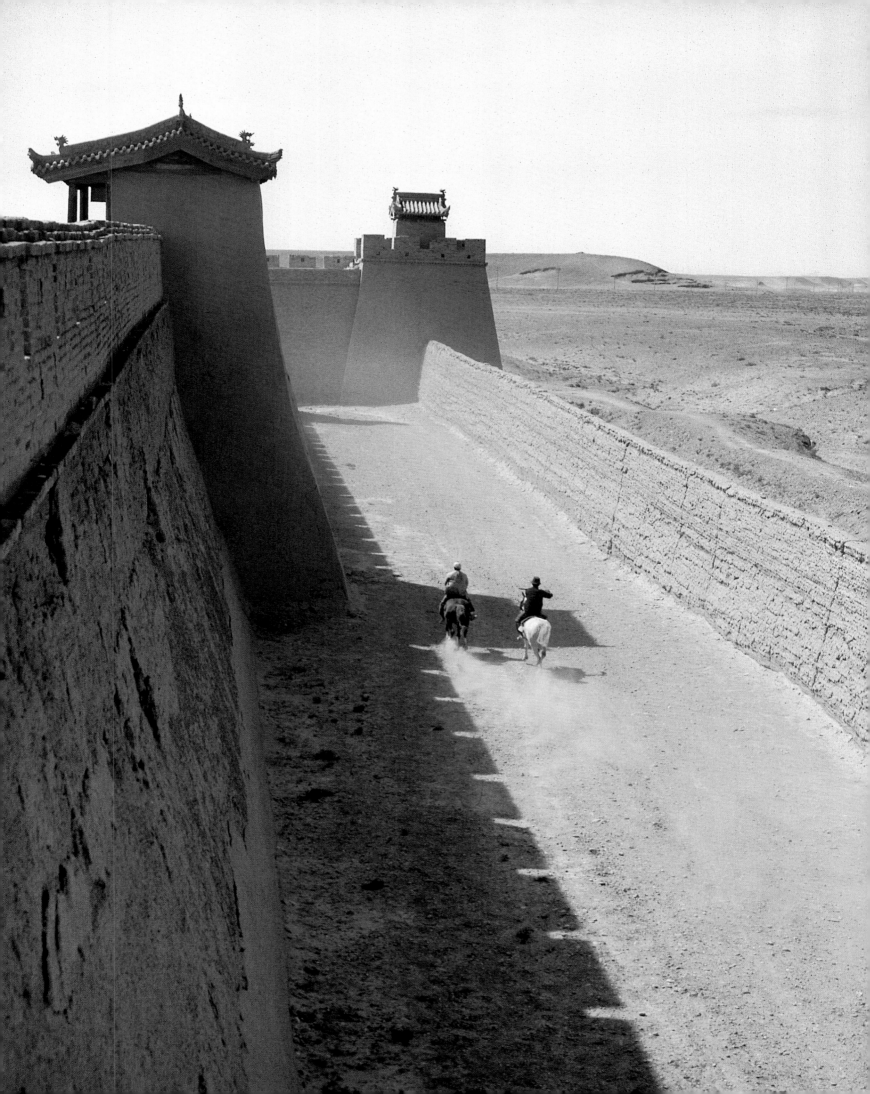

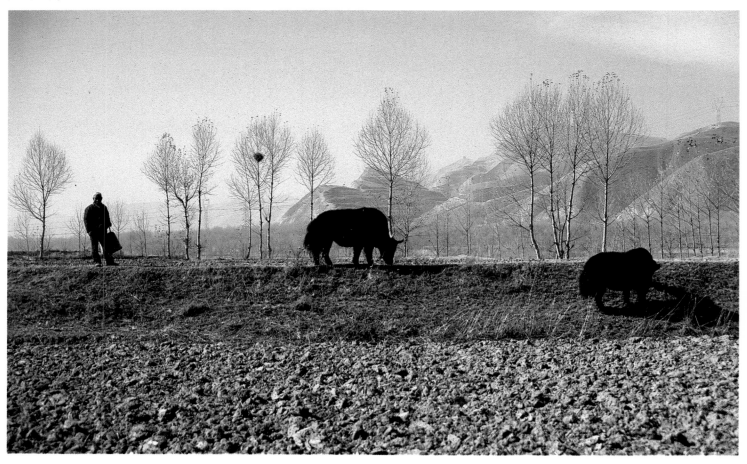

Tibetan yaks and protective herdsman on the bleak plains west of Xining.

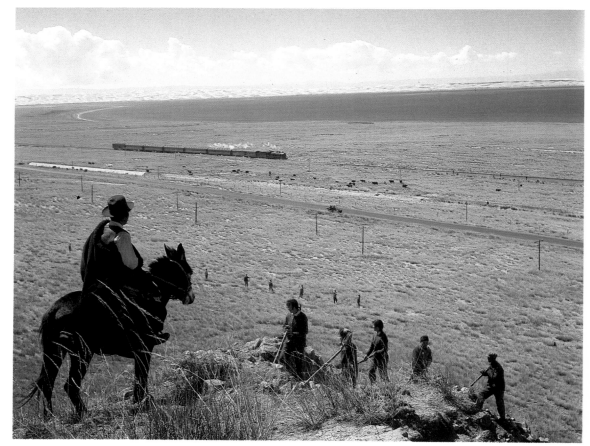

The harsh landscape between Xining and Golmud, and the beginning of the proposed rail route to Lhasa. Golmud is over 10,000 feet up and trains here carry a doctor with oxygen at hand in case of altitude problems.

The oases on the route to Urumqi are settled by Uygur people who raise horses and grow grain and fruit for the city's markets. The agriculture in the region depends totally on well-water and irrigation, but just south of Urumqi, past the barrier of the barren, grey and uniform Tian Mountains, is the highly fertile area known as the Southern Pasture. Another minority people, the Kazakh herdsmen – better known as Cossacks across the Russian border – tend their animals on this vast grassland which in the spring and summer months is rich with bright colour, flowers and wildlife, but which fades swiftly to gold and russet with the first winds of autumn. Another magical oasis near Urumqi is Bogd Fen, or 'Peak of God', the site of the Lake of Heaven. Tourists are taken there to stay in an area which resembles the French Pyrenees; a great stretch of blue water surrounded by pine trees, the habitat of wildcat, deer and bears. The area is only open in the summer months, as temperatures go down to −22 degrees fahrenheit (−30 degrees centigrade) in winter. In summer too, the climate can sometimes be very extreme, reaching a scorching 105 degrees fahrenheit (40 degrees centigrade).

Urumqi is not impressive at first sight. It is built around an arid and lumpy rock called Hong Shan, from which people can view the familiar expanse of industrial buildings, grey concrete flats and broad, straight roads. It is the varied people and cultures of Urumqi which make it worth a visit. More than a quarter of the city's inhabitants belong to minority groups and there are sixteen different groups in all, each with slightly different racial characteristics, clothing and customs. The markets reflect their differing tastes, with furs and skins, Muslim foods and trinkets for sale, as well as delicacies such as Mongolian mare's milk and hard, salty cheese. For the tourists there are jade and musical instrument factories, and the area is also famous for its carpets, now, sadly, often mass-produced and factory-made.

Urumqi is the end of the route by train. The line does continue a little further to the north and west, but it is only used for freight. One can travel onwards by car or plane, but the train waits to turn and carry its passengers back to the green and fertile lands.

Terminus in the far west: Urumqi station surrounded by desert. Truly the end of the line.

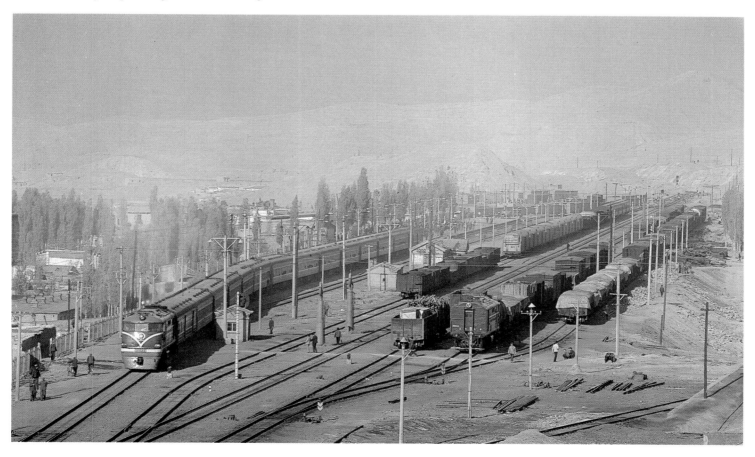

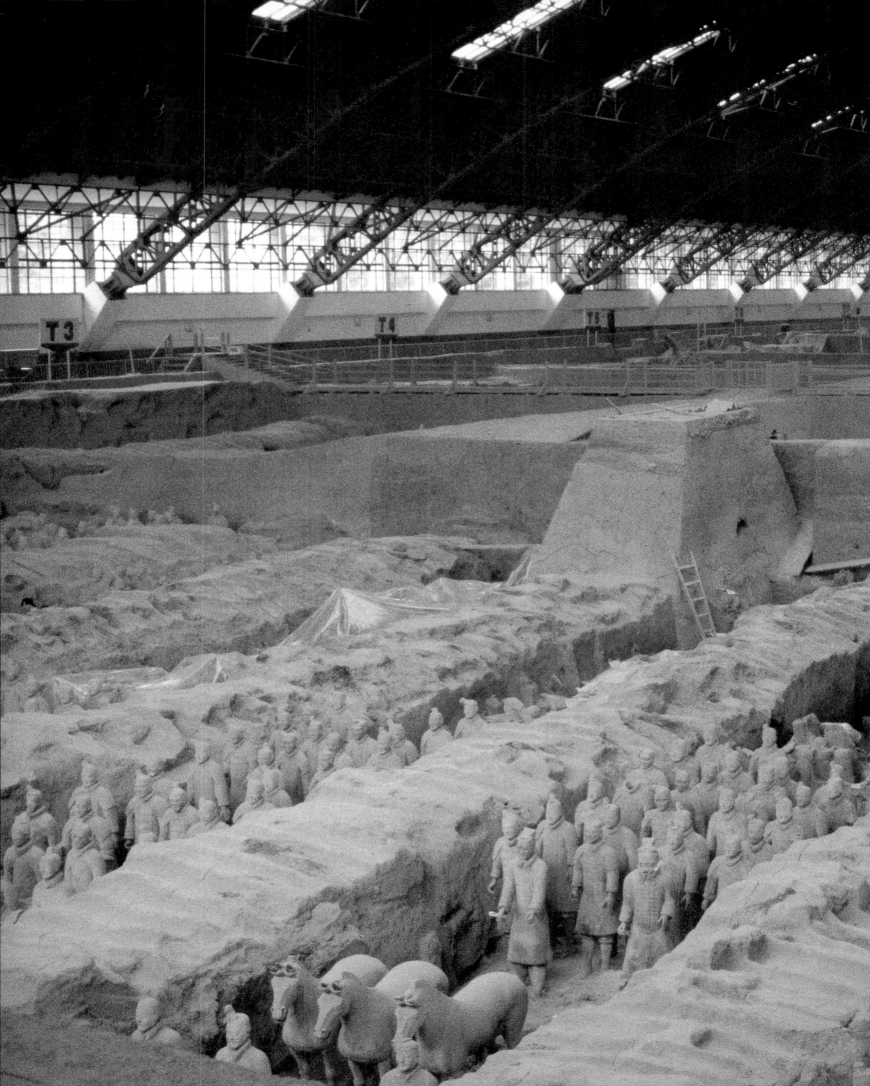

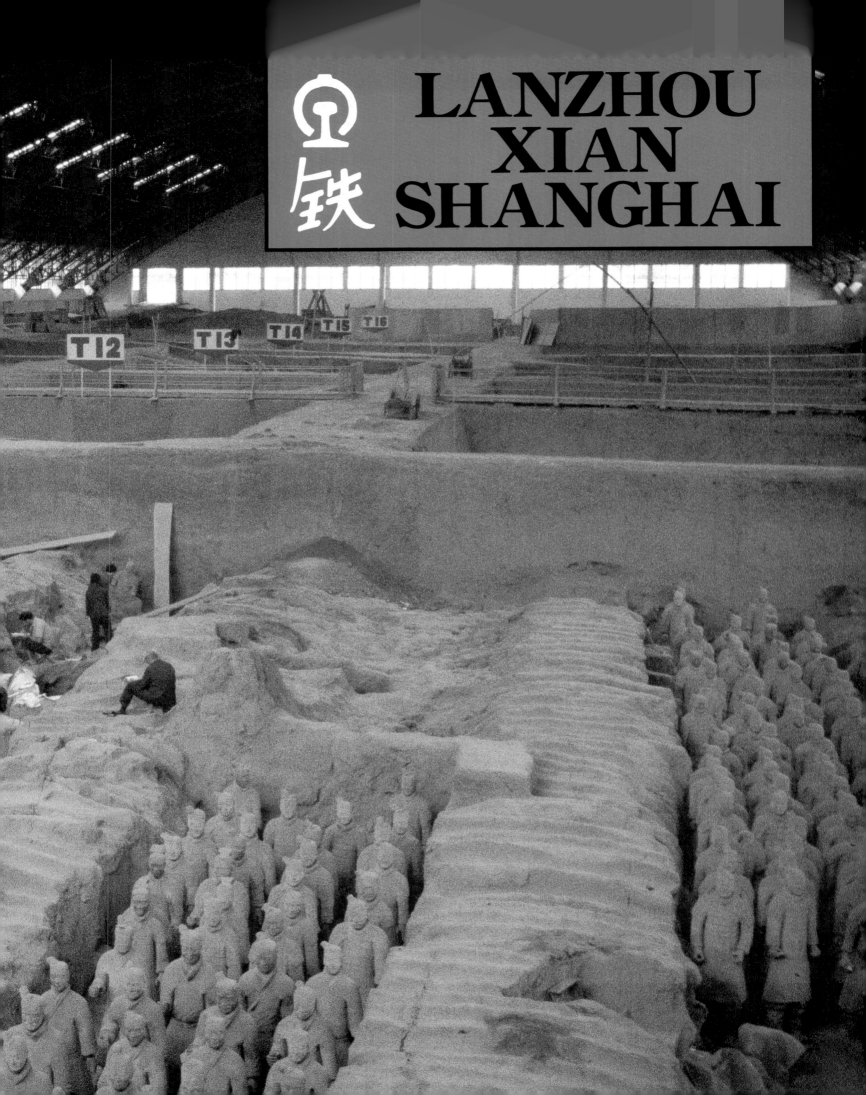

THE ROUTE FROM Lanzhou to Shanghai crosses the heartland of China, dipping slowly from 3,300 ft (1,000 m) to sea level, across widely varying countryside, ranging from virtual desert to lush, fertile flatlands and acre upon acre of paddy fields. Instead of following the path of the Yellow River, which winds north to Inner Mongolia before curling south again on its journey to the sea, the railway runs alongside a tributary, the Wei He, through the craggy, beige-and-golden hills, and rejoins the great river east of Xian. Less than 200 miles (300 km) further on the line breaks away again, heading south-east and crossing the massive Yangtze River at Nanjing before completing the final 125 miles (200 km) to Shanghai. For the first part of the journey the line is electrified, though there are still steam engines to be seen, generally shunting at stations or at adjacent engine sheds. Because Xian nowadays is set firmly on the tourist map, for both Chinese and foreign travellers, soft-class accommodation on the train is once more virtually guaranteed. From Lanzhou to Xian the line drops 1,600 ft (500 m) to a landscape which is still dramatic and rugged in places, but which slowly becomes greener and more accessible as it passes from Gansu into Shaanxi Province. Along this route photography is strictly limited, because the railway passes Dingxi military outpost, and train police patrol the coaches when they know foreigners are on board to make sure that no one takes pictures within twenty miles (32 km) of the barracks. Those who disobey will have the film removed from their cameras, and short shrift from the train staff for the rest of the journey. The land around the outpost is pretty, but less fascinating than many other landscapes that China has to offer, and most travellers will not feel too deprived by the ban. Issuing warnings in areas where photography is not allowed is one of the tasks of the radio operator. The operators on the trains are always women, and each has her own little cabin, with a modern cassette deck, amplifier and microphone as well as her bed and a few home comforts – perhaps a picture, or a spray of plastic flowers at the net-curtained window. Like the Blossoms she is uniformed, with a peaked cap, and she works for five hours at a time, with a two-hour break in the middle of each shift. While she rests the tape continues working, churning out light opera, popular favourites, and many Western tunes, although often to such different arrangements that they are barely recognizable. Also very popular is 'crosstalk' – two comedians firing backchat at each other for anything up to half an hour at a time. The radio operator has a slightly higher rank than the Blossoms, even though she does not have to deal directly with people, but it is a lonely and repetitive job. 'Good morning', she says at every stop. 'Welcome to our train, number 92 from Lanzhou to Xian. We will stop at three more stations before Xian, and our next stop is at Baoji in twenty-five minutes time. A meal will be served in an hour and on the menu is. . .' So far this is very similar to many countries' train announcements, but then she goes on to tell passengers the number of miles they have covered, what sights can be seen on the way and the latest national news, and to quote some party slogans and propaganda – phrases such as 'it is the duty of the people to serve the people'. Then comes a list of instructions: 'Do not spit on the floor of your carriage, or in the corridor. Do not use the toilet while the train is in the station. Sit down please. Do not leave luggage on a

Previous pages: The terracotta warriors of Xian. Only one sixth of the site has been excavated so far and the wonders of the Emperor's tomb itself remain hidden, but in the meantime visitors can marvel at the reconstructed figures and the separate museums showing what the warriors must have looked like when they were first assembled.

seat or on the floor. Do not leave your child unattended. Do not let your child use the floor as a toilet. Do not drop litter on the floor', and so on, all repeated in a sweet, lilting voice, each word enunciated clearly and slowly.

Although most Chinese train officials do not appear to use it, the China Railway Publishing Corporation has its own English/French/Chinese dictionary which is intended to cover any eventuality on a train. It has questions and answers in both languages but, as with many such phrase books, some expressions lose a little in translation. The language used also shows the difference in thinking and expression between East and West. Some of the phrases used seem pompous to a foreigner but they are absolutely correct and literal translations of the Chinese. The two following dialogues are quoted verbatim from the book. F stands for foreigner, and C for Chinese.

F: Thank you very much for all you have done for me.
C: Don't mention it.
F: I'm afraid I have given you too much trouble.
C: No trouble at all. It's our duty.
F: How nice you are.
C: Chairman Mao taught us to serve the people of China and the world wholeheartedly.

An ironical slip occurs in the middle of a dialogue with a Western traveller who loses her handbag:

C: Mrs Boring we have found your handbag. You left it in the canteen. Please check and see if everything is in its place.
F: Everything is here. Thank you very much.
C: Not at all.

Other sections contain instructions, and warnings for the staff to give 'Your dog (monkey) has caused damage to the coach, you have to pay for it', and 'This is your fault. Why didn't you make yourself clear beforehand?'

Despite its anachronisms the book is immensely useful to travellers especially those in hard-class or anyone who is confused by the complicated Chinese ticket system. For example, it is possible to buy a ticket for the journey from Lanzhou to Shanghai at a time when there is no through train, but although the ticket is for the whole journey it may not be transferable to any other train than the one taken at the start, and the traveller may therefore have to buy a new ticket to finish the journey. Alternatively, the through ticket may allow the passenger onto the second train, but not give him a seat or a berth which, assuming there is one free, must again be paid for separately. This system applies throughout China and can be both difficult and exasperating for the foreigner to operate.

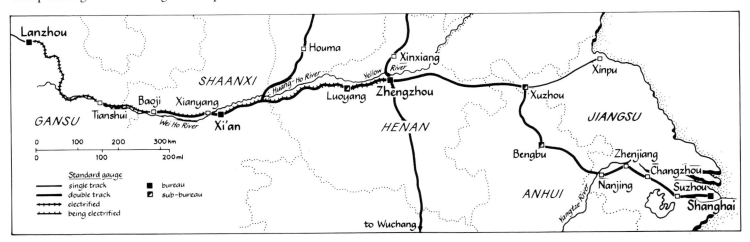

Opposite: *One of the warriors inside the museum. His uniform originally would have been painted in bright blues and pinks, with chain mail and real weapons, but fire has destroyed all the colours.*

Q J No. 3145, smartly kept as befits a 'model crew', undergoes a piston and valve examination at Xian shed. The wearing of safety helmets is an indication of China's move forward in industrial environments.

The first sight of Xian comes after a landscape of mudstone tors and caves. It is China's greatest historical landmark, and once challenged Constantinople as capital of the world, but the initial impression is that of any other Chinese rural city. Behind the mask lies a town dating back to neolithic times, and the capital of many Chinese dynasties. Xian was also the official starting point of the great Silk Road, which linked the town with the Mediterranean at the Levant, by way of 4,000 miles (6,400 km) of mountain and desert. It was at its most travelled during the years of the Roman Empire but as Roman power declined it became dangerous and infested with robbers. The Mongols revived the route in the thirteenth century, and Marco Polo travelled it on his way into China.

The city itself was founded 3,000 years ago during the Bronze Age. The people of the district were expert at forging bronze, and a settlement grew up with the resulting trade. Xian changed its name, and its site shifted several miles over the ages, so the burial mounds and artifacts found in the area are still intact and undamaged by later generations. The city's greatest treasure, the Terracotta Army, was created by the first Emperor of China, Qin Shihuang who became a local leader in 246 BC at the age of thirteen. During the next twenty-four years he conquered nearly all China, creating the Qin Dynasty, and when he died, aged fifty, he left behind a monument almost as memorable as the Pyramids – a great army, facing east to guard his tomb. The warriors and their horses stood in their full splendour for four years after his death. Then revolutionary forces burned down the temple built to cover them, causing serious damage, and hiding them for more than two thousand years. In 1974 a farmer tilling his land rediscovered the warriors, and since then work has gone on continuously to restore them to their original form. Only one-sixth of the army has been fully excavated so far, and although the chariots and the

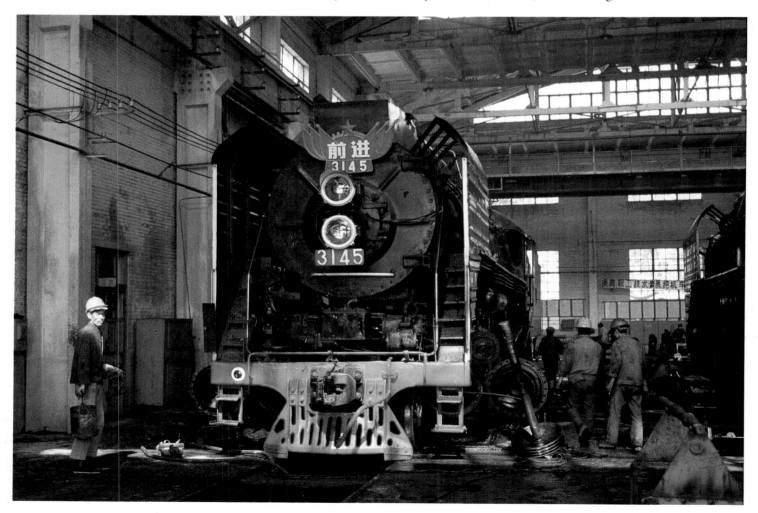

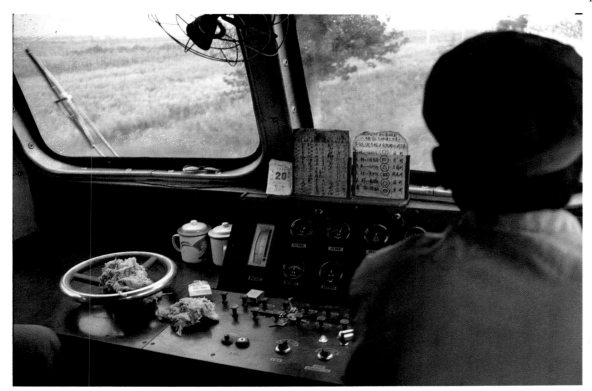

Country train. A view in the cab of a 760 mm local railway diesel on a line near Shijiazhuang. There is a two-man crew, as can be seen by the two tea-mugs on the dashboard. The notices on the windscreen give details of the working timetable and the single-line token sections.

leather harnesses have burnt or perished it is still a breathtaking sight. The soldiers are being rebuilt from the charred wrecks originally discovered, although neither they nor their sturdy ponies have yet been repainted in their original bright colours. Museums on each side of the site show how the army must have looked when it was first sculpted, and provide chilling evidence that the workers who created this masterpiece were put to death on its completion.

Visitors to the tomb have to walk down a wide road of street vendors selling models and pictures, and although photography is forbidden inside the huge aircraft-hangar-like building erected over the warriors, plenty of postcards and slides are on sale for the tourist. There is nothing to show the mysteries of the tomb itself but a mound of grass nearby. It has never been excavated and it seems likely that it will be left for many years.

Xian is filled with temples, parks and ancient sites, many left intact over the last thousand years or more, and there is a separate and smaller terracotta army, as well as relics of the Han Dynasty which followed the Qin. A little more recent is the lovely Fragrant Park, or Huaqing Pool, where hot springs have created a spa. The twentieth-century Chinese leader Chiang Kai-Shek visited here with his mistress in 1936, but had to flee into the hills after a coup by his own generals. Bullet holes are still visible in the windows of his bungalow, and local guides tell how he left his false teeth behind in his hurry to escape.

After the decline of the Silk Road, and the growth of newer cities, the 1930s saw a resurgence in Xian's importance when it was linked to the east by rail. Although rebuilding has increased its similarity to other Chinese cities, it retains obvious signs of its illustrious past, and much of its ancient city wall still stands, with towers marking the four points of the compass. The people are very conscious of the city's heritage and of how best to turn it to their own advantage as tourists flood into the area. Hotels are besieged by hawkers who sell embroidered goods with an intimidating persistence and determination. They are not allowed into the hotel grounds, so they hang their wares on long poles and dangle them over the surrounding walls and fences, setting up banshee wails and shouts whenever they spot a foreigner.

West of Xian the railway continues to follow the Wei Ho River valley, passing a long and narrow flooded reservoir before descending into the lowlands for the first time in more than 1,250 miles

Opposite: Apartment blocks in Shanghai with political banners – 'Long live Chairman Mao's revolutionary line' – hanging from the roof, and washing festooning the balconies. Shanghai is one of the greenest of China's cities, and the newer estates have well-grown evergreens normally uncommon outside parkland. This photograph was taken in 1976, the last year of the Cultural Revolution.

Advertisements and political posters are common in Chinese cities. These often include notices on currently running films, and advertisements for local organizations, such as the Shanghai Motor Service Company.

(2,000 km). The land reverts to paddy fields and continuous cultivation, with ducks gathering on village ponds, attended by children, and water buffalo replacing camels as the principal beasts of burden. The land all the way from here to Shanghai is riddled with rivers and streams and could with some justification be called China's lakeland, although the railway avoids the great stretches of water which dot the paths of the Huang Ho and Yangtze Rivers, the latter winding eastward from Chongqing and its source in Tibet.

Across the flatlands of eastern China there is more obvious evidence of the hard-working lives of the peasant classes. In the hills the only possible cultivation must be by hand, but on the wide, fertile plains to Shanghai the same methods are used when, to the Western eye, the terrain demands machinery – wide fields worked by huge combine harvesters, instead of the little market gardens which are ploughed by pony and ox and harvested by hand.

Shanghai rests at the mouth of the Yangtze, probably China's most legendary city, as a place notorious in history for its opium dens, gambling halls and brothels. It is still regarded as one of China's most cosmopolitan areas but may come as rather a shock to the Western traveller, with its lacklustre grey streets, its beggars and obvious signs of poverty. The roads are lined with a mixture of buildings, ranging from bleak apartment blocks, many still being built, and covered with bamboo matting or net scaffolding, to red-shuttered houses on the narrow sidestreets where the first floor stories lean outwards almost touching one another. On a fine day every house and apartment is draped with washing, hanging from poles and balconies and adding colour to the busy scene below, while gathering smuts from the filthy air belched out by the great barges on the nearby Yangtze. Most visitors to Shanghai are business people – the city has its own exhibition centre and links with the West are flourishing through the export of minerals, a thriving

textile industry, and the giant steel works and petro-chemical factories. Historically, Shanghai was not an important city until the early nineteenth century. It operated as a fishing port and small-time trade centre until the Opium Wars. First Britain and then France opened the city up by enforcing a trade in opium, and later encouraged it to develop into a truly international centre, set apart from the rest of China. Even now the city is full of free enterprise and thousands of small businesses take advantage of the presence of foreign visitors to sell their goods. It seems surprising that in 1921 the Chinese Communist Party was born here. Chairman Mao published his plans for a Cultural Revolution here, before even Beijing had heard the news, and it was here that the infamous Gang of Four had their base.

Although Shanghai is always said to be on the banks of the Yangtze, it is really located on the Huangpu River where it joins the huge estuary. Down by the river is the Bund, an old Anglo-Indian word for the embankment, and a popular meeting place. Parts of the Bund were exclusively for the use of the British during colonial days, and the riverfront here could almost be mistaken for any colonial outpost with its dignified buildings and the seaside atmosphere of its neat miniature parks. Today, it is mostly the young who gather there to study, and to watch the tugs, barges, container ships and fishing vessels as they pass. Foreigners are seized upon with little ceremony but great friendliness, and asked to help with English, or to become a pen-friend. Complicated discussions on topics ranging from poetry to mechanical engineering are quite common, especially in the darkness of the evening, when the lights of the shipping reflect in the constantly changing water, hiding the sullen grey colour that results from pollution.

Shanghai has the greenest city streets in China. Both young and mature trees spread their branches over even the busiest thoroughfares and cast welcome shadows in the hot and humid summer, although their foliage is a little dimmed by the constant dust thrown up by traffic. There are more cars here per head of population than in any other Chinese city, and more

Shanghai has a large and permanent complex devoted to exhibitions of locally manufactured products which serves the function of a national exhibition centre. Engineering and machine tool items are shown in a separate hall.

141

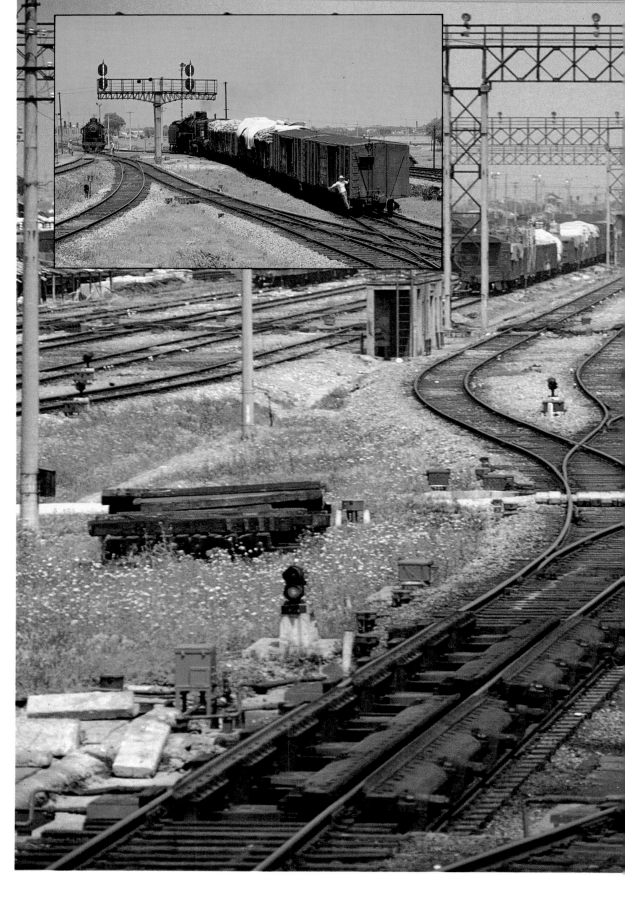

Shanghai Marshalling Yard Two photographs showing the workings of a hump marshalling yard in Shanghai. The American-built, UNNRA-supplied KD$_7$ 2–8–0 has pushed its wagons over the sloping 'hump', and they are now dropping back onto a selected track in the fan of sidings, slowed down in a controlled way by the electrically operated 'retarders' in the foreground.

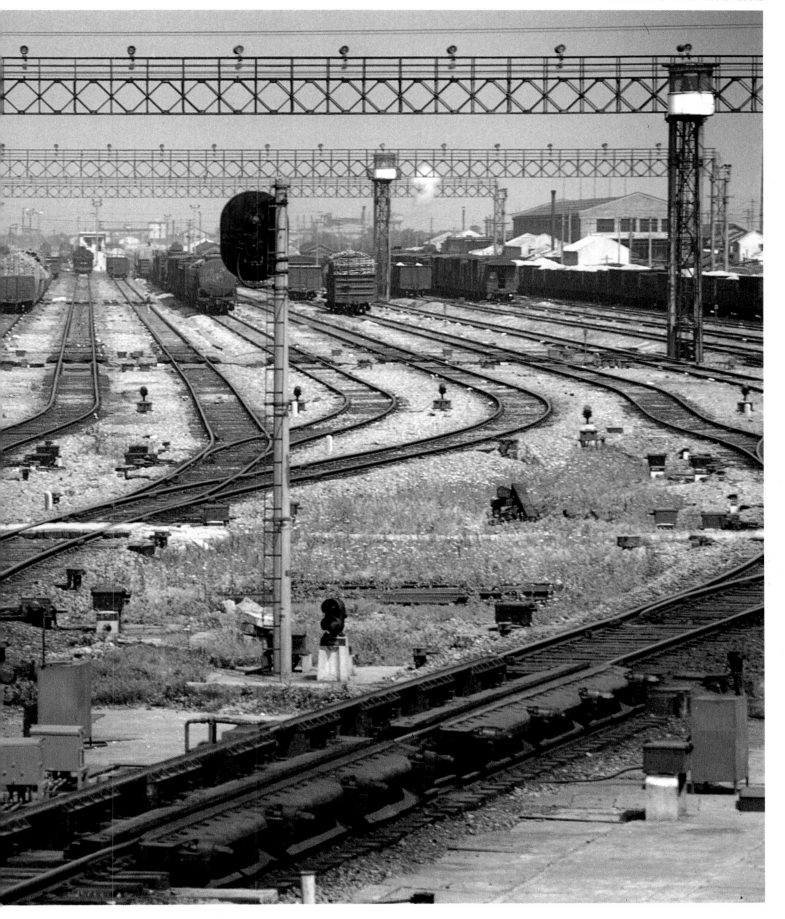

The Grand Canal runs between Shanghai and Beijing, and was a vital communications link for many years. Heavy freight is still carried, but the bulk of traffic is now smaller business and farm goods. This boat-train of logs is passing through Suzhou en route to Shanghai.

consumer goods available to the public. The streets are lined with open-fronted shops selling old-fashioned television sets, single-tub washing-machines in green and yellow, plastic dolls like the ones sold to tourists all over Europe, and brand new electronic organs and personal stereos. Most of the goods are still only available in Friendship Stores for privileged people and foreigners and must be paid for with Foreign Exchange Certificates instead of the local currency.

Deep in the heart of Shanghai is an old teahouse, said to be the original model for the willow-pattern plate design, standing on an island of rock which is reached by grey stone bridges that span a series of goldfish-crowded pools. When the British ran the city the Chinese were excluded from this too, but now it is open to all who can afford to eat in the restaurant there. All around are streets filled with traders, selling plastic toys, balloons, buttons and trivia, all at set prices with no one undercutting his neighbour. Most will bargain with a prospective buyer, but there is very little to tempt the foreigner. At every street corner is a propaganda poster, praising the country's one-child rule, indicating the role of the police as friends and advisers, as well as upholders of the law, or simply reaffirming the aims of the Party. Each poster depicts pale-skinned, round-eyed men and women – the Chinese admire these Western traits, but deplore the size of the average foreigner. Advertisements are common nowadays, mostly in a similar style, and advertising anything, from newspapers to rarely-available deep freezes, bilingually in English and Chinese. Civilian wardens sit or stand at street junctions and watch for traffic problems. They are empowered to act as traffic police when there is a hold-up, but mostly they sit and chat with friends or doze, as the cyclists and truck drivers dodge each other with inches to spare. Trolley buses clatter along the streets, crowded with people whatever the time of day. They are made up of two sections linked by a corrugated corridor, and take right of way over all other traffic. Occasionally one turns too sharply and disconnects itself from the line, and sometimes a piece of the roofing may fall off. When this happens, the driver and conductor simply stop, climb up the side of the bus and rearrange whatever is necessary, giving no apparent thought to the possibility of electrocution or the very real danger of a car crashing into the stationary bus.

One might expect Shanghai's hotels to be the best in China, and those newly built on the edge of the city to cater for the tourists are equal to those of Beijing, but the old colonial buildings still leave much to be desired. The city has replaced the terrible slums for which it was notorious in the early years of the century with much-coveted flats, but sanitation and water supplies for a population of twelve million are still major problems, and the hotels also reflect the fact. Hotel rooms in China are not maintained or decorated to Western standards, and although guests receive small gifts – a comb, toothpaste and a bathcap – the impression of being welcomed is ruined by the dark, smeared remains of cockroaches swatted on the wall by a previous resident and never scrubbed away. Laundry is returned immaculate, and the ever-present thermos of hot water is replaced conscientiously but plug sockets are loose in the wall, wallpaper is peeling, and tiles on the bathroom floor are missing or cracked. In the dining room the standard of service given by the dreamy waitresses is rarely high. It reflects the lack of commitment in a system which does not reward with incentives, and which offers little or no training for hotel staff or salespeople.

Shanghai's most famous tourist attraction is the Jade Buddha Temple, which is constantly packed with people lighting joss sticks and leaving offerings for the icons in a series of golden shrines swathed in coloured materials. The name comes from two beautiful white jade buddhas brought from Burma a hundred years ago. Their smooth, cool loveliness is enhanced by the fact that this is one of the few temples where the statues are carefully maintained. Many other temples are dim and dingy in comparison, the bright colours and smooth carving obscured by the dirt of years. There are few other major sights because Shanghai is a comparatively young city which has concentrated all its energy on commerce. It is unrepresentative, its short history clouded by foreign interference, but for a place to watch people and observe the highs and lows of Chinese life it is unrivalled.

The Yangtze River finishes its long journey across middle China just north of Shanghai. It winds through eight provinces, and before the coming of the railways was the only major route from east to west. This photograph gives a typical view from the Bund in Shanghai, showing the huge variety of boats and shipping – from sampans to ocean-going liners.

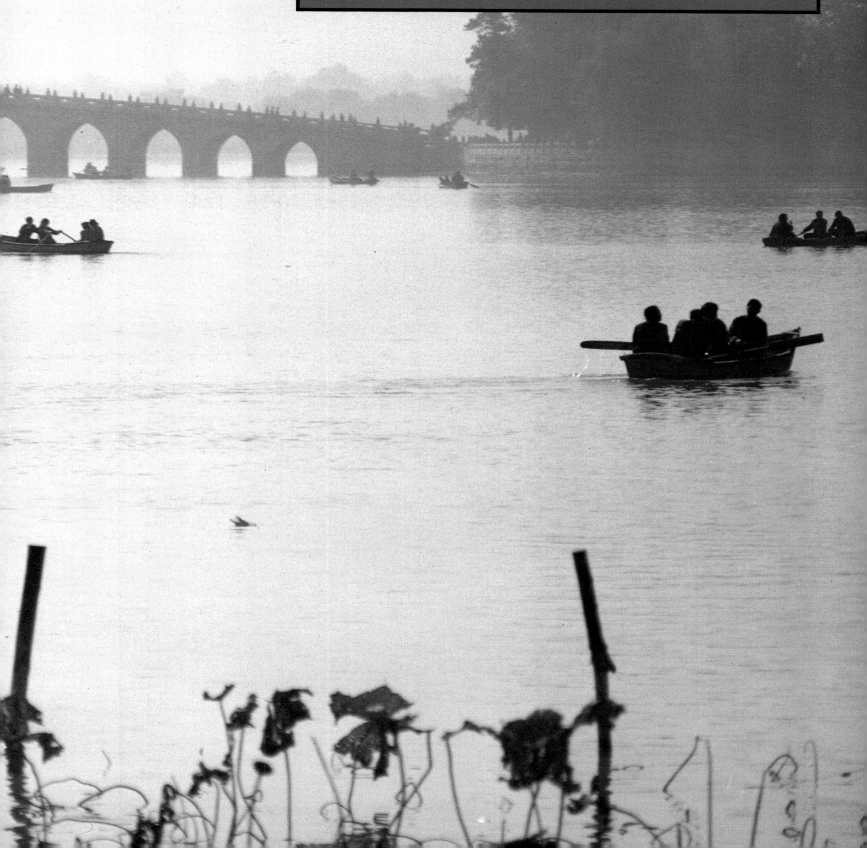

TRANSPORT BY RIVER, rail and air, and facilities for travellers to and from Shanghai have been of primary concern to the city in the last few years, and the railway station, the international river dock and the airport have all been rebuilt, renovated, or extended to accommodate more people. The eighty-year-old station, with flower beds behind the buffers, green wooden canopies over the platforms, and weeds growing on the track, was replaced early in 1988 with a vast new concrete edifice, more than twice the size and capable of coping with 200,000 passengers a day. All Chinese trains are numbered, and it is Train No. 14 which takes the route from Shanghai to Beijing; as well as being allegedly the most comfortable train in the country it is certainly the fastest – the only non-stop passenger express in China.

It does change engines and take on water during the journey, but does not drop off or collect passengers, and in consequence it is three hours faster than any other train over the same distance, and 30 per cent more expensive. The seventeen-hour trip is spent in a series of pink coaches which are much smarter than average. The staff wear a matching uniform consisting of jacket, trousers, shirt and tie, and peaked hat, there are intricate lace tablecloths and stylish lamps on the compartment tables and thick, good-quality woven Chinese carpet on the floor. Hard-class lying is no different from that on any other train, but hard-class sitting is replaced in many carriages by soft-class sitting, complete with covered seating and carpeted floors. Because of the expense, fewer people take this train, and those who can afford to generally travel in a sleeping compartment, giving passengers with only a sitting ticket the chance to spread out on a double seat overnight, and to have a far more comfortable journey.

Unhappily, the luxurious surroundings do not include better service, and many travellers feel that they are treated far worse on the 'best train in China' than on most others. The Blossoms can be surly and unwelcoming, refusing to return a greeting and forgetting to bring cups for tea, or to refill the thermos flasks. The food too is variable, ranging from unpalatable offerings of pork-fat soup, gristly beef and bony giblets of chicken to excellent freshly-caught seafood. However, the food is often reluctantly, and even belligerently served, and requests for tea instead of beer or a soft drink refused. A can of Coca-Cola, or any other delicacy, spotted on the buffet trolley is only for the buffet trolley customers, and cannot be bought by a diner to eat with his or her meal.

All trains leaving Shanghai pass through a hinterland of tenement flats, houses and shacks. Unlike other cities there are glimpses of road flyovers as well as the single-bar level crossings where people on bicycles wait patiently for the trains to pass. As the urban landscape thins out, smallholdings, market gardens and farms appear, growing larger the further they are from the city. Some are communes where the inhabitants are rich enough to build detached two-story houses for their families. The land around is flat and green, acre after acre planted with rice, with fruit trees acting as windbreaks, each painted white around the base to discourage animals or insects from damaging the wood. Herdsmen chivvy flocks of brown and black ducks along the mud tracks towards shelter for the night, or to backyards where they will be caged and sent to market. The ducks have clipped wings and are free to roam around the little ponds dotting the landscape, which are used to grow lotus or stocked with fish to breed for sale.

Previous pages: The Kunming Lake by the Empress's Summer Palace, a regular holiday spot for the Beijing millions. The Seventeen Arch Bridge is one of the many architectural wonders.

At exactly 9 p.m. the No. 14 train crosses the Yangtze by way of the great bridge at Nanjing, a stunning example of Chinese civil engineering. It is known as the Chang Jiang Bridge – 'Chang Jiang' is the Chinese name for the Yangtze – and was under construction throughout the 1960s. Trains travel inside its vaulted metal girders for a journey of four miles across the river itself, and another three on the approaches from either side, taking the train up to a height of 230 ft (70 m) above the Yangtze. The sensation is similar to becoming airborne, looking down at first on narrow fields, ponds and tracks, with tiny people tilling and harvesting, and then crossing the broad, grey waters of the inland sea, dotted with cargo ships and fishing boats bobbing and heaving in the wake of the industrial traffic. Ten great steel supports carry the bridge, and around five thousand people were involved in its construction before the official opening in 1968, which finally liberated all the traffic needing to cross the river from the delays and tribulations of the ferries. The bridge incorporates two railway lines and a road and caused a severe loss of livelihood for the many people who kept a boat to transport farmers and their wares to the opposite side. Ferries do still exist, even the lumbering train ferries, which would carry

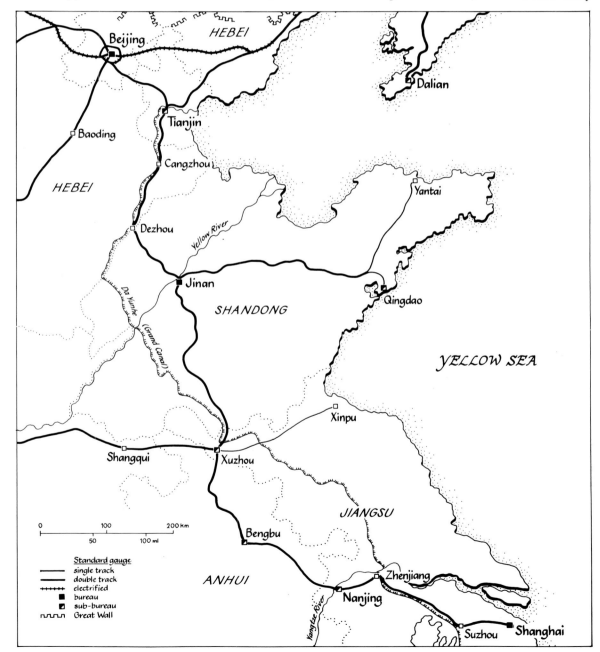

Train No. 13 for Shanghai at Beijing main station. This is China's premier train, with red-and-cream livery and air-conditioned coaches. It is timetabled as non-stop although there is a halt to change engines and crew en route. Train No. 13 carries a specially enhanced fare structure in view of its unique status in China as a non-stop express train.

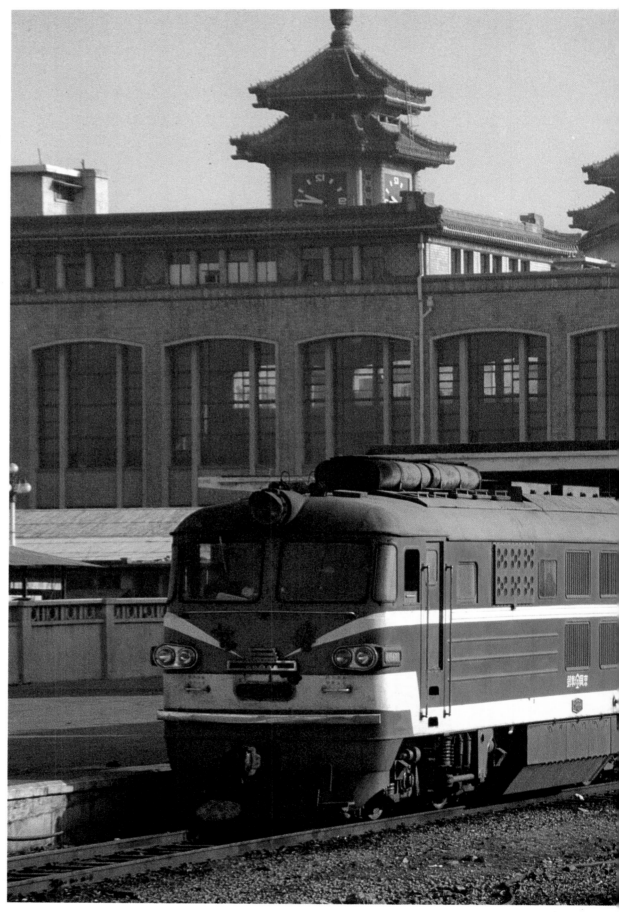

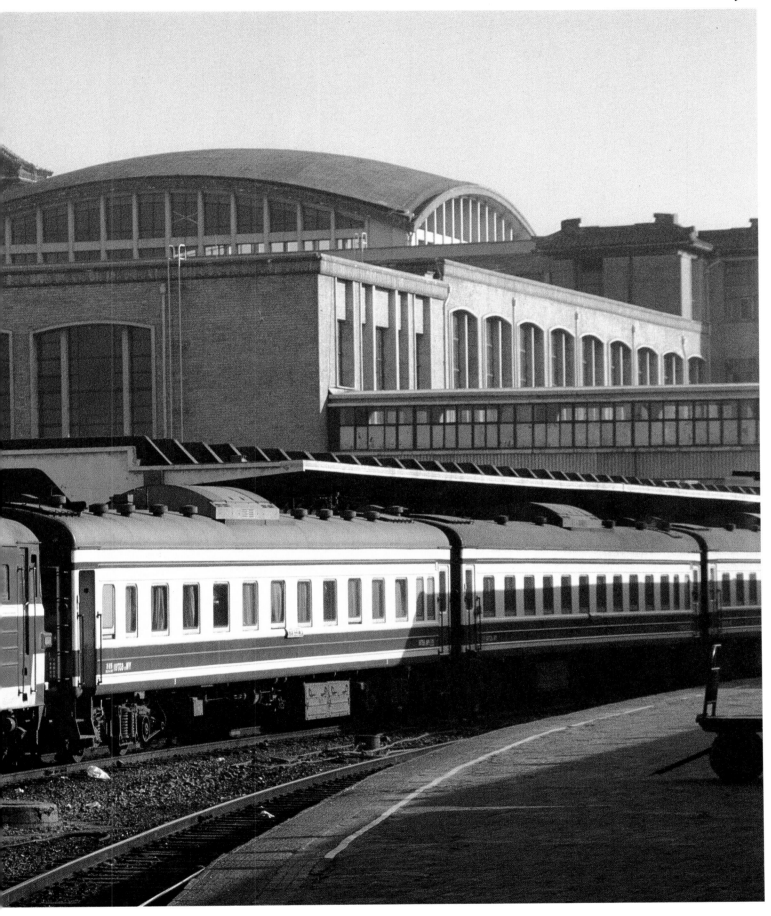

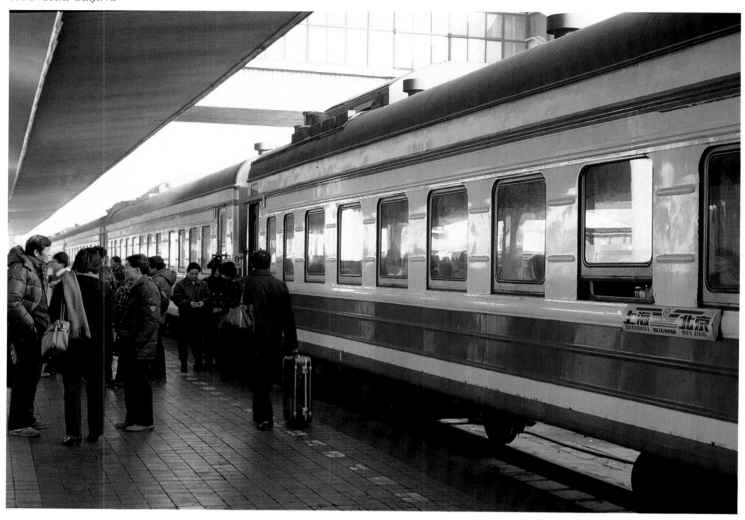

The Shanghai–Beijing express waits at the platform for passengers to board.

carriages across in sections, causing lengthy delays. They lie dormant, moored on the banks of the Yangtze in case they should ever be needed. Meanwhile the diesels thunder through their metalwork tunnel, beneath cars, lorries and cyclists, and ponies patiently pulling their load with scarcely the flicker of an ear at the tumult.

By morning there is still little change in the scenery, although a few more trees dot the landscape and the rice crop is mixed with cotton plantations. For nearly 125 miles (200 km) before it reaches Beijing, the train follows the path of Da Yunhe, the Grand Canal which links the rivers around the capital with the Yellow River, and then runs south again to the Yangtze, giving Beijing and Shanghai a direct link by water for the passage of minerals, foodstuffs and textiles. The outskirts of Beijing consist of sprawling acres of small factories, interspersed with shanty-town dwellings of brick and concrete, roofed with tarpaulin, and apartment buildings. Ponies and carts, and farmers' trucks become fewer, to be replaced by cars and bicycles, and, on entering the city, the broad dual-carriageway is lined with white-trunked willow trees and 6 in (15 cm) high, brightly painted iron railings along the pavement. At 10 a.m. the No. 14 train pulls into Beijing station with its red-tiled, green-roofed platforms, bilingual signs and great halls walled in red and lit by huge 1950s-style lights. Passengers arriving in the city disembark and walk down a subway to emerge across the grand central foyer, and out through metal turnstiles, but those leaving often have to travel up the long escalators to reach their platform, causing terrible confusion and worry to country people who may never have seen a moving staircase before. One often sees an elderly person or a mother and child dither and hesitate before trying to step on, and there are frequent falls and accidents, although there is always a member of staff

on hand to switch the escalator off. Outside the station is a wide concourse where passengers sit on or alongside their luggage until they are allowed into the huge, echoing, dimly lit chambers to await their train.

Beijing has more roads than any other metropolitan area of China, and it is the only city with a subway system. Known as the Underground Dragon, it carries more than a quarter of a million passengers a day, crammed like sardines during the rush hours when trains run every four minutes. There is a single, fixed fare no matter how far one is travelling, so it is often cheaper than the city's bus service and much warmer during the winter when temperatures sink as low as -4 degrees fahrenheit (-20 degrees centigrade). Beijing is also one of the few Chinese cities where Western people are a common sight; as the capital, and diplomatic centre, it has a large community of Westerners. The main Friendship store in Beijing is well stocked with ornaments, antiques, fur, silk and even Cadbury's chocolate, as well as other Western brand-name foods unobtainable almost anywhere else in China, and the city is full of restaurants representing all the different Chinese cuisines, specialists catering for every taste, ranging from Mongolian food

Foreign diesel. An ND₂ diesel electric locomotive approaches Nanjing station. These are 1974–5 derivations of the Romanian 060 DA class, built under licence from two Swiss companies SLM and Sulzer by Electroputere and supplied under barter arrangements. The signs on the platform are safety notices, roughly translated as 'stop, look and cross over'.

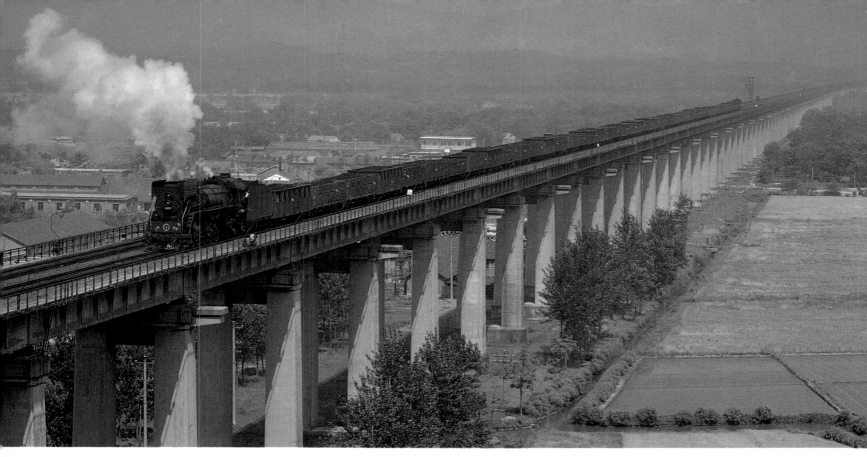

The northbound approach to
the Nanjing bridge, with a
heavy freight train climbing
up over the concrete arches
towards the box section which
spans the great river. It is a
long climb from the flat
terrain of the main line
because the river span must
be high enough to allow the
uninterrupted passage of
large ships.

Opposite: One of the
experiences available to the
privileged is to stand
alongside the tracks as the
trains roll north and south
over the 4 mile (6,700 metre)
rail and road bridge at
Nanjing, over 2,000 tons
carried in up to sixty wagons.

Nanjing bridge seen from the
river. Red flags top the towers,
and the long steep approach
for the railway disappears
into the smog.

154

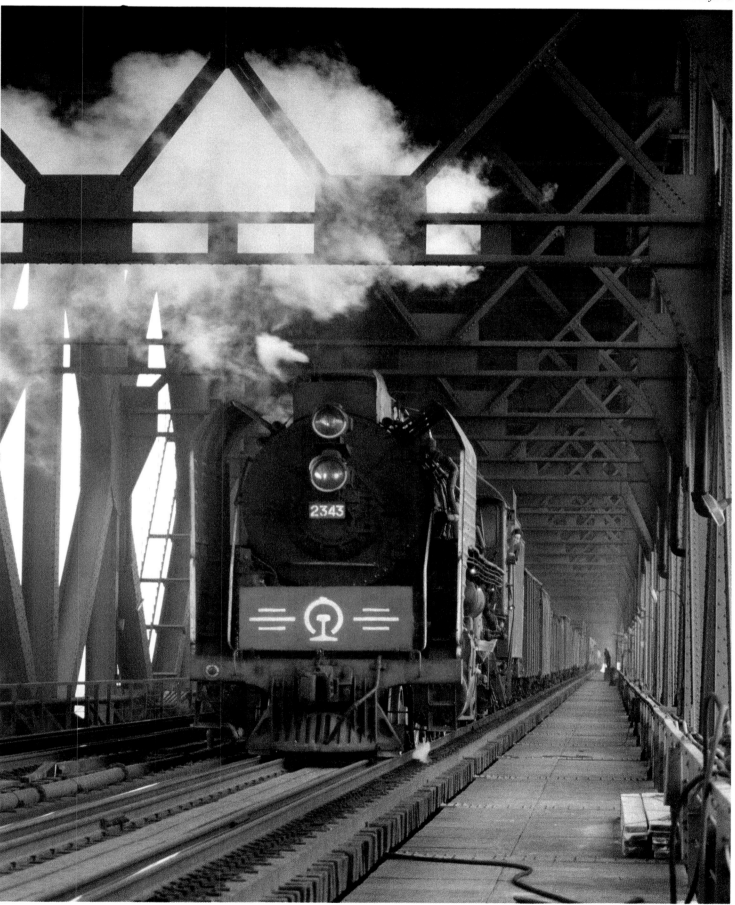

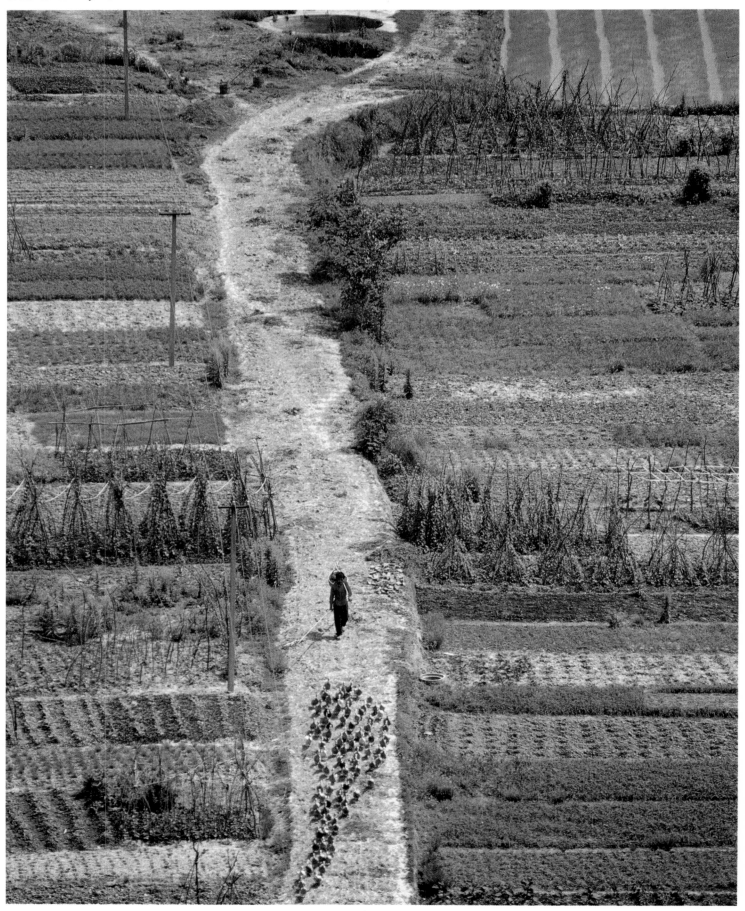

Before the construction of the Nanjing bridge the only way across the Yangtze River was by ferry boat. Seen against the murk of air pollution, these train ferries are still kept ready in case of an emergency, as this is a vital rail route from Shanghai and the south to Beijing.

to Beijing Duck. There is a Kentucky Fried Chicken takeaway, and several fascinating 'Western Restaurants' where the Chinese serve their idea of British food including boneless steak and chicken, bacon and eggs, salad, sea fish and egg mayonnaise, often in strange combinations, and generally bearing about as much resemblance to British food in Britain as a meal in the Chinatown district of a Western city would to Chinese food in China.

Beijing's origins are those of a frontier city trading with the Mongols and the Koreans. Although the Great Wall passed just north of it, the city had no real political significance until Kublai Khan chose Beijing, or Khanbaliq as he called it, as his capital. Before the thirteenth century all China's conquerors and unifiers, had based themselves at Xian, on the Silk Road, but it was to be in Khanbaliq that the great palaces were built and other major advances made – gunpowder was invented here, and paper money created. The city's glory lasted for just over a hundred years until the coming of the Ming Dynasty took over. The Ming emperors made Nanjing their capital and renamed the old city Beiping, or 'Northern Peace'. Within forty years it had been reinstated and christened again – Beijing, 'Northern Capital' – and the focus of power has remained

Opposite: Looking down from the bridge to the countryside below. A farmer herds his ducks along the dust pathway between the highly cultivated, individually owned strips.

157

Opposite: *Chairman Mao's Mausoleum seen from the entrance to the Forbidden City (now the Palace Museum) in Beijing.*

there ever since. Kublai Khan's palace was destroyed, and the Forbidden City built in its place, its satellite palaces and temples dating originally from the Ming era, although the complex has been substantially reconstructed in each century and most of what remains is only about two hundred years old. The Forbidden City was named for obvious reasons; even after the Republic was founded, no one but the former emperor, Pu Yi, and his family and courtiers were allowed within the enclave. Many of its most ancient treasures have been lost or destroyed during the fires which have repeatedly damaged the wooden buildings over the ages, but it is still one of the most fascinating places in the world to visit, with its multiplicity of palaces, courtyards, throne rooms and carved stone walkways. The Summer Palace of the Emperors is, perhaps, even more beautiful with a huge, lotus-strewn lake and elegant pavilions.

The main gate into the Forbidden City fronts Tiananmen Square, the central focus of Beijing, and location of the Great Hall of the People, and Chairman Mao's mausoleum. Everyone who visits Beijing ends up in the square sooner or later, and the huge flagged area is crowded with tiny photographic stalls, waiting to take souvenir pictures of visitors and their families with the Monument to the People or the Gate of Heavenly Peace as a backdrop. National Day in October is celebrated there with entertainments and military displays, and at night people wander in the square, meeting friends or playing chess under the tall, globular-shaped street lights. Mao lies in state in a cool marble-coated building, enshrined in a glass case. The face on display is probably a death mask, but visitors are forbidden to stop and stare as they file through, and one is left with the eerie impression that China's greatest statesman is merely asleep. The composed figure seems still to be watching over the country that admits his errors, but does not let them disguise his tremendous achievements.

Beijing is filled with temples in varying standards of renovation and repair. Many are now completely stripped and used as warehouses or factories, and those which survived the Cultural Revolution are generally unkempt and dim, although the last few years of greater religious freedom have seen a revival of care and interest in the old buildings. The most interesting is the Yonghegong temple, once an Imperial Palace and converted into a Tibetan lamasery in the eighteenth century when the authorities decreed that as well as the Dalai Lama in Lhasa, there should be a Mongolian Living Buddha in Beijing. This development ensured that a great deal of

Beijing's metro system is frequently crammed with people taking journeys of up to two hours to and from work. Here, an uncharacteristically empty train at a quieter time of day.

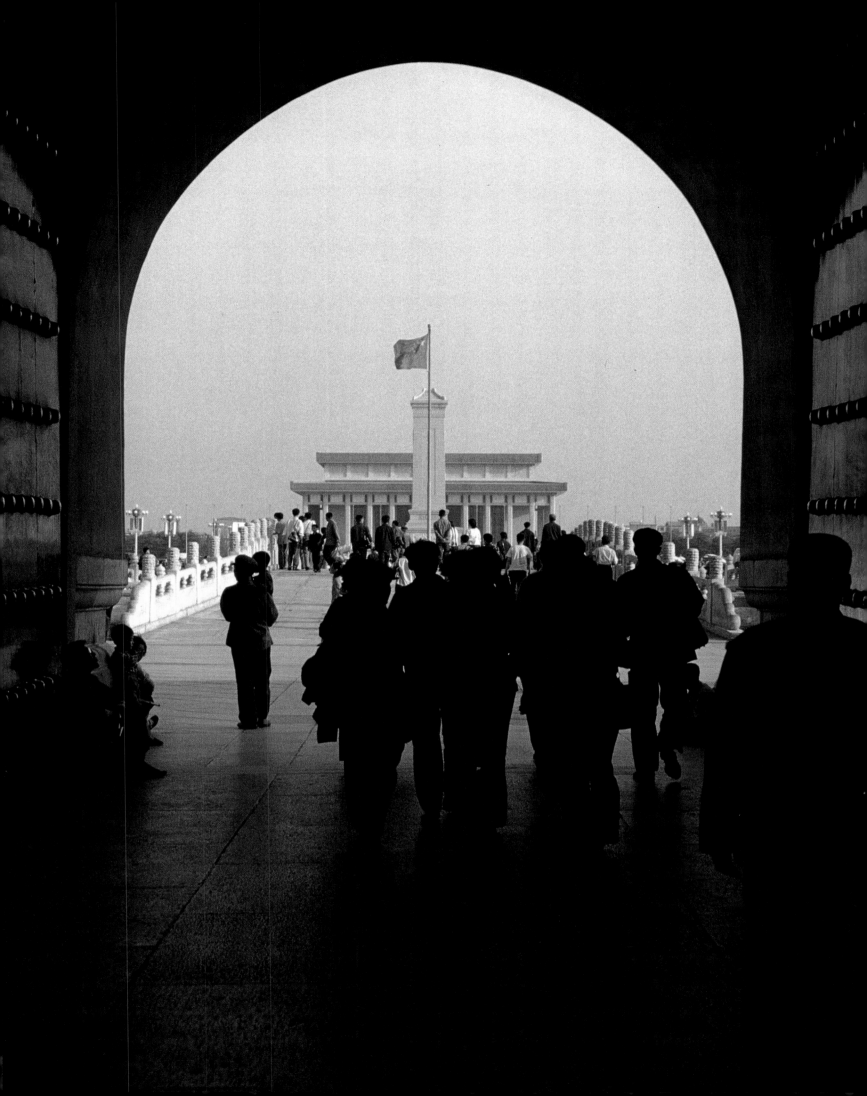

The Summer Palace with its beautiful carved and painted wood pagoda on top of the main hall.

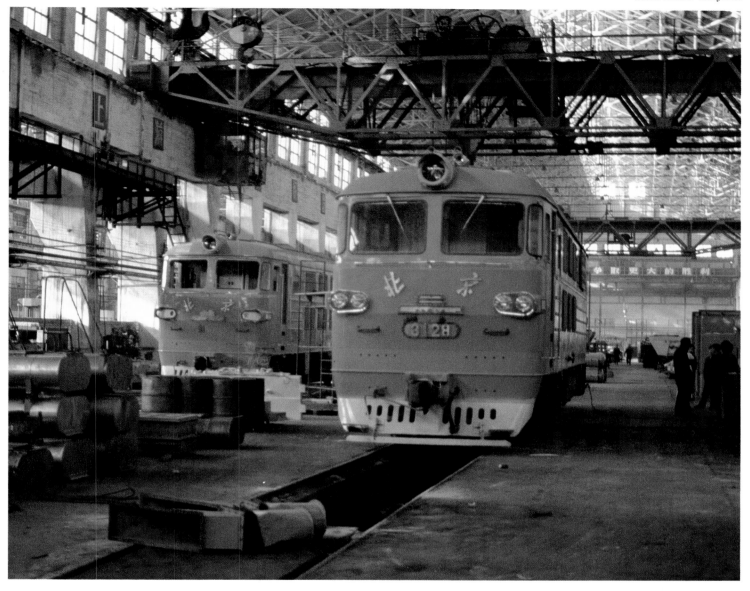

religious power was held in the capital and this, in turn, left a legacy of carvings, icons, sculptures and pictures, in addition to the Buddhas themselves, some of which are as much as 33 ft (10 m) high.

Beijing locomotive works is one of the three largest and best known in China, the other two being the Dalian works in South Manchuria, and the Sifang depot in Qingdao. It was built in 1901, but the name was changed to 'February 7th Locomotive Works' to commemorate a strike by railway workers at Zhengzhou twenty-two years later. Today its main product is a diesel hydraulic passenger engine, appropriately called the Beijing, which is closely related to German-designed diesels and a very efficient worker, with top speeds of up to 75 mph (120 kph). A larger, twin-engined version of the Beijing was designed during the 1970s for heavy freight, but was never actually produced, unlike the Dongfeng ('The East Is Red'), a diesel electric engine which has become increasingly popular in recent years, and is also manufactured at other workshops. In addition the factory acts as a repair depot for both steam and diesel locomotives, employing up to six thousand workers. It has an interest in foreign trade, producing information leaflets and sales brochures in both Chinese and English, and hoping to catch the modern market. It is one of Beijing's lesser-visited tourist attractions, but appointments can be made both for business parties and private enthusiasts, and they are warmly welcomed and proudly shown around.

Inside the Beijing February 7th Locomotive Works, which belong to the China National Railway Technical Equipment Corporation, showing BJ class diesel hydraulic locomotives in the paintshop. The factory manufactures its own engines, transmissions, bogies and final drives turning out between thirty-five and forty complete units a year.

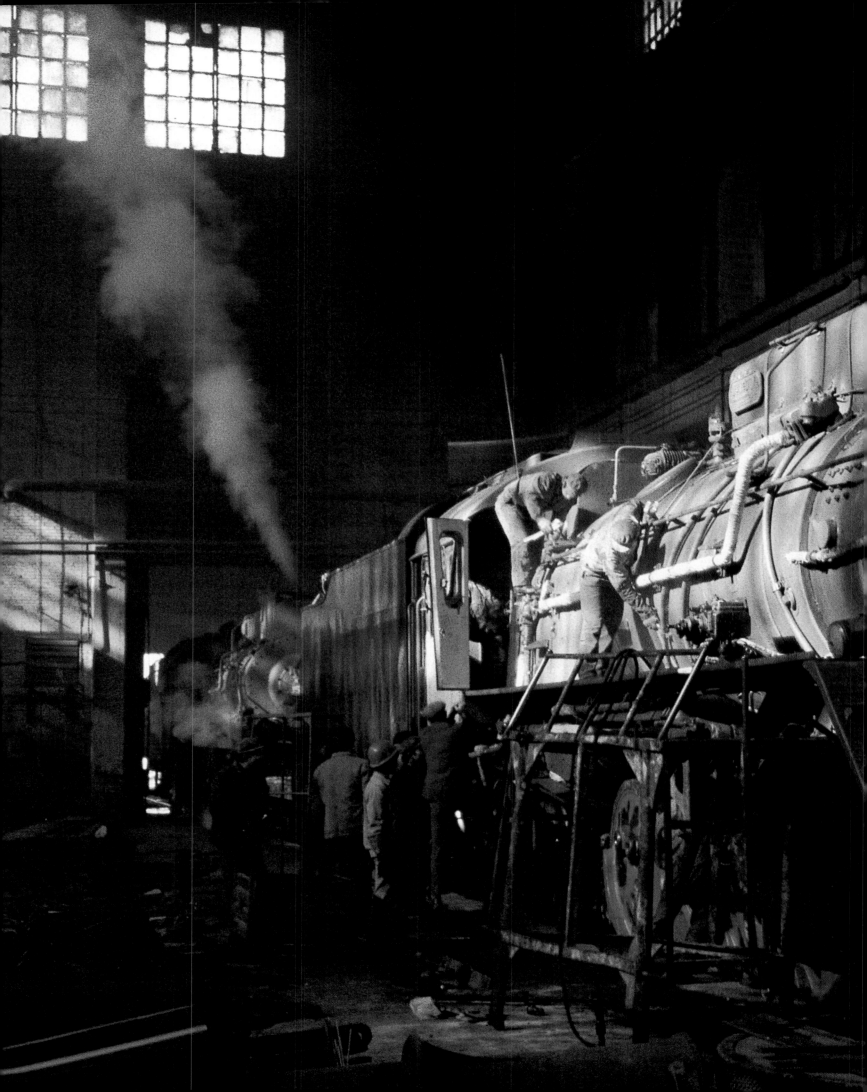

BEIJING TO DATONG

BEIJING HAS TWO stations, one for the local trains, and the other a majestic, yellow-brick, towered edifice which handles passenger traffic to the rest of the country. The main station even features a clock which chimes the tune of 'The East is Red' every hour on the hour. Up to forty million people a year pass through its portals to catch one of the 150 daily trains to all parts of China. Lhasa is the only Chinese-ruled capital which is not directly linked with Beijing, and international trains bound for North Korea, Mongolia and the USSR each depart once a week. To cope with all this traffic a new station, Beijing West, is being built and should be opened within the next two years. The stations will be linked by a brand-new section of the subway system.

Soft-class tourist passengers are generally whisked through the gates to their own white-seated waiting-room, often already occupied by a couple of smoking soldiers or police, and Blossoms, who pour tea from pretty, coloured teapots or the more usual metallic blue or red thermos flask. Other passengers wait in an enormous green-seated waiting-room, often crouching on the bare floorboards or curled up on their twine-wrapped bundles to wait. The Chinese are nearly always early, and foreign visitors in parties generally find themselves at the station a full hour before the train leaves. Stations are nearly always crowded, negating the popularly-held belief in the West that the Chinese are not allowed to travel; all that really limits them nowadays is time, for many cities in this huge country are at least twenty-four hours apart by even the fastest trains, and most Chinese people have only one day off a week. Exceptions to this rule are public holidays, like the Spring Festival, or National Day, when workers are given several days to get home to their families and to celebrate Liberation with feasts and fireworks. Students have longer holidays, and compassionate and special leave are available when necessary, but most travellers will be traders, either unit delegates on business, hoping to conduct deals in other cities, or farmers who have brought their wares for sale or come to buy essential goods which are not available in rural areas. There are also arranged holidays for conscientious and award-winning workers, and educational visits, organized by the work units to show their staff how a different company or subsidiary operates. A Chinese man or woman who left his or her job and travelled purely for interest would face opposition, for everyone is constantly asked their business and their unit, and general wanderlust is thought to be unsound. Westerners travelling together in a group are accepted by the Chinese as bringers of trade, and student backpackers are considered youngsters and tolerated good humouredly, but the older single traveller does not make sense to the Chinese, who themselves have never been permitted the luxury of time to do as they wish, or to travel simply for pleasure.

Tickets for Chinese trains are only available up to three days before departure, and those arriving on the intended day of travel are quite likely to be too late. Return tickets do not exist either, which means queuing again when the traveller wishes to come home, and makes a simple overnight trip to another town almost impossible unless you have someone to sort it out for you at the other end.

Previous pages: *Finishing touches to a JS class 2–8–2 locomotive at Datong Steam Locomotive Factory. A pilot engine is waiting to shunt it outside to be painted and tested before the journey to its new depot.*

Beijing to Datong is a journey of about seven hours, which crosses the flat plain surrounding the city and climbs into the hills guarded by the Great Wall of China, offering an unequalled view of the Wall itself, climbing and dipping, perched on impossible outcrops and riding sharp, inhospitable ridges. The hills are rugged, layered rock, terraced with rice and maize wherever there is soil, but for the most part barren and inaccessible. The planes of rock lie horizontal at first, then become vertical. Sharp, beige-coloured outcrops and tors mark the hilltops, while tumbled, shattered rocks and boulders line the valley slopes, reminders of the landslides which have ripped away the last remaining earth. The road and railway run almost parallel for part of the way and the view is often spoilt by endless electric cables stretching along the valley floors and over the hills. Two diesels haul the train as far as Qinglongqiao, where Zhan Tianyou, the engineer responsible for the line, is remembered by a stiffly posed statue. Then one engine changes ends and the train reverses in order to cope with the gradient, passing under the Great Wall itself and continuing the journey north-west. The next halt for all but express trains is Badaling, a stone's throw from the most-frequented part of the Wall, where tourists can walk along a reconstructed section and buy souvenirs. Two local trains from Beijing's smaller station and, in summer, one from the main station bring visitors from the city every day, flooding the Wall with Chinese, Hong Kong Chinese, Japanese and Western people. For all its fame as one of the greatest fortresses and barriers in the world, the Great Wall was never completely effective. Even during the periods when China was most unified there were never enough men to act as sentries over its entire 3,100 mile (5,000 km) length, and it became more of a highway than a barricade. The Wall was built two thousand years ago, during the Qin Dynasty, each area building its own section and then linking them up. On completion it stretched from Shanhaiguan on the eastern coast to just beyond Jiayuguan in the western desert. Many thousands of men, mostly convicts or soldiers, worked on it, but only a few areas were constructed in stone, the greater part being built of a kind of daub and wattle which needed constant repair. Now only a few stretches have been restored to their original grandeur, and two of these are near Beijing. Traders sell T-shirts proclaiming 'I climbed the Great Wall of China' in English, Chinese, or both, and locals crouch at the roadside selling walnuts, crab apples, vegetables and soft drinks. At Badaling there are even camels for the tourists to pose with, and they can dress as Marco Polo, with a cloak and sword provided for a small fee. The newer reconstruction of the Wall, a few miles further from Beijing and higher in the hills is the more dramatic of the two sites, surrounded by maple trees which flare crimson and scarlet in the autumn, and which in an early October snow provide the contrast of ice and fire. From an open-air market at the base of the hills, visitors can take a cable

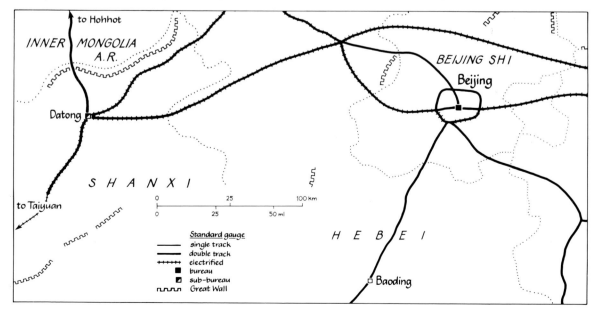

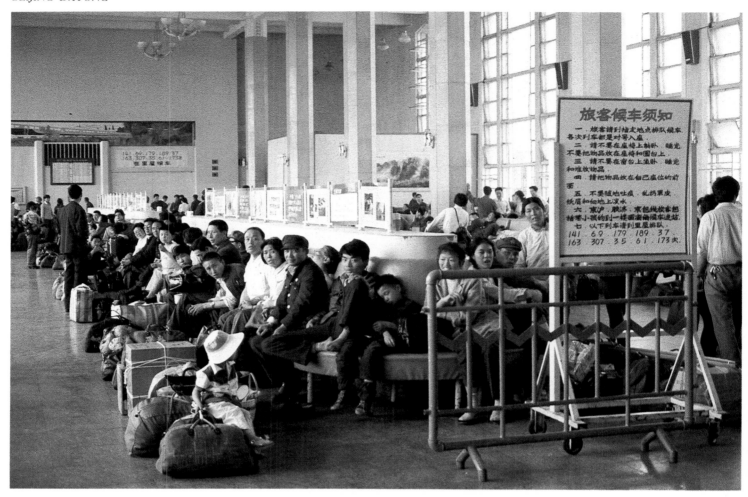

A hard-class waiting-room at Beijing's main station. The Chinese tend to arrive up to an hour early for all trains, but are not allowed onto the platforms until shortly before departure.

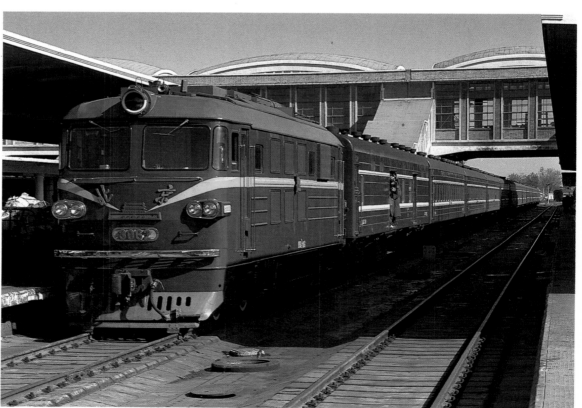

Beijing main station is a terminus completed in 1959 with very adequate facilities for what is now extremely heavy traffic. A BJ diesel hydraulic locomotive stands at the head of a train from the north comprising fourteen coaches, including a soft sleeper and a dining car.

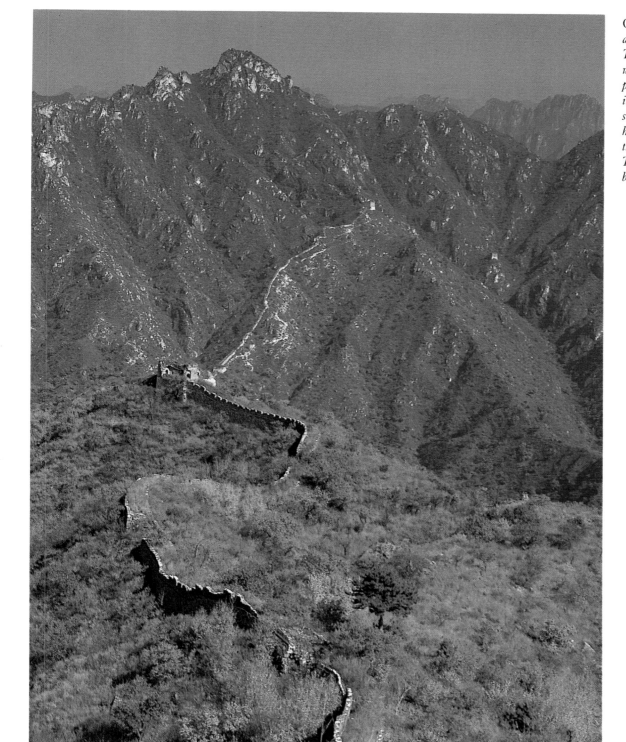

Overleaf: *The Wall is astonishingly steep in places. This part is one of several which have been painstakingly reconstructed in recent years. The lower section has become a base for hawkers selling 'I climbed the Great Wall of China' T-shirts and other tourist bric-a-brac.*

The Wall climbs seemingly impossible barricades and precipices to the north of Beijing. Tourists generally walk the restored parts, but those who travel further see far more of its grandeur.

167

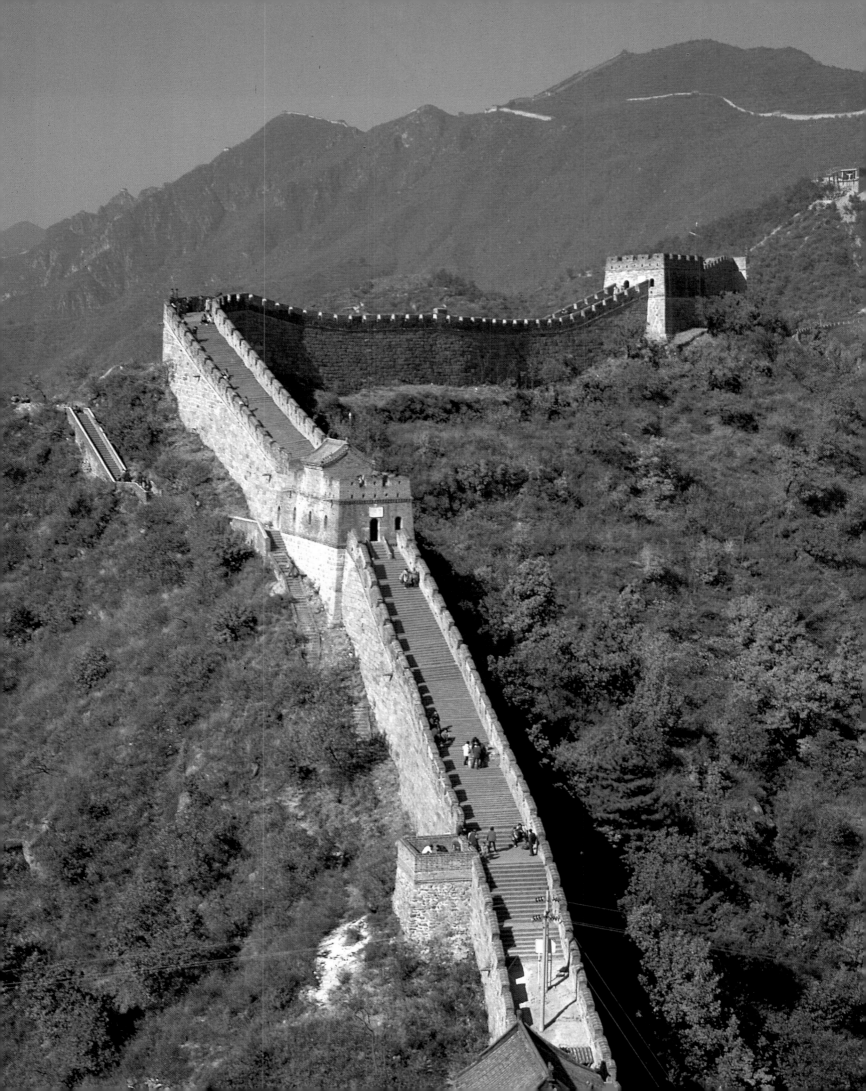

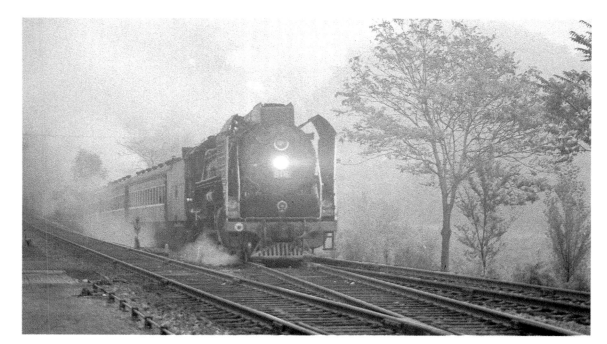

*QJ 2–10–2 No. 918
approaches Qinglongqiao
station in fog, after climbing
the first stage of the zig-zag
from the Nankou Pass. Its
passengers are bound for
Badaling – not a good day to
be visiting the Great Wall.*

*Qinglongqiao (new) station,
the reversing point for trains
coming up the zig-zag from
Nankou and Beijing. Because
of the load there is a steam
engine at each end, and QJ
No. 901 will come off once
the train reaches Badaling
on the far side of the tunnel
running under the Great
Wall.*

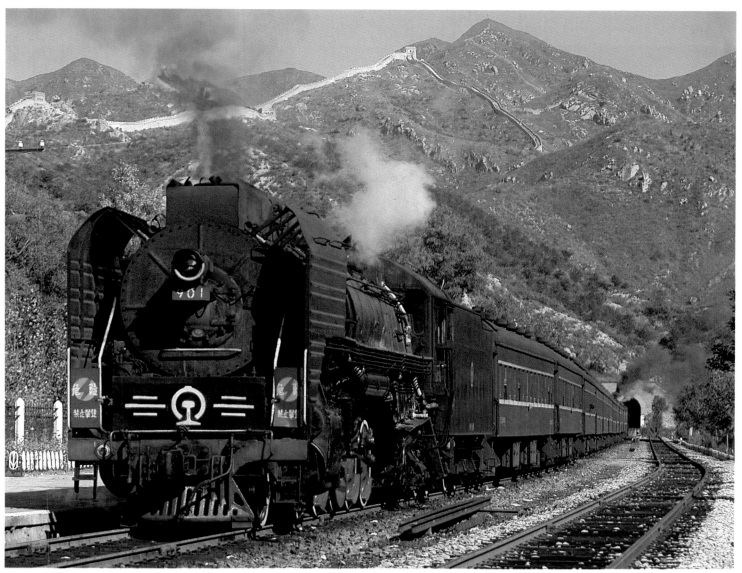

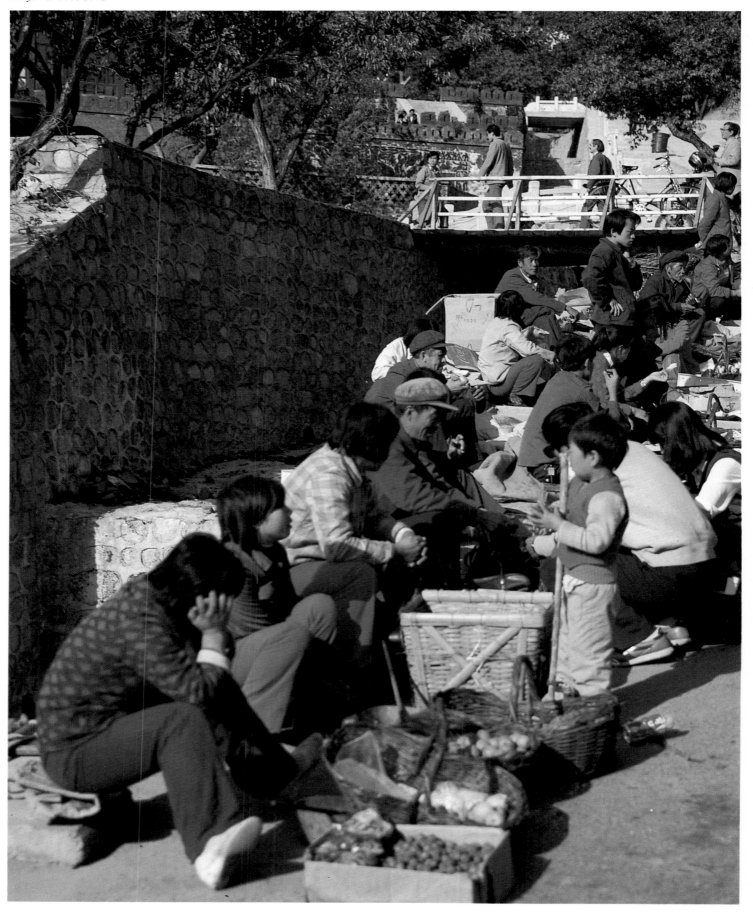

car or climb the 1,112 steps to the battlements before walking along the steep ramparts for about half a mile in each direction. Beyond this the Wall is a ruin, sprouting scrub and trees, but the strong hearted can climb further, over rubble and grass to the last crumbled guardpost, and stand gazing at the battered, ruined remains staggering and snaking across valley and ridge, disappearing and re-emerging for mile upon mile over the mountains, as far as the eye can see.

From Badaling to Datong, the train climbs continually along the valley of the Yang Ho River to a broad, near-desert plateau covered with scrub and brush. Very little is cultivated because of the poor agricultural quality of the land, but coal is mined under the grey and yellow earth, and sometimes an industrial or mining town suddenly materializes, puffing clouds of acrid smoke into the air, and revealing glimpses of pitheads and mounds of slack and gravel before disappearing back into an empty landscape. The train crosses the river on a long, narrow bridge of concrete and steel, then turns south-west towards the arid lands of the Gobi Desert, passing the ruined remains of a section of the Wall built independently from the rest as a 500 mile (800 km) loop around the barren northern lands. Datong lies just south of the northern arc of the Wall and the border with Inner Mongolia, and is a sturdy mining town which also does a brisk trade in shoes; leather is easily available from the north. The city was briefly China's capital, forming the base for the northern Wei people who ruled in the fourth century, and came to be known as the Jin Dynasty. Their legacy was the mysterious and enthralling series of buddhas in the cave carvings at Yungang, on the outskirts of Datong, where more than 50,000 statues, large and tiny, are etched into the mountainside, covering a distance of about half a mile (1 km). Some of the soft stone outside the caves has worn away, but most of the cool, dusky interiors are almost as clear as the day they were carved, with swirls of the original, vivid colours still in evidence.

Opposite: It is not only tourist traders who pitch camp at the Great Wall. Local people sell fruits and food to visiting Chinese, as well as hoping to catch the foreigner's eye.

The 1,400-year-old sandstone Buddha carvings at the Yun Gang caves near Datong are among the most spectacular in China. Some caves are barricaded, but children still climb in and out of cracks in the stone with little concern for the handiwork of their ancestors, which is already eroded by wind and weather.

The Jin Dynasty lasted one hundred years, but Datong retained its importance as one of the richest coal-mining areas in China, and when the railway was built in 1909 it became even more prominent, supplying much of northern China with fuel for its steam engines. For the railway enthusiast, Datong's main attraction is its steam engine factory, the last one in the world in full production. It was opened in 1953, and even now the staff say they manufacture three hundred steam engines a year, both the huge multi-purpose QJ, and the equally modern JS which is to replace the old Japanese JF as a shunting locomotive. In 1987 the factory built 125 QJs and 160 JSs, though its long-term future could well be in some doubt. Datong Locomotive Factory is even working on a prototype for a gas-fuelled steam engine, although the whole project is top secret, and informed sources imply that it is not making good progress. Visitors are permitted to tour the factory by prior appointment, and Datong is so accustomed to visits from groups of engineers or steam enthusiasts from all over the world that the factory has its own small hotel to cater for them. Not all the premises are open, and many work areas are off-limits as far as photography is concerned, but the section which is on view offers a unique chance to see steam construction – considered obsolete in the rest of the world. Visitors are given helmets (although many of the workers do not wear them) and can walk through the workshops where wheels and tubes are forged and bent, past eerie piles of psychedelic colours as twisted wires catch the faint light from long, grimy windows, and overhead cranes which swing parts at head-height across the walkways. The scene resembles Dante's Inferno, with the flash of blue fire from welding mingling with yellow and red flame, and the roar and crash of metal parts coming together to manufacture an engine out of the lifeless iron. The engines take shape, progressing through a series of buildings and turning from skeletons into the dignified and fully operational locomotives which lack only a spark to bring them to life. They are completed at the rate of almost one per day and are shunted outside by a resident JS, to be test-driven, and painted in sparkling black and red, ready to start work.

Workers at the factory have few safety rules, and hardly anyone wears protective clothing or goggles. The ground beneath their feet is slippery with oil and dirt, and conditions are such that a European or American environmental health inspector would be horrified. But the Chinese are very proud of their factory, and rightly so, for with the minimum of technological aid they work swiftly and efficiently, turning out engines to a rigid timetable. Like all factory workers in China, their entire life is governed by their work unit. A baby born here will spend its first few days in the factory hospital and as it grows will join first the kindergarten and then the school. Chinese children are generally model pupils taught that learning is the most important thing in the world, and shouting out agreement whenever the teacher asks 'Understood?' As well as the three Rs, even the youngest are taught their duty to the state and each other, and learn about the system they will grow up in. Whenever there are visitors to any factory unit the children are put on display, singing in harmony. Their songs have titles such as 'I am happy to be the monitor of my class' which are usually improving in tone – that example includes lines about staying behind to clean the blackboard rubber to help the teacher. Slightly older children may give gymnastic demonstrations or show off their artistic talent. Children born to parents at the factory go on either to the unit college, or to an outside training school to learn a skill, such as nursing, which they will return to their unit to practise. Alternatively they may go straight to work at a simple job such as sweeping the roads, or cleaning. College graduates become the next factory workers, mechanics, engineers, fitters and designers. For leisure they walk in the company parks, go to the company cinema or theatre, or read books from the unit library. They live in apartments on the site, and marry fellow workers at about the age of twenty-five. Abortion is available in the unit hospital, and the couple's one planned child will be born there as well, completing one cycle and beginning the next. The system sounds extraordinarily limited to Westerners but it has the guarantee of work and security, although it makes little allowance for creativity or movement. In China it is the accepted norm.

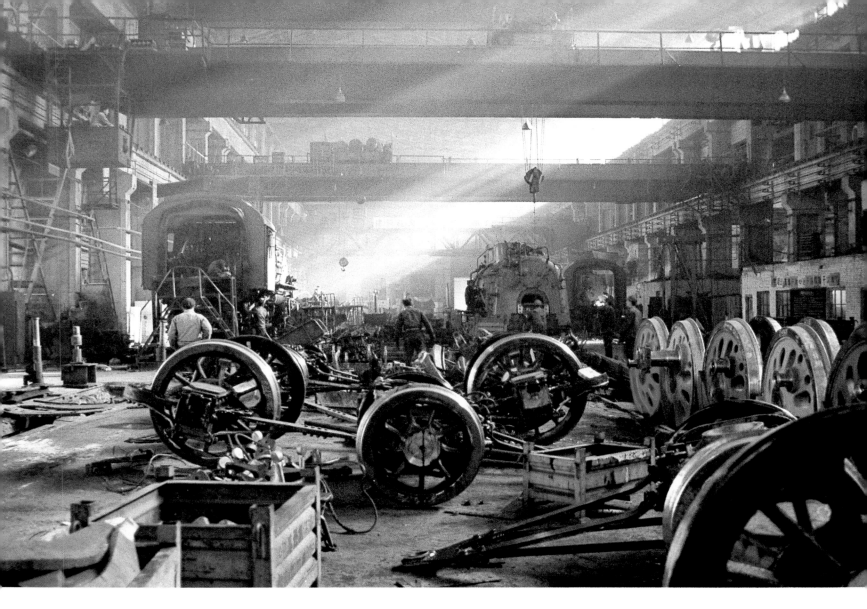

From Datong the traveller can return to Beijing, go north into the Gobi Desert, or journey south to Taiyuan en route for Xian. Taiyuan is capital of Shaanxi Province: a city with a history pitted with wars, mostly due to its location along the route northern armies used to attempt invasion of China. Fighting was so frequent that more than twenty temples in the town were dedicated to the god of war, although few of these survive. Nowadays, Taiyuan is best known for its immense deposits of iron ore and coal, some believe the largest in the world. Since the Second World War the city has become a major industrial centre in the middle of a complex rail network which is principally used for the transport of industrial materials and is not on any tourist itinerary. From Datong, most travellers take the route which leads through first Inner and then Outer Mongolia to Russia. The tracks run due north, starting in flat, grey barren lands, mostly shale and gravel, with patches of smooth, windblown sand arcs and tough, hardy bushes. Sixty miles (100 km) beyond Datong, the last river before Ulan Bator in Outer Mongolia sinks underground and the dust beats across the land, blown by dancing winds that burn and sting the skin. In summer it is searingly hot in daytime; at night, the winter temperatures can drop to −22 degrees fahrenheit (−30 degrees centigrade), but even this apparently deserted landscape has its moments of glory in spring and early summer, when the hills and valleys are covered with green shoots and grasses, and the Mongolian people grow what crops they can – potatoes and some wheat – in the brief flowering season. The Mongolians are herdsmen, breeding sheep, camels, horses and cattle; throughout the ages they have been famed for their sturdy, speedy ponies and, unlike the Chinese, they still ride instead of merely using the horse as a beast of burden. The border of Chinese Mongolia comes at Erlian, a mining town, desolate and windblown,

The erecting shop in the comprehensive locomotive factory at Datong where over three hundred Q J class 2–10–2s and JS class 2–8–2s are still built every year. The working conditions are dark and somewhat Dickensian but are improving steadily over the years.

173

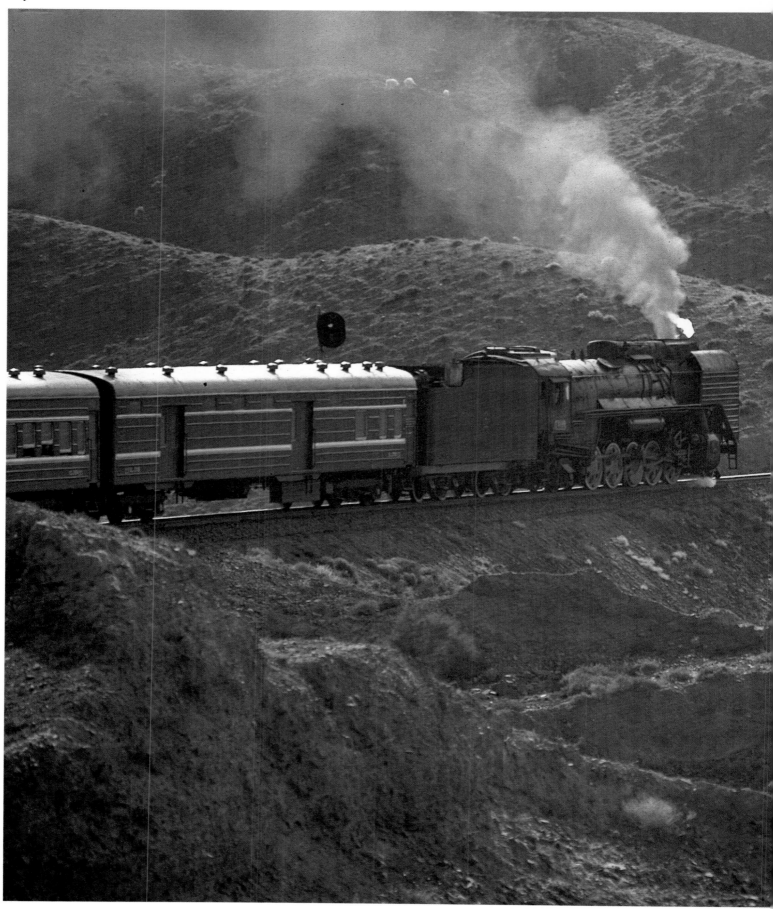

A passenger's-eye view as the Beijing–Lanzhou train climbs up into the bleak landscape. The nearby Gobi Desert is harsh and desolate, but people still live here, building by artesian wells or along the banks of the Yellow River.

175

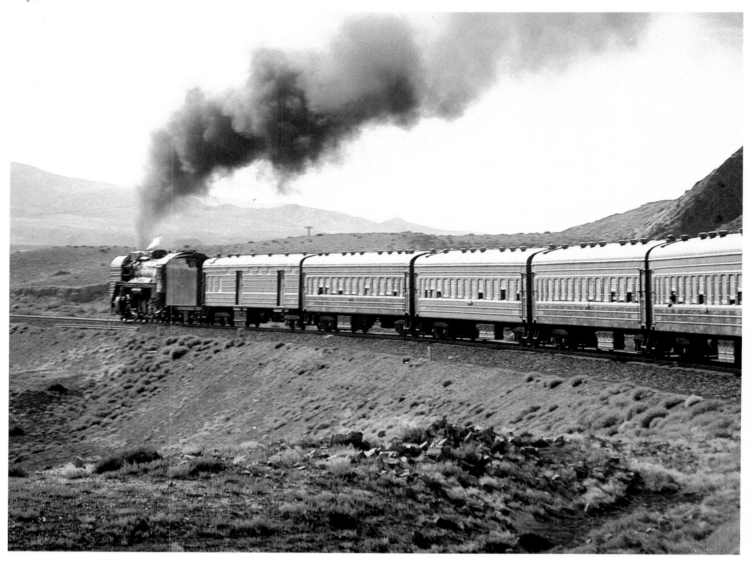

Beyond Zhong Wei, the train from Lanzhou steams into the desert.

populated by Han Chinese, Mongols and people of Russian descent. Passengers going further pass through immigration and customs here before the train changes bogies on to the Russian gauge of 5 ft 0 in and sets out through the steppes of Mongolia, and its capital, Ulan Bator, then onwards for another four days, through Siberia and west to Moscow.

The second route north from Datong travels some twenty-seven hours, all behind steam, through the Gobi Desert to Lanzhou. Only five hours from Datong is Hohhot, the capital of Inner Mongolia, a young town where the annual summer festival features daredevil races and stunts by horsemen from all over the autonomous region. North of the city are fertile grasslands which attract visitors wishing for a sight of Mongolian nomads and their herds of livestock, and to see the flowering of the desert during its brief summer. For the rest of the journey the sights depend on the season. Spring brings a certain fertility even to the Gobi, with artesian wells supplying irrigation along a line of oases and on the beds of rivers, which dry up on the surface, but still run below the shale. But in autumn or winter the Gobi is utterly barren, a great expanse of nothing for mile after mile. Some hills may be seen, and many deep-cut, dried-up river valleys, and everywhere dust and sand. Strangely the Yellow River which cuts through the desert does nothing to make the landscape greener after September has passed, and travellers can see a great, winding blue river in the heart of the desert with occasional patches of cultivation, but mostly with dull, dry, infertile earth on its banks.

The edge of the desert is mostly shale and gravel, but further in the fine sand blows into mile after mile of dunes sheltering numerous villages.

Mongolian horse breeders in the rolling hills not far from the capital, Ulan Bator.

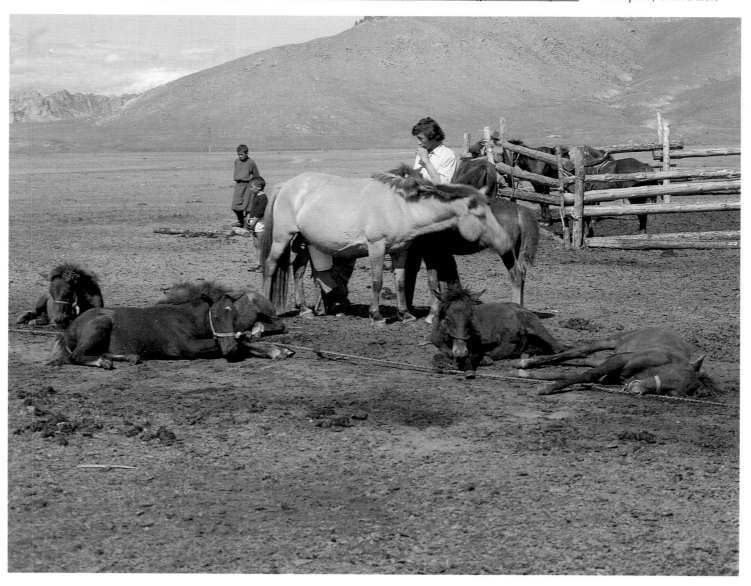

BEIJING TO THE RUSSIAN BORDER

AUTUMN IS THE best season for travelling to Manchuria, China's north-eastern spur, for though the land is arid and dry in places, the colours of cabbages and ripening maize dot the landscape, adding spice and contrast. Cabbages are to be seen everywhere in the north towards the end of the year – growing in the fields, being loaded on to lorries and carts, drying on balconies and roofs, and lying on the roadside for collection for the winter. In the cold months the temperature falls so low that no green vegetables are available; very few people have any kind of refrigeration, and although apples can be stored, without the cabbage harvest there would be no greens for the table until spring. The cabbages are distributed to different districts and left to dry on the pavement before their buyers take them home and store them in a cool, dry place to be revitalized by cooking in water or oil throughout the dark winter months. Every street corner has its cabbages, every cyclist carries some home on the back of his or her machine, every apartment block has them strung from the windows, and every road rumbles with lorries full of cabbages coming in from the countryside.

The Beijing–Changchun line is the first stage of the journey for the weekly train to Siberia and Moscow via Manzhouli, and is a fifteen-hour trip from the capital through productive land sprouting mile after mile of maize to make the sweet yellow bread which supplements rice in the modern Chinese diet. The route takes in first a series of traditional farming communes and villages, clustered on the broad curve of a river or situated by the main road to the nearest market town, then the large city of Shenyang (once the well-known Japanese-occupied town of Muckden) followed by some smaller industrial and mining towns, before finally arriving in the redbrick, cluttered outskirts of Changchun with their unusual littered embankments and sloganed walls, and the small, untidy factories which supply parts for the city's main products – trucks and carriages. Dead and decaying cars are piled on scrapheaps together with other industrial debris, concealing the fact that Changchun is one of China's prettier cities overall, built mostly in coloured brick with painted wooden windowsills of yellow or green, and acres of parks. Before the twentieth century its history is obscure, and its present buildings date from the 1930s or later; there are no temples or historical remains in Changchun. From 1933 to 1945 it was the capital of Japanese-ruled China with Pu Yi, the last real Emperor of all China, as its puppet figurehead. The Japanese took him from exile when they created their alternative China, 'Manchuquo', built him a palace which must have seemed dismal in comparison to the Forbidden City where he was born, and allowed him to do nothing and go nowhere. The Russians took over at the end of the Second World War, jailing Pu Yi once again, and he remained in prison until the late 1950s, when he was given a job as a gardener in Beijing. It is rumoured that he was much happier in the final years before his death in 1967 than when, in his youth, he held power of a kind. His last wife, whom he married when she was very young, is still alive and is said to be working in a library in Changchun.

The imposing buildings created by the Japanese for administrative centres are now principally used by the university and the research institutes, which are responsible for some of the most advanced work in China in the fields of archaeology and literature. The city is now the capital of

Previous pages: *A station on the old Trans-Siberian route from Harbin to Mudanjiang. The architecture is very similar to that on the existing route from Irkutsk to Vladivostok. The slogan reads 'Iron discipline, unite together, good quality service'.*

Jilin Province and one of the few in the country which has both trolley buses and trams, carrying its workers, crammed into claustrophobic crushes, at all hours of the day. Changchun is also a major railway junction, with its own locomotive depot and repair factory and a humpyard for sorting out the incoming wagons for distribution to other destinations. These are always shunted by the same, resident engine towards a long, low mound of several feet in height where a yardman, timing every move carefully, uncouples one or more wagons as they climb the hump. As they pass over the top of the incline they roll down at increased speed into a preselected siding. The points are then changed, and the next load trundles on to a parallel track for another destination. The operation is a masterpiece of co-ordination, and a manoeuvre which was common throughout the West up to a decade or so ago, enabling trains to be remarshalled before continuing a journey

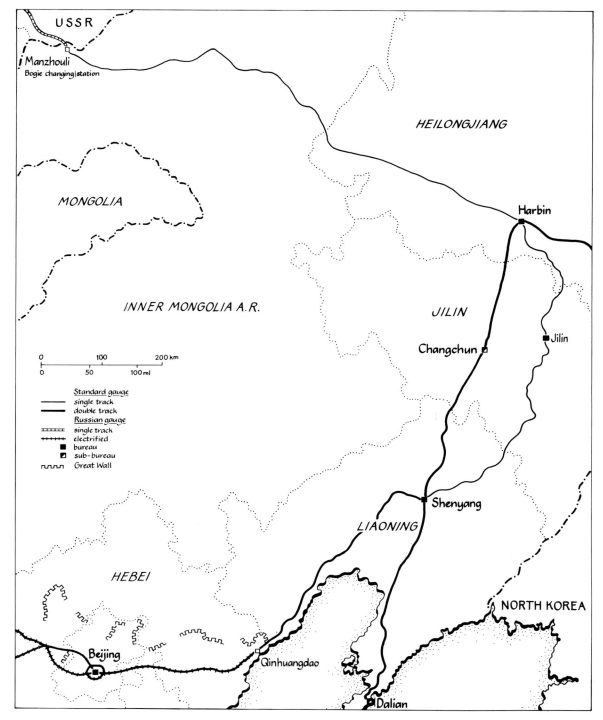

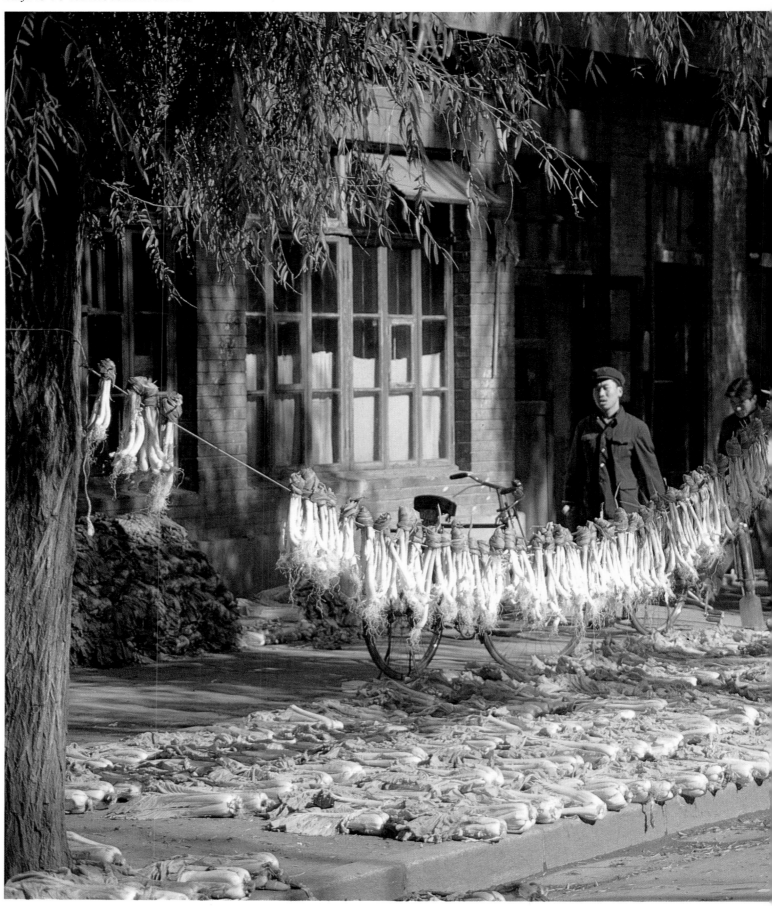

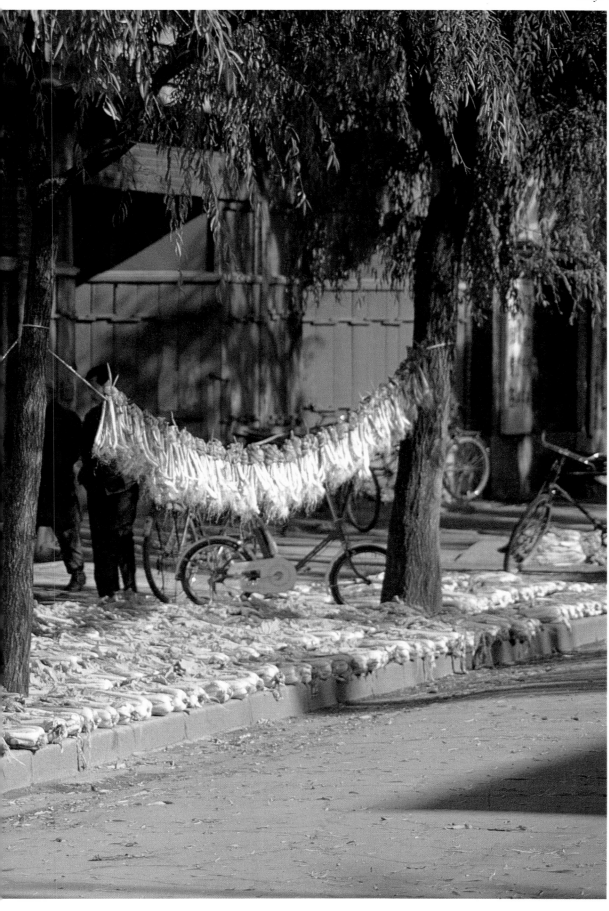

Cabbages are dried in the streets of northern China for much of the autumn, and then stored in dark places throughout the winter when there are no fresh vegetables available. This is an everyday scene in late October or early November in the Manchurian city of Changchun.

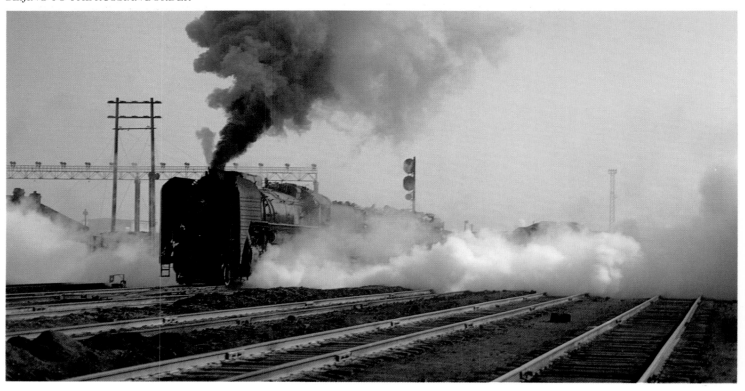

A modern Q J class 2–10–2 begins its long journey south with a heavy train of coal, logs and other merchandise. Most of these wagons have come down from the north via Harbin, but the train has been augmented by some others containing locally produced goods.

and ensuring that they have a correct load for their next major port of call. The humpyard lies at the end of the Changchun station platforms; Japanese-built in the 1930s, the station itself is full of character, with coloured bricks forming a green façade, statues and painted window frames. If Chinese progress follows its current pattern the building will soon be demolished to make way for a uniform concrete and steel one, sadly losing its individuality and character. Passengers enter the station by the usual metal gates and turnstiles, and Blossoms wave the crowds through, but stop anyone who looks as though they are from another area or country. The Beijing–Trans-Siberian express route passes through Changchun, so staff have to handle international tickets as well as the local Chinese ones. This sometimes leads to confusion, for international vouchers are the only tickets in China which do not have to be issued at the place of departure. They can be collected in Beijing, or even London, and are franked in Russian, which is not always understood; sometimes foreigners have to find a translator very fast to explain the situation to an attendant who has not been fully briefed. With only one train for Russia leaving each week, a mistake can lead to a seemingly endless delay.

Close by the station is the locomotive depot which looks after the day-to-day servicing of the engines – still, in Changchun's case, mostly steam. It is built in the American style with a semi-roundhouse and a huge turntable onto which engines are shunted and directed into stalls where they will be examined and repaired, their wheels removed, and the steel tyres turned or replaced whenever necessary. Just a hundred yards (90m) away is the refuelling and watering section where both home-based locomotives and the visitors from as far as 125 miles (200km) away are coaled and watered for their next journey. After the border between two railway administration areas is crossed, an engine will usually be changed for one from the new area at the earliest convenient point – a major function of large depots like that at Changchun. Crews on the locomotives work in twelve-hour shifts and China operates two separate systems of manning them. The old – some would say better, though less economic in manpower – system involves three crews, each of three men, held totally responsible for one engine; looking after it in a way which is only possible with familiarity and knowledge. All three crews go with the engine into the depot for its service, and to the locomotive factory for its regular complete overhaul. The new

system allows whichever crew is on duty to drive whichever engine is due to work next. It is easy to recognize which system is operated where, as the crews wholly responsible for their engine turn out cleaner, smarter and fresher-looking locomotives, whereas the engines not allocated to a specific team are frequently unclean and scruffy. On most days a wide variety of QJs, JFs, RMs and SLs can be seen at the depot, but the QJs are becoming more and more common, replacing other classes, and diesels are moving in too.

After 100,000 miles (161,000 km), a locomotive needs more than just a wheel check, a boiler overhaul or a valve inspection, and it is sent to the locomotive repair factory for a complete rebuild. There is only one of these in each major railway district, and steam engines in this part of Manchuria come to Changchun to be stripped down completely, the boiler de-scaled, re-stayed and re-tubed or sometimes even is completely replaced, all fittings removed and renovated, and brake pumps and injectors replaced. The locomotives lie like decapitated bodies with rusty entrails strewn here and there, appearing fit only for scrap, but the talent of the engineers recreates each one as new. Like the Datong Locomotive factory, the repair workshops are dark and gloomy, enlivened only by the blue spitting flame of welding guns and the spark of metal. Workers and visitors walk on concrete floors, avoiding the pools of oil and water and the

A JF class 2–8–2 acting as yard pilot drops off a tank wagon onto the maze of tracks in Changchun's efficient hump yard.

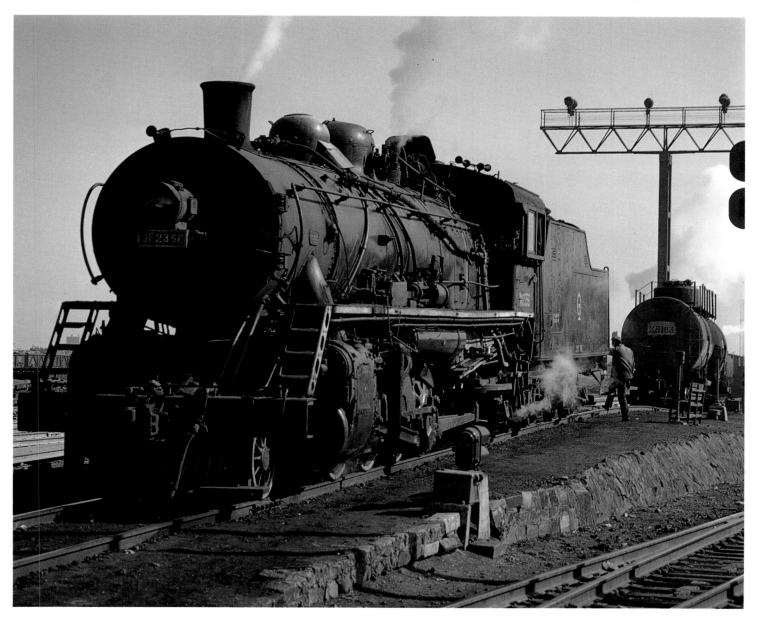

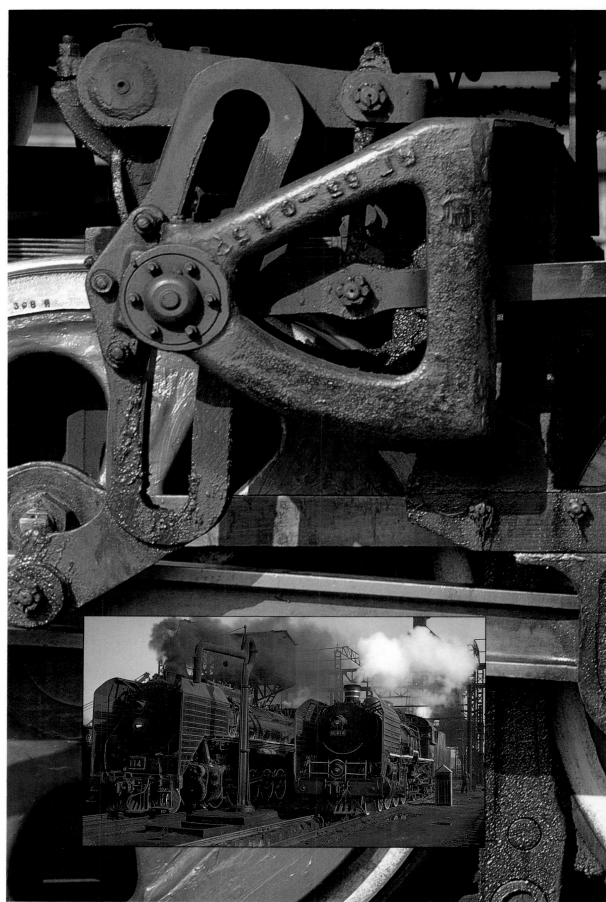

Cross head, slide bar and motion of a Changchun-based QJ class 2–10–2.

Inset: *New and old classes of steam locomotives stand side by side in Changchun locomotive depot in October 1987. On the left is one of the earlier QJ 2–10–2s built at Datong; on the right SL 618 a Chinese-built (Sifang) Pacific waiting for a return passenger train to Jilin.*

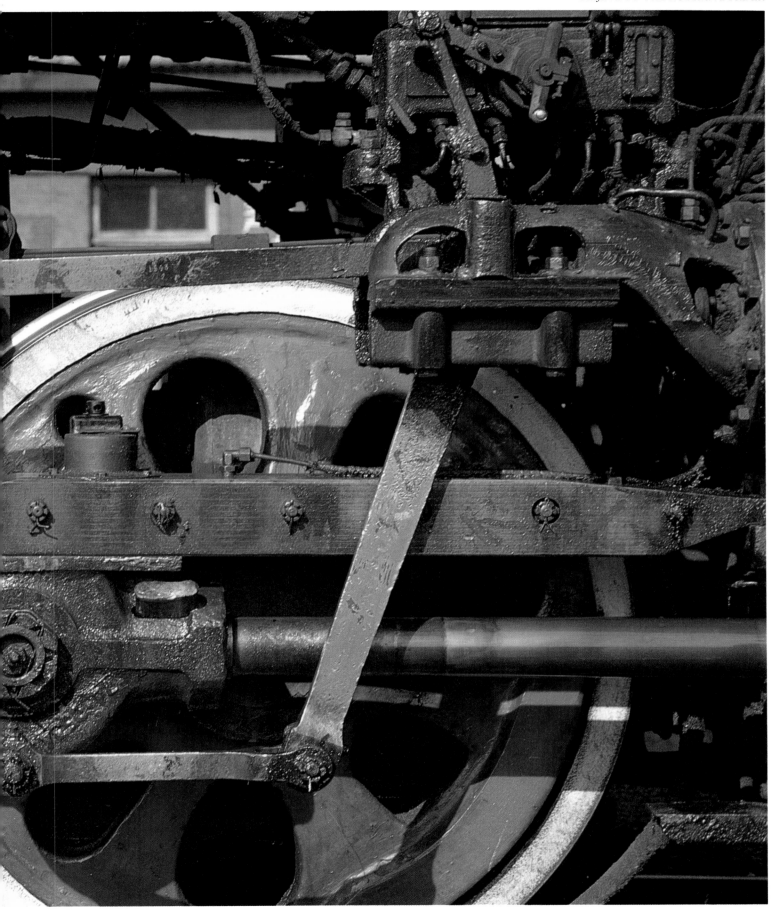

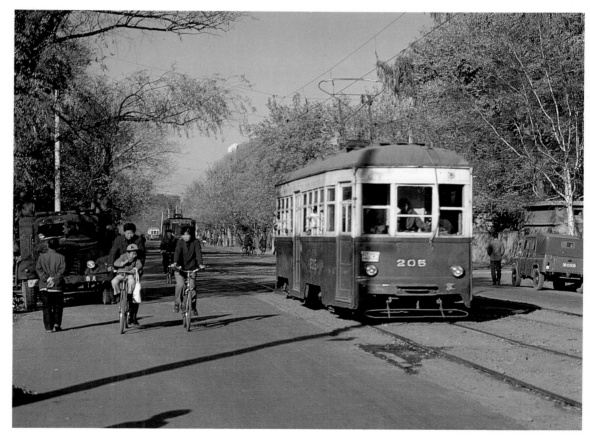

Local people gather around the base of the Russian memorial in a Changchun park to listen to a local story teller. The northern Chinese tend to be more conservative in their dress than people in the south, even in the 1980s.

Opposite: *Changchun Film Studios recording the adventures of the Monkey King, China's best known storybook character. This is one of the leading film studios in China.*

Changchun is one of the few Chinese cities still using an extensive tramway system and attracting enthusiasts from all over the world. These bogie units run an efficient service backed up by the more usual trolley buses.

188

heavy parts carried by overhead cranes, which trawl up and down the building in the light from the high, narrow windows. Visitors are admitted by appointment only, but many railway enthusiasts are keen to stop at the Changchun workshops to see the various examples of Chinese steam engines and to admire some of the best workmanship anywhere.

The city's other sights include China's first automotive factory, which builds limousines, cars and trucks – the latter to a well-tried and simple 1946 design, though it has been claimed for some years that a new type of vehicle is on the drawing board – and a carriage factory where, by appointment, visitors can see the manufacture and repair of the great railway coaches, although not the metro cars built for the Beijing subway, which are still made behind closed doors. The factory is currently working in conjunction with the Derby works in England on new designs. Changchun also has a thriving embroidery industry, and one of China's largest film studios where foreigners can walk around Ming Dynasty sets and props stores. Most of China's home-grown films are dubbed here.

Five hours due east of Changchun is Jilin City, a colder, harsher place where most of the people in the dry winter months wear face masks to protect themselves from the dust, the chemical factory pollution and the chilling winds. Curiously, more women in the north of China wear make-up than in any other region. They use eye-liner and a pale foundation as well as lipstick, and nowhere more than here is the Western woman's complexion more admired, more stared at and more criticized if it is less than perfect. The weather in Jilin can be very harsh, and around the Di'er Sounhua Jiang River there are strange sights in winter – trees filled with icicles and snowsprays caused by frozen steam from the city's hydroelectric plant which pumps hot water directly into the river.

Looking down over Jilin from the Beishan Park. The city is often swathed in an orange haze of pollution from the heavy chemical industry on its outskirts.

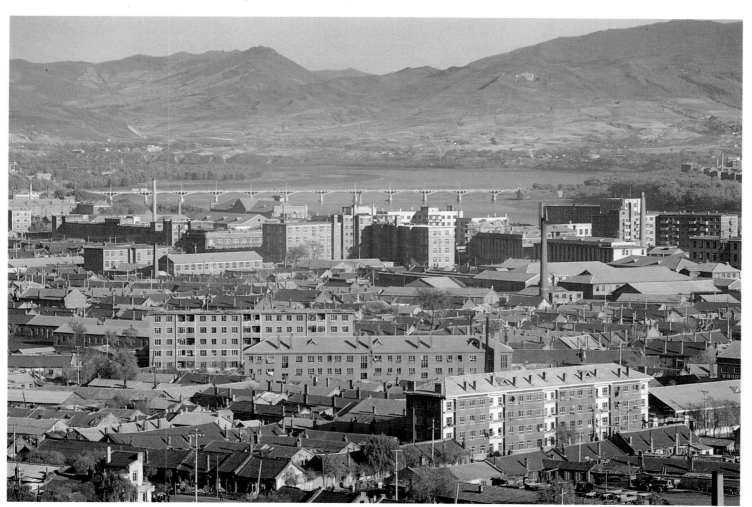

Following pages: *The single line from Shenyang to Jilin is a long one, with trains taking up to ten hours for the journey. Even today these can be steam-worked by SL Pacifics, although the diesels are rapidly taking over.*

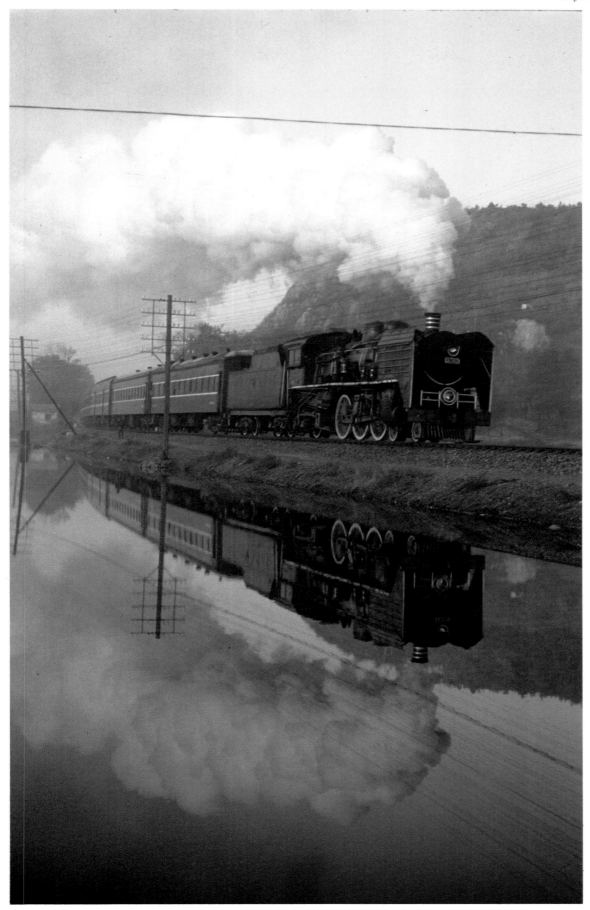

An autumn morning in Beishan Park, Jilin. The train is a local coming in from Tonghua, eleven hours to the south-east.

191

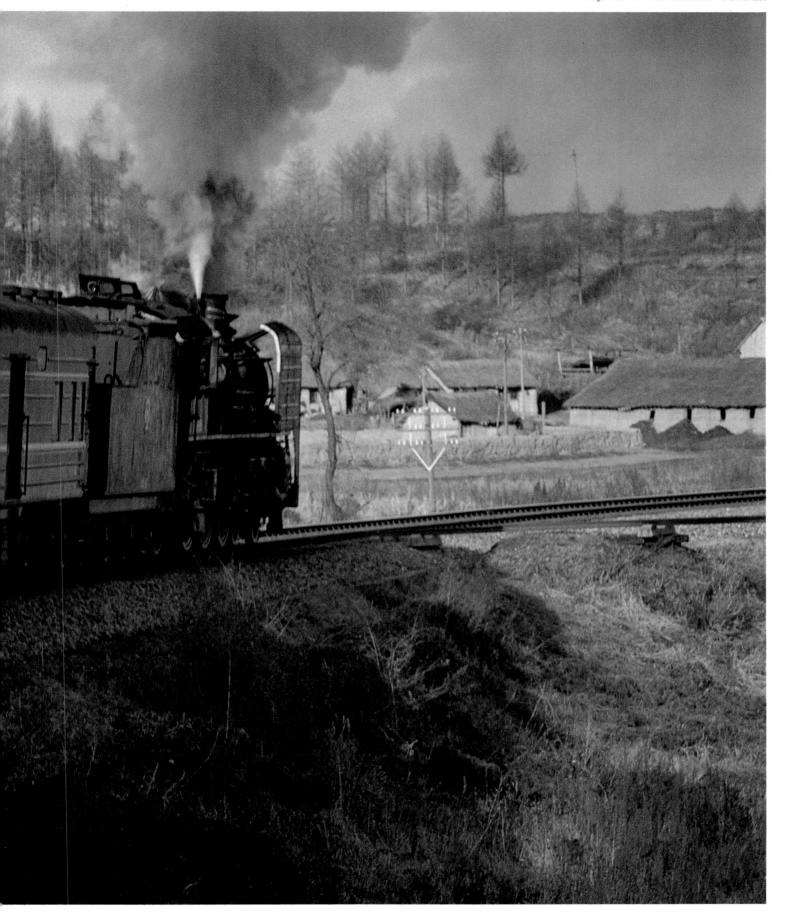

Following pages: One of China's three named locomotives (the other two are diesels) Marshall Zhu De. *His portrait adorns the smokebox door and other plaques accompanied by shining brass numbers are fixed to the cab sides. This has been a regular Harbin engine for some years, used to haul heavy freights over the southbound main line. On the shed at the same time was the original* Marshall Zhu De – *JF 1191, awaiting possible preservation at Shenyang Railway Museum.*

A train of empty timber bolsters en route from the standard gauge rail head at Shan Hetun to the timber-cutting area. The photograph clearly shows that these lines are not cheaply built narrow gauge systems, but well-constructed railways. The locomotive is a Chinese-built 0–8–0 belonging to the standard class used for this work.

Jilin is one of the recipient cities for timber from the Shan Hetun Forestry Railway in neighbouring Heilongjiang, China's most northerly province. China has seventy-nine such railways, all narrow gauge, built solely to bring wood from the hills to the main line for distribution. Most are situated in the north-east, habitat of the Manchurian tiger as well as that of bears, wolves and wildcats. Although these local railways are not generally open to the tourist, they are important, both in their own right and as the predecessors of many private tourist railways in the west. Shan Hetun Railway can be reached from Jilin either by road or rail, though for much of the way the term 'road' should be seen as a euphemism. In winter it is a frozen mud track, unsignposted, under a sky of startlingly bright stars, on which it is easy to lose oneself after a visit to the Forestry Railway. Both the main line railway and the road cross flat, cultivated lands scattered with young silver birch and scarred with coal mines, and brick kilns may be seen between market towns and smallholdings. Many houses are neatly tiled, their surrounding walls made from broken pots and gourds, sold cheaply by the brick and pottery works and piled together like dry stone. Dogs snuffle and pigs root, unpenned, in the villages, where open sewers run down the side of the main streets, crossed by bridges of planks. In the autumn the countryside is vividly yellow and gold, the haystacks arranged like spiky Christmas trees, and a wilderness of rubble, animal feed, barbed wire and plastic sheeting around each cottage. Maize is hung on the young trees in clusters, like bananas, and cabbages lie drying on the roofs. Even on bare shacks, with no more than one room and no internal sanitation, there is nearly always a television aeriel. China ensures that state communications are received even in the deepest countryside. The Shan Hetun Railway has been lengthened several times to reach further into the hills for more timber. Since the end of the Cultural Revolution, reforestation has begun and the countryside is now holding its own, but so much woodland has already been lost that it will take decades to replace the trees. The railway carries both pine and birch trunks down to Shan Hetun. Here, the local people are bundled up against the cold for much of the year, and drive covered wagons pulled by sturdy northern ponies very similar to the Norwegian Fjord breed. Very few Western people make the journey into this remote country, and strangers are the objects of intense scrutiny, and are overwhelmed with hospitality.

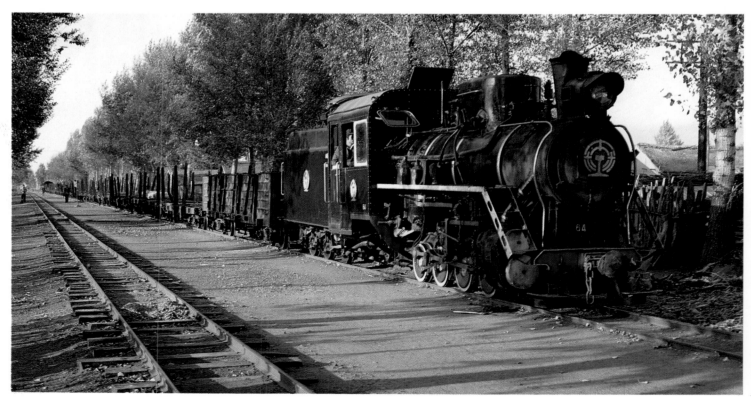

Manchuria is forestry railway country, and many 760 mm lines run long distances from the main line rail heads to the timber areas, where the landscape is scattered with small lakes or broad rivers.

The yard south of Harbin station, with one of the many timber trains coming in from the north-west. The station is in the background, with a DFH₃ diesel hydraulic engine at the head of a Beijing-bound express.

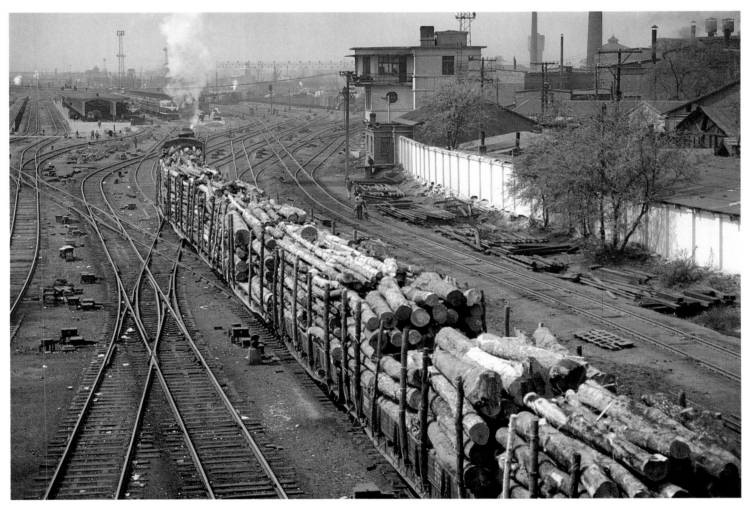

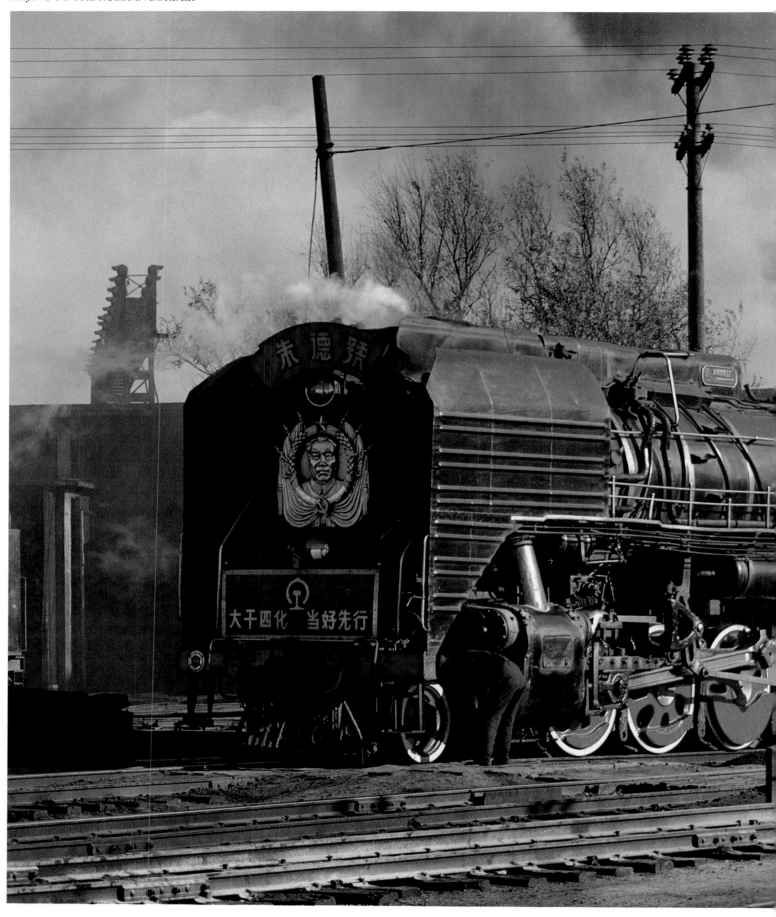

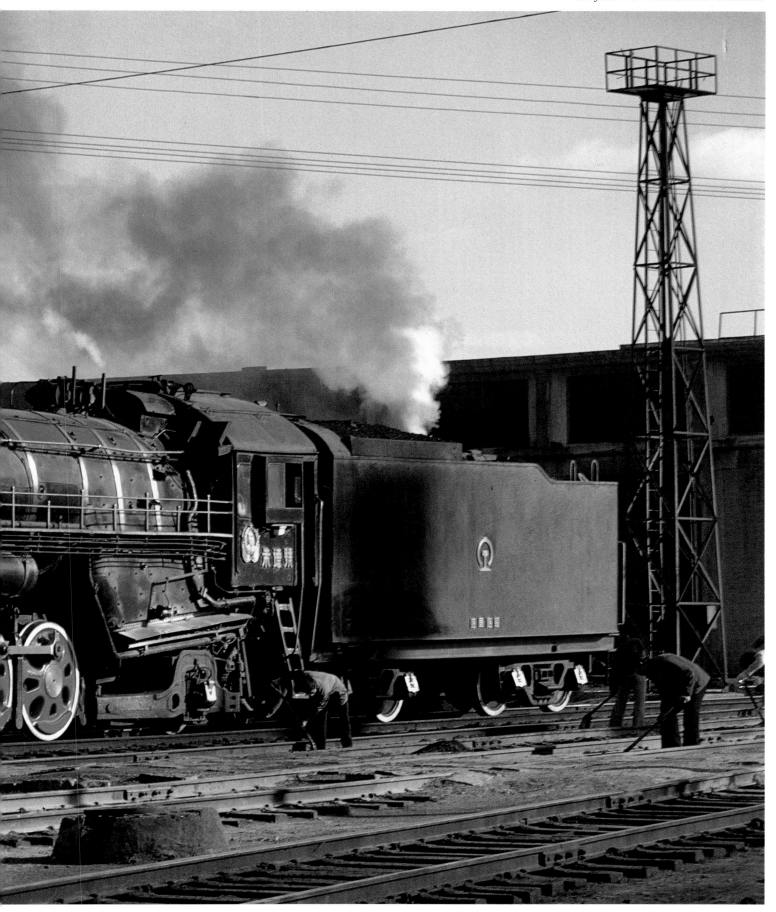

Following Russian tradition, Harbin has a narrow gauge children's railway in one of its parks. These lines, common throughout Soviet-influenced parts of the world, are staffed by children – with the exception of the driver – teaching them the joys and responsibilities of running a vital section of the state – its railway system.

Opposite: *RM Pacific No. 1070 takes a southbound express out of Harbin station, whilst a JF class 2–8–2 shunts the adjacent yard.*

The staff of Harbin's Children's Railway, including a white-uniformed railway policeman.

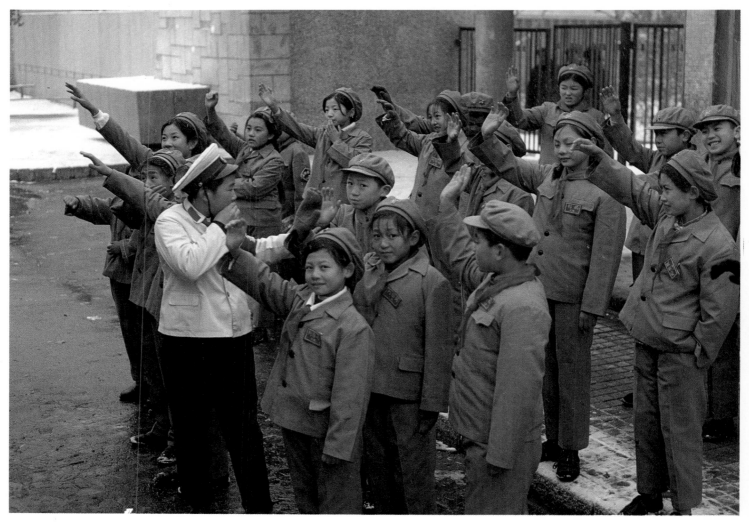

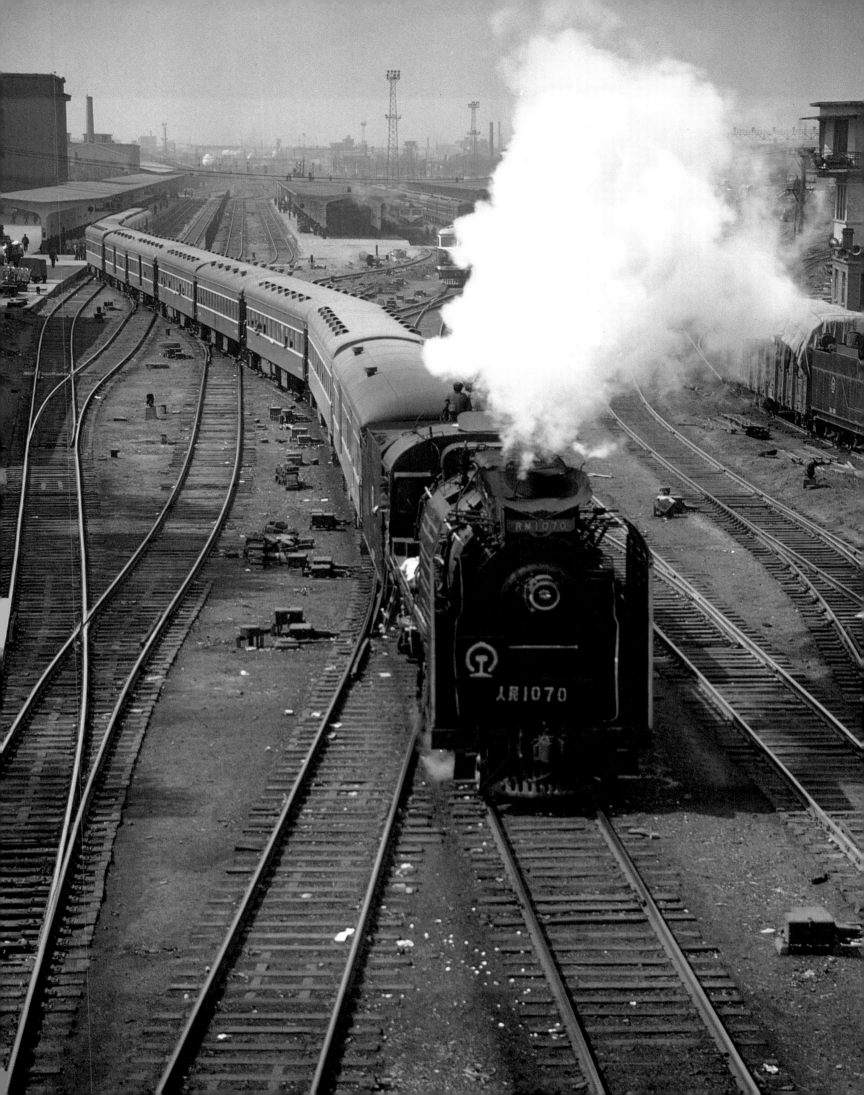

Winter in Harbin is always severe, with icy winds blowing from Siberia as well as constant flurries of snow. The trams and trolley buses keep going, whatever the weather.

Inset: *Crowds push to board a trolley bus as the winter snow begins to take effect in Harbin.*

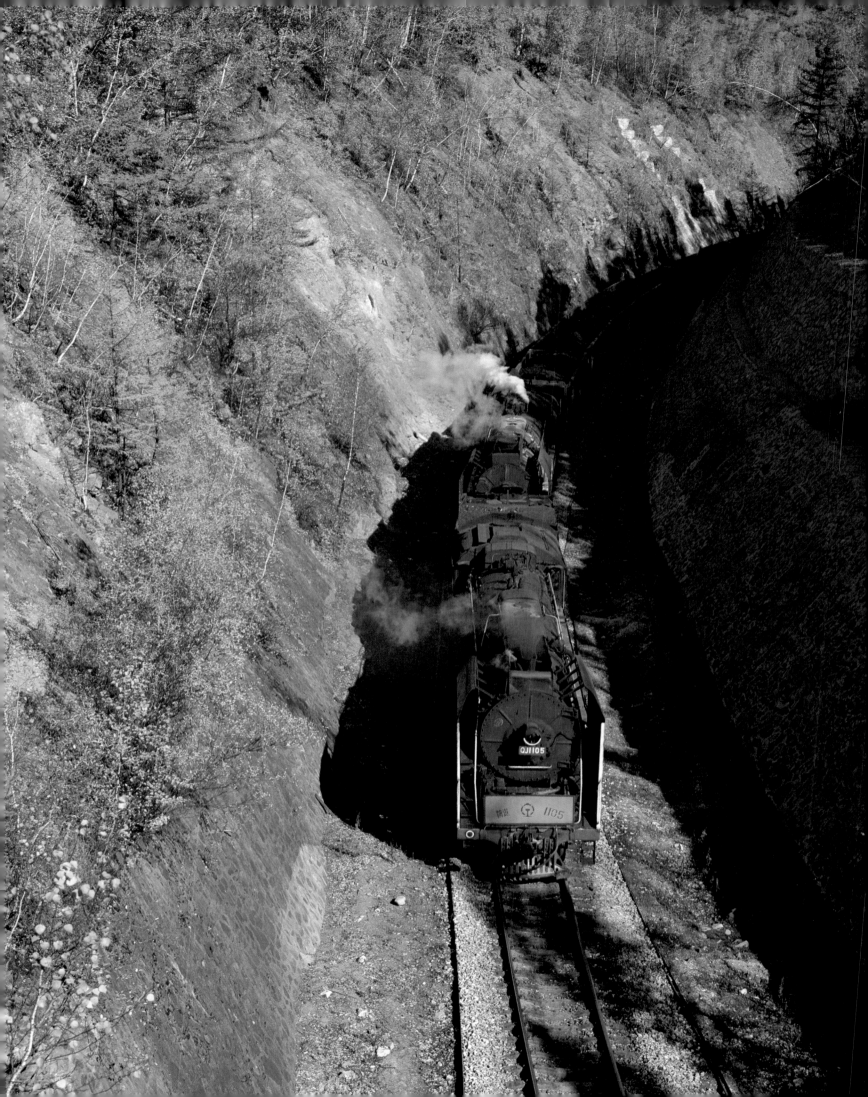

Further north is Harbin, the capital of Heilongjiang, a city frozen by icy winds lying in the middle of one of the widest flat plateaux in the world, where much of the north's wheat and maize are grown. Originally it was a fishing town, stretched along the banks of the Songhua River, but a great influx of Russian immigrants early this century has left an indelible imprint for the city lay on the line of the Trans-Siberian Railway en route for Vladivostok. The Japanese stopped Russian immigration when they invaded Manchuria, but so many had already fled there during the 1917 Revolution that Harbin's architecture and street layout owes more to the Russians than to the Chinese. It is an attractive city of spires and cupolas, with many near-derelict churches. The intensely northern atmosphere of the town is particularly apparent at the time of the Ice Lantern Festival in mid-winter, at Chinese New Year, when the local people create huge ice sculptures depicting animals, people and ancient Chinese legends. Harbin's fishing industry has been ruined by its chemical factories, paper mills, cement manufacturing and food processing industries, all of which have polluted the river, but it is a busy market town, and sometimes a surprising one, with its Russian backstreets. Another relic of its Russian past, although a more recent one, is the Children's Railway, a 1¼ mile (2 km) long, narrow gauge track with its own diesel and carriages, which is situated in the Children's Park, and operated completely by children under thirteen, with some adult guidance – very much a Russian positive educational practice.

From Harbin a section of the railway turns north-west across the most northerly spur of Inner Mongolia to the border at Manzhouli, crossing an undulating forest landscape where the rivers are often frozen, there is very little agriculture and few settlers. At the border there are customs and immigration checks and a no-man's land where the train is transferred from Chinese control to Russian, with a change of bogies on each carriage – the staff, with the exception of those in the dining car which is Chinese and comes off at Manzhouli, have been Russian from Beijing. The journey on the railways of China is over and the long passage to Moscow is about to begin.

The bogie-changing sheds at Erlian on the Chinese–Mongolian border, where the gauge widens from standard to the Russian 5 ft 0 in. A similar operation takes place on trains going through Manzhouli.

Opposite: Two Q J class 2–10–2s take a heavy freight through the forested hills near Buogetu, on the route from Harbin towards the Russian border at Manzhouli.

Chinese Steam Locomotive List

Those visiting China's railways today will be lucky to see more than the standard types of 4–6–2, 2–8–2 and 2–10–2 at work and already the writing is on the wall for the Pacific class. The American-built UNNRA KD7 2–8–0s can be found in a few depots, and working passenger trains and the 762 mm gauge locomotives for the forestry and local railways are still being built: these are not listed here in detail as they do not come under the general jurisdiction of the Chinese State Railway system. The locomotive classes and types listed below have been taken from an official locomotive dimension book published in 1975 so its contents are somewhat out of date, though of particular interest to those who have seen these older types since China opened its doors wider to the west in 1976. The list will also provide information for those whose interest lies in the steam locomotive world-wide. The book is described as a 'new edition' and usefully lists the classes and types which were added or had disappeared in the twenty years since the 1955 edition. These are as follows:–

Standard gauge classes added/developed since 1955: DK2, GJ, YJ, SY, ET7, XK13, RM, JS, FD, QJ, SL 601.

Standard gauge classes deleted since 1955: TH5, TH6, TH14, SL15, 941, SL16, SL18, SL19, SL20, MT3, ML2, ML4, PL3, PL6 96–98, KD15, KD18, JF18, JF20, AM2, XK8, XK10, XK11, XK12, MG12, MG4, MG591–99, MG9, MG10, MG11, (AM = 4–4–0, ML = Mallet or articulated).

Metre gauge classes added since 1955: KD55, JF51 751–754.

Metre gauge classes deleted since 1955: XK51, XK52, FA, FA52, LS51, MG51, MG52, PL51, PL52, AM51, TH51, SL51, KD51, KD52.

600 mm gauge class added since 1955: SN.

In the tables which follow basic dimensions are included to assist in identification of hitherto unknown classes. Where figures are missing this is because they do not appear in the official dimension book.

Class	Nos. (i)	Type	Where built	Years (ii)	Driving wheel diameter mm	Cylinder diameter x stroke mm	Coupled wheel spacing mm
Standard classes							
RM	1001–	4–6–2	Sifang	1958–60	1750	570 × 660	1830 × 2
SL	601–	4–6–2	Sifang	1956–58	1750	570 × 660	1830 × 2
SL	371–572	4–6–2	Japan	1935–44	1750	570 × 660	1830 × 2
SL	341–370	4–6–2	Japan	1933	1750	570 × 660	1830 × 2
SL	301–340	4–6–2	Japan	1934–41	1750	570 × 660	1830 × 2
QJ	0001–0003	2–10–2	Dalian				
QJ	1004–1008	2–10–2	Tangshan	1956–60	1500	650 × 800	1600 × 4
QJ	1502–1506	2–10–2	Shenyang (iii)				
QJ	3001–3002	2–10–2	Changchun				
QJ	3501–3518	2–10–2	Datong	1958–60	1500	650 × 800	1600 × 4
QJ	0004–0005	2–10–2	Dalian				
QJ	1001–1003	2–10–2	Mudanjiang	1958	1500	650 × 800	1600 × 4
QJ	1501	2–10–2	Tangshan (iii)				
QJ	2001–2003	2–10–2	Shenyang				
QJ	101–469	2–10–2	Datong	1964–69	1500	650 × 800	1600 × 4
QJ	475–595						
QJ	470–474	2–10–2	Datong	1968–73	1500	650 × 800	1600 × 4
QJ	596–						
QJ	6001–	2–10–2	Datong	1968	1500	650 × 800	1600 × 4
FD	1001–2000	2–10–2	USSR	1931	1500	670 × 770	1625 × 4
FD	2201–2250						
FD	2001–2004	2–10–2	USSR	1941	1500	670 × 770	1625 × 4
JS	5001–5146	2–8–2	Dalian, Chishuyen	1957–	1370	580 × 710	1473 × 3
JS	5301–5353						
JS	5147–5300	2–8–2	Dalian, Chishuyen	1961–	1370	580 × 710	1473 × 3
JS	5354–						
JF	1–70	2–8–2	Japan	1919–24	1370	580 × 710	1473 × 3
JF	501–574						
JF	71–73	2–8–2	Japan	1936	1370	580 × 710	1473 × 3
JF	74–500	2–8–2	Japan	1935–43	1370	580 × 710	1473 × 3
JF	575–2121	2–8–2	Sifang, Japan	1936–45/52	1370	580 × 710	1473 × 3
JF	2122–2500	2–8–2	Sifang, Dalian	1953–57	1370	580 × 710	1473 × 3
JF	4001–						
Other standard gauge locomotives							
KF1	1–	4–8–4	England	1936	1750	530 × 750	1900 × 3
MT1	1–	4–8–2	Japan	1936	1750	630 × 760	1830 × 3
SL1	1–20	4–6–2	America	1914–22	1580	508 × 660	1676 + 1677
SL1	21–30	4–6–2	America	1929	1580	508 × 660	
SL2	31–36	4–6–2	America	1917–21	1750	533 × 660	1880 × 2
SL2	41–100	4–6–2	America	1922–27	1750	533 × 660	1880 × 2
SL3	101–270	4–6–2	Japan	1934–40	1750	530 × 660	1830 × 2
SL4	271–280	4–6–2	Japan	1919	1750	533 × 660	1829 × 2
SL5	281–290	4–6–2	Japan	1926–28	1850	584 × 710	1980 × 2
SL6	291–300	4–6–2	Japan	1927–28	1850	584 × 710	1980 × 2
SL7	751–800	4–6–2	Japan	1934	2000	600 × 710	2080 × 2
SL8	801–830	4–6–2	Japan	1937	1850	600 × 710	1930 × 2
SL9	831–850	4–6–2	Japan	1905–1922	1750	530 × 660	1900 × 2
SL10	851–870	4–6–2	America	1922–25	1680	508 × 660	1778 × 2
SL11	871–880	4–6–2	America	1908	1750	508 × 660	1880 × 2
SL12	881–900	4–6–2	Japan	1942	1750	580 × 660	1829 × 2
SL13	901–920	4–6–2	Belgium	1937	1750	500 × 710	1850 × 2
SL14	921–930	4–6–2	England	1933	1750	508 × 710	1829 × 2
SL15	931–940	4–6–2	America	1921	1750	508 × 710	1829 × 2
TH1	1–20	4–6–0	America	1908–12	1750	482 × 610	1981 + 2438
TH1	21–30	4–6–0	America	1912	1750	482 × 610	1981 + 2438
TH1	31–40	4–6–0	England	1911	1750	482 × 610	1930 + 2489
ST1	1–20	2–10–2T	Czechoslovakia	1929	1320	635 × 710	1422.5 × 4
ST2	21–30	2–10–2	Germany	1935	1370	560 × 710	1450 × 4
ST3	31–50	2–10–2	Belgium	1937	1400	645 × 710	1600 × 4
DK1	1–70	2–10–0	America	1919–23	1370	584 × 710	1473 × 4
DK2	71–130	2–10–0	America	1916	1320	635 × 711	1422 × 4
DK3	131–140	2–10–0	Japan	1937	1400	630 × 750	1500 × 4
SY	0001–0650	2–8–2	Tangshan	1960–73	1370	530 × 710	1470 × 3
JF2	2501–2550	2–8–2	America, Japan	1924–32	1370	570 × 660	1498 + 1829 + 1498

Class	Nos. (i)	Type	Where built	Years (ii)	Driving wheel diameter mm	Cylinder diameter x stroke mm	Coupled wheel spacing mm
JF3	2551–2602	2–8–2	Czechoslovakia	1927–30	1400	520 × 710	1500 × 3
JF3	2603–2700	2–8–2	Belgium	1929	1400	520 × 710	1500 × 3
JF4	2701–2900	2–8–2	Japan	1935	1500	630 × 760	1600 × 3
JF5	2901–3000	2–8–2	Japan	1923–27	1370	570 × 660	1570 × 3?
JF6	3001–3022	2–8–2	Japan	1933–35	1370	530 × 710	1470 × 3
JF6	3101–3149						
JF6	3023–3043	2–8–2	Japan	1935	1370	530 × 710	1470 × 3
JF6	3044–3100	2–8–2	Japan	1935–45	1370	530 × 710	1470 × 3
JF6	3150–3600						
JF7	3601–3640	2–8–2	America	1913–24	1370	533 × 710	1524 × 3
JF7	3641–3650	2–8–2	England	1931	1370	533 × 710	1524 × 3
JF8	3651–3660	2–8–2	Czechoslovakia	1935	1135	450 × 560	1250 × 3
JF8	3661–3670	2–8–2	Czechoslovakia	1935	1150	450 × 570	
JF9	3671–3710	2–8–2	Japan	1940–43	1450	580 × 710	1524 × 3
JF10	3711–3740	2–8–2	America	1942	1520	533 × 710	1600 × 3
JF11	3741–3770	2–8–2	America	1918–20	1370	508 × 710	1524 × 3
JF11	3771–3790	2–8–2	America	1937	1370	508 × 710	1524 × 3
JF11	3791–3800	2–8–2	America	1930	1370	508 × 710	1524 × 3
JF11	3801–3810	2–8–2	England	1932	1370	508 × 710	1524 × 3
JF12	3811–3840	2–8–2	America	1922	1270	508 × 710	1448 × 3
JF13	3841–3850	2–8–2	Czechoslovakia	1939–40	1370	515 × 710	1500 × 3
JF13	3871–3885						
JF13	3851–3870	2–8–2	Czechoslovakia	1939	1370	515 × 710	1500 × 3
JF14	3886–3895	2–8–2	Germany	1937	1370	508 × 710	1570 × 3
JF14	3896–3905	2–8–2	Germany	1936	1370	508 × 660	
JF15	3906–3915	2–8–2	America	1928–29	1321	508 × 711	
JF17	3921–3925	2–8–2	Japan	1931	1370	533 × 660	1575 × 3
JF17	3926–3930	2–8–2	England	1934	1370	533 × 660	1575 × 3
KD1	1–50	2–8–0	England	1907–08	1270	560 × 660	1473 + 1397 + 1499
KD2	51–70	2–8–0	Belgium	1925	1400	600 × 660	2000 + 1550 + 2450
KD2	71–90	2–8–0	Belgium	1931	1400	600 × 660	2000 + 1550 + 2450
KD2	91–110	2–8–0	France	1935–36	1400	600 × 660	2000 + 1550 + 2450
KD3	111–145	2–8–0	England	1906–11	1370	572 × 710	1575 + 1524 + 1575
KD3	146–155	2–8–0	Weimantie (iv)	1914–15	1370	572 × 710	1575 + 1524 + 1575
KD4	156–180	2–8–0	England	1926–30	1420	533 × 660	1740 + 1664 + 1803
KD4	181–198	2–8–0	England	1926	1420	533 × 660	
KD4	199–200	2–8–0	England	1927–28	1420	533 × 660	
KD5	201–460	2–8–0	Japan	1897–1921	1250	508 × 610	1524 × 3
KD6	461–500	2–8–0	America	1942–46	1450	483 × 660	1575 × 3
KD7	501–750	2–8–0	America	1946	1520	560 × 710	1626 + 1626 + 2311
KD8	751–760	2–8–0	America	1920	1295	559 × 660	
KD9	761–790	2–8–0	America, Japan	1919–41	1370	533 × 660	1575 × 3
KD10	791–810	2–8–0	America	1905	1420	560 × 710	1575 + 1549 + 1829
KD11	811–830	2–8–0	America	1907–08	1370	560 × 710	1500 + 1574 + 1600
KD13	851–860	2–8–0	Belgium	1936	1400	520 × 660	
DB1	1–50	2–6–4T	America	1907–08	1370	482 × 660	2134 + 1879
DB1	51–60	2–6–4T	America	1907	1370	482 × 660	2134 + 1879
DB1	61–80	2–6–4T	Japan	1926	1370	483 × 660	2134 + 1879
DB2	81–120	2–6–4T	Japan	1934–36	1370	530 × 710	2210 + 1880
YJ	201–250	2–6–2	Jinangongchang	1959–61	1370	482 × 660	1470 × 2
YJ	251–	2–6–2	Jinangongchang	1959–61	1370	500 × 710	1470 × 2

Class	Nos. (i)	Type	Where built	Years (ii)	Driving wheel diameter mm	Cylinder diameter x stroke mm	Coupled wheel spacing mm
PL₁	1–30	2–6–2	America	1907–08	1270	483 × 610	1778 + 1575
PL₂	31–50	2–6–2	Japan	1935	1370	500 × 710	1470 × 2
PL₅	61–75	2–6–2T	England	1887–1914	1067	356 × 508	
PL₆	76–95	2–6–2T	England	1921–25	1370	432 × 610	1829 × 2
PL₉	131–165	2–6–2	Belgium	1920–23	1500	510 × 660	2108 × 2
PL₉	166–200	2–6–2	America	1920–22	1500	510 × 660	2108 × 2
PL₉	201–215	2–6–2	Czechoslovakia	1936	1512	510 × 660	2108 × 2
PL₉	216–230	2–6–2	America	1920	1500	510 × 660	2108 × 2
MG₁	11–20	2–6–0	Tangshan	1914	1520	482 × 610	
MG₁	31–40	2–6–0	England	1909	1520	482 × 610	2286 × 2
MG₁	41–45	2–6–0	America	1909	1520	483 × 610	
MG₁	46–50	2–6–0	Tangshan	1908–09	1520	482 × 610	2134 + 2438
MG₅	101–110	2–6–0	France	1902–05	1500	500 × 650	
MG₇	118–125	2–6–0	Germany	1910–11	1350	500 × 630	
MG₈	131–145	2–6–0	America	1916–19	1270	432 × 610	1900 + 1681
ET₁	1–20	0–8–0	America	1920	1370	560 × 660	1524 × 3
ET₆	61–70	0–8–0	England	1936	1200	420 × 600	1650 × 3
ET₆	71–80	0–8–0	England	1938	1200	420 × 600	1651 × 3
ET₇		0–8–0T	Poland	1959–61	1100	550 × 550	1400 × 3
GJ		0–6–0T	Chengdugongchang	1958–61	1000	480 × 500	1500 × 2
XK₂		0–6–0T	America	1943	1370	430 × 610	
XK₁₃		0–6–0T	Poland	1959–60	1100	460 × 540	1760 + 1640

1524 mm gauge locomotives

Class	Nos. (i)	Type	Where built	Years (ii)	Driving wheel diameter mm	Cylinder diameter x stroke mm	Coupled wheel spacing mm
DK₂		2–10–0	America	1916	1320	635 × 711	1422 × 4
JF₆		2–8–2	Japan	1935–45	1370	530 × 710	1470 × 3

Metre gauge locomotives

Class	Nos. (i)	Type	Where built	Years (ii)	Driving wheel diameter mm	Cylinder diameter x stroke mm	Coupled wheel spacing mm
DK₅₁	601–612	2–10–0	Germany	1937	1000	450 × 500	1200 × 4
DK₅₁	641	2–10–0	Germany	1939	1000	450 × 500	1200 × 4
JF₅₁	701–721	2–8–2T	France	1913/23	1050	450 × 500	1200 + 1200 + 1450
JF₅₁	731–738	2–8–2T	France	1926	1050	450 × 500	1200 + 1200 + 1450
JF₅₁	751–754	2–8–2T	Kunming	1958	1050	460 × 500	1200 + 1200 + 1450
JF₅₂	741	2–8–2T	France	1914	860	530 × 400	1300 × 3
KD₅₂	401–405	2–8–0	Switzerland	1939	1050	470 × 550	1250 + 1250 + 1800
KD₅₅	501–585	2–8–0	Japan	1897–1921	1250	508 × 610	1524 × 3

600 mm gauge locomotives

Class	Nos. (i)	Type	Where built	Years (ii)	Driving wheel diameter mm	Cylinder diameter x stroke mm	Coupled wheel spacing mm
SN	17–31	0–10–0	America	1926–30	711	330 × 406	812.8 × 4

Notes: (i) The number series quoted represent blocks of numbers reserved for a class, not necessarily the actual numbers of locomotives, eg there were only 18 Lung Hai Pacifics forming class SL₁₃, but a block of 20 numbers. (ii) Generally speaking years of construction, but in some cases years into service. (iii) These were prototype QJ locomotives, the first four batches with four-axle tenders, the second four with six-axle. It is not clear from the dimension book which particular engines were built at which works. (iv) Weimantie = Railway of the Manchurian Puppet Regime.

The steam locomotives supplied to and used by the forestry and local railways generally consist of 0–8–0s whose origin appears to be familiar Russian forestry motive power. As a large number of these lines date from the time of Russian aid this is understandable. The locomotives are specified as 250hp, capable of running at 35 kph, and weigh 28 tonnes in working order. They come from a number of builders in the Eastern bloc – Russia, Poland and Hungary – plus Finland (probably supplied as Russian war reparations). Those built in more recent years and on the current programme come from the steam locomotive factory at Shijiazhang.

The tables below provide information concerning the diesel and electric locomotives which are currently in use for both passenger and freight service on Chinese Railways.

DIESEL

ND₂ Class
No. Series: 0001–0130 +
Wheel Arrangement: Co Co
Diesel Engine: Sulzer 12 LDA 28B
Power Rating: 1540 kW at 850 r.p.m.
Transmission: Electroputere generator 6 × Electro. motors
Weight: 120 tons
Maximum Axle Load: 200 kN
Maximum Speed: 100 km/h
Builder: Electroputere Romania 1974–75

The ND₂ Class locomotives are derivatives of the Romanian 060 DA class, built under licence from the Swiss organizations Sulzer and SLM.
The ND₂ class appear to be confined to passenger traffic in the southern provinces of China. An influx of new American GE diesel electrics may well cause replacement.

BJ Class
No. Series: 3001–3150 +
Wheel Arrangement: B B
Diesel Engine: 12 240 Z
Power Rating: 2000 kW at 1100 r.p.m.
Transmission: EQ 2027 hydraulic transmission
Weight: 92 tons
Maximum Axle Load: 260 kW
Maximum Speed: 120 km/h
Builder: Beijing 'February 7' Plant 1969–1985 +

Combines a Voith-type hydraulic transmission with a medium speed four stroke diesel based on the American General Electric FDL series.
Used north and west from Beijing for passenger traffic.

DFH₃ Class
No. Series: 0001–0176 +
Wheel Arrangement: Co Co
Diesel Engine: 10E207
Power Rating: 1350 kW at 850 r.p.m.
Transmission: ZQFR 1350 generator 6 × ZQDR 204 motors
Weight: 126 tons
Maximum Axle Load: 210 kN
Maximum Speed: 120 km/h
Builder: Dalian

The DFH₃ has been used for many years on the international train to the Hong Kong border and later into Hong Kong. This is a similar class to the earlier DF with the motor gear ratio arranged for higher speeds. DFH₂₁ is the metre gauge version used in Yunan Province, south of Kunming.

DFH₄ Class
No. Series: 0001–0176 +
Wheel Arrangement: Co Co
Diesel Engine: 10E207
Power Rating: 1350 kW at 850 r.p.m.
Transmission: ZQFR 1350 generator 6 × ZQDR 204 motors
Weight: 126 tons
Maximum Axle Load: 210 kN
Maximum Speed: 120 km/h
Builder: Dalian from 1972

DFH₄ Class locomotives are used very widely on passenger trains south of Beijing.

DFH₃ Class
No. Series: – 4311 + 0001–0125 +
Wheel Arrangement: B B
Diesel Engine: 2 × 12 180 ZL
Power Rating: 2 × 1000 kW at 1500 r.p.m.
Transmission: 2 × SF 2010 Z hydraulic transmissions
Weight: 84 tons
Maximum Axle Load: 210 kN
Maximum Speed: 120 km/h
Builder: Qingdao from 1976 approximately

The locomotive is an equivalent to the German class 221 in both layout and power, but not in detail design. There are similarities to Henschel imports. Usually seen working passenger traffic north from Beijing to Harbin. This class is still in production. A version of this type is used on the Tan–Zam Railway.

NY₇ Class
No. Series: 0011–0030 +
Wheel Arrangement: C C
Diesel Engine: 2 × MA 12 V 956
Power Rating: 2 × 1870 kW at 1500 r.p.m.
Transmission: 2 × Voith L 820 hydraulic transmissions
Weight: 138 tons
Maximum Axle Load: 230 kN
Maximum Speed: 120 km/h
Builder: Henschel 1972

When built they were the most powerful diesel hydraulic locomotives in the world. Based in Beijing and appear to be confined to passenger traffic, including the difficult Nankou Pass Line.

ELECTRIC

SS₁ Class
No. Series: 1001–1264 +
Wheel Arrangement: Co Co
Current: 25 kV 50 Hz
Power Rating: 3900 kW
Power Conversion: Silicon Rectifier
Motors: 6 × four pole axle hung
Weight: 138 tons
Maximum Axle Load: 230 kN
Maximum Speed: 95 km/h
Builder: Tianxin

The type is still in production, and two experimental types SS₂ and SS₃ have been built with power output raised to 6530 h.p.

Photograph Acknowledgements

All the photographs in this book were taken by Patrick and Maggy Whitehouse unless otherwise credited.

The pictures which appear on the pages listed below are reproduced by kind permission of the following sources:

10–11, *Remunerative Railways for New Countries* by Richard C. Rapier, E. & F. N. Spon, London, 1878; 12, the Kowloon-Canton Railway; 13, 14 (upper left), the Library of Congress; 15, the Compagnie des Wagons-Lits; 17 (top three pictures) Mitchell Library, Glasgow (North British Collection), (bottom picture) National Railway Museum; 20, UNNRA Archives; 26–7, R. J. Jarvis; 191, J. Forrester; 21, 22, 23, 25, 34–5, 42 (top), 46, 64, 74–5, 79, 82–3, 86–7, 98–9, 104, 118–19, 122, 128–9, 130 (bottom), 131, 150–51, 152, 154 (bottom), 202, 203, The China Railway Publishing House.

Index